REAL LIFE WRITINGS IN AMERICAN LITERARY JOURNALISM: A NARRATOLOGICAL STUDY

REAL LIFE WRITINGS IN AMERICAN LITERARY JOURNALISM: A NARRATOLOGICAL STUDY

GURPREET KAUR

PARTRIDGE
A Penguin Random House Company

Print information available on the last page.

To order additional copies of this book, contact
Partridge India
000 800 10062 62
orders.india@partridgepublishing.com

www.partridgepublishing.com/india

CONTENTS

FOREWORD

In the modern era, science and technology have pierced through every corner of human life, leaving man with a feeling of nothingness without it. It is sad to know that man has thought himself to be the unconquerable, but the bitter reality is that the unconquerable has become destructive. Moreover, it is a fact that all is not well with the age of globalization and technology. Modern man is not having enough clarity between what is real and what is its construction, the right and wrong, the fact and fiction, and the clear and the ambiguous. This is the dilemma of every individual in the present culture and society.

With the drastic changes coming up in the life style of modern man, the writers have also been apprehensive about the future society. They are desirous of restoring vanishing moral values, eliminating social evils, conquering deadly diseases and saving society as well as Mother Nature for coming up generations. It is an urgent necessity for man to come out of the vain glorious illusions of modern civilization and introspect for redemption and purification.

As is the temper of the age, so are the protagonists in the literary works. The writers at the dawn of twentieth century were representing a strange and unknown kind of harassed and bewildered species that man was becoming in the disillusioned society. There was an impression of

disbelief for the technology and commodification of the culture in some of the writings. The writer, according to Hollowell, turned away from fiction to witness and record moral dilemmas of the times: He declined to invent characters and plot in order to reinforce his own shaky confidence in the face of a feeling of impending apocalypse (*Fact and Fiction* 15). The writers were using a powerful means of narrative writing to reflect these issues. Chiefly, anxiety and paranoia are the subjects of concern in most of the writings of American authors and literary journalists, like Ernest Hemingway, Tom Wolfe, Norman Mailer, John Hersey, etc.

Literary Journalism is a genre that carries not only events with it but also thoughts, emotions, attitudes, motives, and expectations experienced in that act. It is basically a journalistic text that reads like a novel. It is indeed firstly journalism. This means that the author needs to approach its topic as any journalist would and then employ literary or narrative techniques that would make the draft similar to a novel or a short story. Every single sentence, every single word must be true, just like it should be in ordinary, traditional journalism. He must not make up scenes, and invent no dialogue. It is observed that the literariness comes from the techniques and not from fictionalized events. This genre appointed the techniques of realistic fiction to portray daily life.

It was America where this genre had its strongest scholarly traditional roots. But with the passage of time, it started appearing in other cultures and literature with variation in form. Earlier literary journalism was just 'a write up', but now the situation is that it is being taught at universities in America and elsewhere, under the name of 'Literary Journalism' and 'Creative Nonfiction'.

International doctoral dissertations are being submitted and many critics have explored this area. This genre can be seen as a genre surrounded by other related forms of literature like, autobiography, fiction, science writing, conventional journalism and history. It begins with the reality of the world as we find it.

The book ***Real Life Writings in American Literary Journalism: A Narratological Study*** is an attempt to read the selected texts of John Hersey, Truman Capote, Norman Mailer and Don DeLillo, and to know their relevance to the context of literary journalism.

It is an attempt to study the effectiveness of journalistic fiction as a genre to convey reality. It also aims at examining the extent to which the truth has been tampered with and events bent in such fiction, so as to suit the writers' purpose. Through this kind of fiction the readers are forced not only to recall the major historical events narrated, but also their reactions and thoughts about them.

The book is divided into seven chapters on the basis of common themes in the selected texts under study. Chapter I introduces and establishes the significance of the theories of literary journalism given by critics like John Hartsock, John Hellman, Kevin Karrane, Ben Yagoda, Tom Wolfe, and Mas'ud Zavarzadeh. Chapter II provides a window to the American literature in the context of this genre. Chapter III examines the disciplines of narratology and rhetoric expounded by literary theorists like Gerard Genette, Gerald Prince, Mieke Bal, James Phelan, Norman Sims, and Porter H. Abbott. Chapter IV discusses the blurring of genres, namely of literature and journalism, in the narratives written by Norman Mailer like *The Armies of the Night* and *Of a Fire on the Moon. The Armies of*

the Night is based on the political event of the march to the Pentagon. *Of a Fire on the Moon*, being Mailer's most meta-textual work is concerned with the problem of representing the technical subject of Apollo 11. Chapter V studies the lives of real criminals, murderers, and their execution in *In Cold Blood* (1966) by Truman Capote, *The Executioner's Song* (1978) by Norman Mailer, and *Libra* (1988) by Don DeLillo. Chapter VI studies the major texts depicting violent incidents of the bombing of Hiroshima in *Hiroshima* (1946) by John Hersey and effects of 9/11 attacks on the twin towers through *Falling Man* (2007). Finally, Chapter VII attempts to sum up the ideas gained through this research.

This book provides a significant history of the development of literary journalism and at the same time also contributes some new perspectives to the already established field. It intends to be an essential sourcebook for all literary journalism readers.

I hope that the readers will find the endeavor as useful and enriching as I did.

Dr. Gurpreet Kaur

Acknowledgements

Over the past five years I have received support and encouragement from a great number of individuals. Foremost, I would like to thank my subject advisor, Dr. Reetinder Joshi, for her continuous support during the writing of this book, for her patience, motivation, enthusiasm, and immense knowledge. She guided me through all the stages. I couldn't have imagined having a better advisor and mentor.

My sincere thanks are due to the Punjabi University, Patiala for making me gain an enriching experience throughout the years of my research. I am fortunate enough to meet the Professors and staff members of the English Department and Research Branch who gave me their timely support and wonderful suggestions for tackling research related issues.

I also wish to give my heartfelt thanks to my colleagues in the academic world whose comments have been most helpful in the writing of this book.

Research institutions like the American Library, Delhi, its branches and Osmania University Centre for International Programmes, Hyderabad, proved highly invaluable for my work.

I owe a great deal to my parents, my in-laws, especially my husband and mother-in-law, my lovely sons, Avneet Singh and Prabhroop Singh, who have believed in my abilities and given all their support every time.

This list is incomplete and I apologize to anyone I omitted.

Finally, I thank the one above all of us, the omnipresent God, for answering my prayers, for giving me strength not to give up at any stage. Thank you so much Dear Lord.

CHAPTER 1

Defining blurring of Genres in Literary Journalism

CHAPTER 1

Defining blurring of Genres in Literary Journalism

Sometime after World War II, there was a turbulent period in the history of United States. There were multiple reasons for the sufferings of the people of United States like murders of John F. Kennedy and the King, and spread of Columbia Students' strikes. It was remembered as an era of protest marches. The chief event that the period witnessed was a protest march on the Pentagon, of which the novelist Norman Mailer was an active participant. The situation was becoming more and more hopeless in America. The result was shattering of families, damaging of social trust and destruction of economy. Journalism was obviously expected to play a crucial role in the history of American literature. And indeed it did.

Journalism in America has since long time back recognized itself as a powerful tool of communication. It has been a forerunner in disseminating information around the globe. It could be about anything like sports news, political events, simply weather forecast or public affairs. Journalists are not simply reporters who pass on information. To do field-work, meet people, interact with men and deal with situations so as to collect bits

of information, is a part and parcel of this profession. Not only is it essential for the journalist to help educate the citizens, but he must also serve as the citizens' eyes and ears in scrutinizing the powerful forces of nature and society. It is in this ideological framework that the journalist functions as investigative reporter (Altschull 263). He shows us a way to see and understand the world.

However, journalism is a comprehensive term which encompasses magazines, radio and press associations, and aims at diffusion of information. Journalism refers to a process of active fact-gathering, not just working from memory or sensory observation, but doing what reporters call reporting. The term journalism is derived from the French word 'journee' meaning work performed, and in Latin 'diurnalis' conveying daily recurrence. Kipling's six questions- who, what, how, where, when, why- prove to be a useful checklist for news stories, and it is certainly possible to write an introduction that includes them all. The much-quoted textbook example is: 'Lady Godiva (WHO) rode (WHAT) naked (HOW) through the streets of Coventry (WHERE) yesterday (WHEN) in a bid to cut taxes (WHY)' (Wynford Hicks, Sally Adams and Harriett Gilbert 15), being complete in every sense.

Journalists identify pertinent topics and write about them in accessible prose. Their aim is to work in the direction of accuracy, fairness, truth, free speech, objectivity, skepticism, originality, and creativity. They also care for the knowledge of current events, readerships and public policies, respect for deadlines and textual discipline and clarity. They fulfill the responsibility resting on them in a certain way. But 'the role and status of journalism, along with that of the mass media, has undergone profound changes over the last two decades

with the advent of digital technology and publication of news on the Internet' (Wikipedia).

Novelists, on the other hand, also share many of these functions and values. They believe in informing, educating and entertaining readers through texts with creativity, clarity, vision and forms of truth. They arrange things so that the reader can see patterns and shapes in the chaos of life. They also provide a glimpse of the subjective universal, which is only accessible through art and literature. With the use of language, symbols, narrative, metaphor, character and all other literary tools, novelists allow readers access to meaning and truth. Literature may not provide meaning, but it enacts, nevertheless, a search for meaning and understanding that, in turn, provides readers with the tools to come to terms with the world around them.

Furthermore, writing narrative in reporting is the toughest challenge for writers. Mostly the facts are so messy that they don't yield to the demands of a story. Some versatile American journalists, who had expertise of handling fiction also, adopted various techniques that allowed journalism to enter literature, naming it as New Journalism, or literary journalism or creative nonfiction or journalistic fiction or narrative journalism. They brought together the techniques of social realism and such devices as realistic dialogue and scene-by-scene construction (telling the story by moving from scene to scene rather than by historical narrative). Now the writing was not just 'necessarily plain and simple' but had 'life, colour and immediacy' (Ibid. 133). Literary journalism blurs the line again between 'factual fiction' and 'fictional fact', which, according to Carey (2007: 7), was drawn to separate reporting from social commentary in the advent of realist

writing. Moreover, literary journalism rebelled against the objective ideals of modern journalism, bringing it closer to the novel.

Literary journalism is also criticized as being the bad child of "the modern age of media and hype" (Yagoda 1998). But, looking back through the ages, there are many examples of what is now called literary journalism, of blurring the line between fact and fiction. Yagoda believes that what has changed "is not the practice of literary journalism but expectations about truth" (1998). In contrast to standard reportage, which is characterized by objectivity, direct language, and the inverted pyramid style (letting the writer rank the information in the article in order of its importance), journalistic fiction seeks to communicate facts through narrative storytelling and literary techniques. In contrast to the difficult, angular shape of the pyramid story, Yaros (2006: 287) suggests that the narrative structure enables an audience with 'low levels of (background) knowledge' to process meanings more effectively. It is believed that narrative form conveys information better, satisfying the complex information demands of the postmodern society to a great extent.

The concept itself has been described with different terms, like new journalism (Wolfe), creative nonfiction (Lee Gutkind), literary journalism (Norman Sims and Mark Kramer), New New journalism (Boynton), and dramatic nonfiction (John Franklin). Hartsock suggests that the multiplicity of terms for this form indicates the 'fluid nature of its boundaries.' He also describes it as 'epistemologically fluid' – like the early novel, a 'shifting form' which attempts to mirror a changing reality that combines 'the interplay of consciousness' and phenomenal experience. (1999: 433). Connery, who

has taken the lead in defense of "literary journalism," acknowledges the difficulty of the form's identity when he cites the need for a justification for the name in his *A Sourcebook of American Literary Journalism*: "Use of the word 'journalism' is preferred over 'nonfiction' because the works assigned to the literary form are neither essays nor commentary. It is also preferred because much of the content of the works comes from traditional means of news gathering or reporting" (15). In his book *New Journalism* (1974), literary journalism expert Tom Wolfe writes that literary journalism is superior to prose fiction because of "the simple fact that the reader knows all of this actually happened" (9). Cindy Royal also explains (2000), literary journalists attempt to convey deeper truths than what simple facts alone cannot (3).

This chapter reviews the theories of journalistic fiction laid down by critics, literary journalism historians, and contemporaries. Literary journalism seems to be a response to an issue raised by the novel in the nineteenth century, namely, the correspondence between literary illustration and the reality that it imitates (Watt and Carnochan 2001: 11). Although the seeds of the journalistic mode in American literature might have been unintentionally sown in the beginning of the nineteenth century, yet the possibility of a prose form having the elements of journalism and fiction was recognized by the New Journalists in the 1960s and 1970s. The search for better comprehension of facts lead the writers to search for information that could be expressed naturally. Literary journalist Tom Wolfe has written in *New Journalism*:

> The most gifted writers are those who manipulate the memory sets of the reader

> in such a rich fashion that they create
> within the mind of the reader an entire
> world that resonates with the reader's
> real emotions. The events are merely
> taking place on the page, in print, but
> the emotions are real. Hence the unique
> feeling when one is absorbed in a certain
> book, 'lost' in it. (48)

This faculty brought to motion the emotions of the readers, putting them in a similar environment. The reader immediately feels as if being with the characters.

Such attempts to apply the techniques of novel writing to journalism were seen in 1890s in works like Lafcadio Hearn's portraits of *African American Life on the Cincinnati levee*, and Mark Twain's *Life on the Mississippi and Innocents Abroad*. A second era during the 1930s and 1940s included such luminaries as Sherwood Anderson, Ernest Hemingway, Edmund Wilson, James Agee, and John Hersey. In more recent times, authors most often associated with literary journalism included John Heresy, Truman Capote., Joan Didion., Edward Eoagland., Tracy Kidder., Michael Herr, Adrian Nicole Leblanc., Norman Mailer, John McPhee., Richard Preston., Richard Rhodes, Hunter S. Thompson., Tom Wolfe., and Don DeLillo. This kind of genre has received attention from a number of critics and scholars, including John Hartsock, Norman Sims, Mark Kramer, Chris Anderson, John Hellmann, John Hollowell, Barbara Lounsberry, Thomas Connery, A. J. Kaul, Kevin Karrane, Ben Yagoda, John J. Pauly, Louis Dudek, R. Thomas Berner, Ronald Weber, Everette Dennis, Michael L. Johnson, James Emmett Murphy, Dan Hallin, D. L. Eason, Robert Boynton, and others (Sims

9). This chapter aims at putting up a theory based on the contributions of the above mentioned critics.

Journalistic fiction is a true, well-researched, authentic story that could have been written in a dry newspaperly manner, but is written with style, vivid description, and narrative flow that immerses the reader in the story. This method of depicting facts is also known as New Journalism. The phrase "New Journalism" was popularized in *New Journalism*, by Tom Wolfe in 1974. He described new journalism as "intense" and "detailed" reporting presented "with techniques usually associated with novels and short stories" (1973: 15). Basically, four techniques or narrative devices were elucidated by Wolfe which are common to the new journalists and connect them to fictional realism: (1) scene-by-scene construction, or depicting people in dramatic scenes as in traditional storytelling; (2) complete dialogue as recorded and remembered rather than journalism's selective quotations to "involve the reader" and define characters; (3) the act of presenting scenes through characters' eyes i.e. using third-person point of view; and (4) "status details," which is explained extensively:

> This is the recording of everyday gestures, habits, manners, customs, styles of furniture, clothing, decoration, styles of traveling, eating, keeping house, modes of behaving toward children, servants, superiors, inferiors, peers, plus the various looks, glances, poses, styles of walking and other symbolic details that might exist within a scene. Symbolic of what? Symbolic, generally, of people's

status life, using that term in the broad
sense of the entire pattern of behavior and
possessions through which people express
their position in the world or what they
think it is or what they hope it to be It
lies as close to the center of the power of
realism as any other device in literature.
(*New Journalism* 31-33)

Wolfe cited the works of talented feature writers of the day,
like Gay Talese, Jimmy Breslin, Truman Capote, Hunter S.
Thompson, as well as examples of his own writings.

The relationship between the reporter and the people
and events described by him have changed leading
the reporter to become somewhat subjective towards
presenting the facts instead of being purely objective
(telling the truth as it is). John Hollowell in *Fact & Fiction:
The New Journalism and the Nonfiction Novel*, defines
new journalism against traditional news reporting: "The
most important difference [...] is the writer's changed
relationship to the people and events he depicts" (1981:
22). He observes that style—"the use of fictional devices
borrowed from short stories and novels"—was an
important feature that set new journalism apart from
conventional newspaper stories (22). Moreover, 'New
journalist records his personal reactions to the people
and events that make news,' (22) and 'The new journalist,
also strives to reveal the story hidden beneath the surface
facts, but the conventional reporter must dutifully report
their statements' (23). John Hellmann, on the other hand,
considered new journalism to be new. In *Fables of Fact:
The New Journalism as New Fiction*, he states:

First, it overcame the weaknesses of the traditional fictional contract, in which the author promised plausibility, by replacing it with a journalistic one promising factuality; second, it overcame the limitations of conventional journalism and realistic fiction by exploiting fully and frankly the power of shaping consciousness found in fabulist fiction. The result was a new form both wholly fictional and wholly journalistic through which the individual human consciousness could directly make or organize the seemingly chaotic world into a work embodying a meaningful engagement of the two. (1981: 19)

Consequently, Hellmann classifies new journalism as a genre of its own. He asserts that new journalists aimed to create an aesthetic experience, which is read because it contains not just factual information, but also the author's interpretations, impressions, and personal experiences of a certain subject matter (24–25).

Fiction writers are free to create stories, but literary journalists write using dialogues and scenes they have witnessed, having discussions with other witnesses, or research conducted by them. Thomas B. Connery defines the practice of literary journalism as 'nonfiction printed prose whose *verifiable* content is shaped and transformed into a story or sketch by use of narrative and rhetorical techniques generally associated with fiction' (1992: xiv). He argues that a fundamental quality of literary journalism

is that it is based on 'actuality,' or real people, places, and events; 'verifiable detail is essential' (Ibid. 6).

Sometimes, literary journalism is also the written equivalent to a documentary, or movie based on a true story or real event, for example, the movie *Infamous* (1966) is based on *In Cold Blood* by Truman Capote. The new form communicated the bizarre social reality of American life. Tom Wolfe argues that the conventional journalistic practices reflected 'who-what-where-when' reporting which usually served to reinforce the middle-class reader's values. But the best new journalists use a variety of writing techniques to place the reader "inside" a world he may find quite different from his own (Hollowell 26).

At the time of emergence of journalistic fiction, the realistic novel had declined due to its failure to give expression to the greatly altered consciousness of our experience. The novelist's dissatisfaction with realism was also another reason which led to experiments with language and with narrative form. However, the form and style of the news story was transformed by the use of fictional devices borrowed from stories and novels because of the ever-increasing "knowledge explosion" in the society which demanded a news coverage with greater depth and background, with psychological insights into the major figures behind the news, and with interpretation and analysis, placing the news in a broader context. All this required greater freedom for writers in terms of style and form.

The formulas and conventions of the conventional reporting as explained by *Esquire* editor, Harold Hayes, are:

> There was an anecdotal lead opening into the general theme of the piece; then

some explanation followed by anecdotes or examples. If a single individual was important to the story, some biographical material was included. Then there would be a further rendering of the subject, and the article would close with an anecdote. (qtd. in Hollowell 25)

So, in a usual news story the basic units are facts and quotations, but in journalistic fiction a writer's aim is to reconstruct the experience with a beginning, as well as an end, while unfolding the events. He also portrays characters with psychological depth; and conveys information while providing the background which is usually not possible in newspaper and magazine reporting due to space requirements.

Norman Sims goes on to say that literary journalists "view cultural understanding as an end" and present that understanding by letting "dramatic action speak for itself" (1995: 6). He also enlisted "the boundaries of the form": (1) immersion, or what Wolfe calls "saturation" reporting ; (2) structure; (3) accuracy; (4) voice; (5) responsibility; (6) underlying meaning or symbolism (8). For him 'accuracy' is one of the defining characteristics of literary journalism. Mark Kramer, another literary journalist and educator, has a belief that there is a contract between the literary journalist and readers that 'the writers do what they appear to do, which is to get reality as straight as they can manage, and not make it up' (1995: 23). L. Wilkins (1989: 181) defines literary journalism as a story 'which connects the objective facts of the event with the cultural facts of symbols and myth.' Characters, also, should not be wholly invented by the author nor composed from two or

more real people (Sims 1984: 15). For Barbara Lounsberry the basic four features of literary or artistic nonfiction are: (1) documentable subject matter; (2) exhaustive research; (3) the scene; and (4) fine writing.

Characterizing the genre further, Hollowell adds two more fictional devices to the four listed earlier by Wolfe i.e. "interior monologue" and "composite characterization," which means compressing evidence of multiple real personalities into one fictional character (26). Another characteristic of new journalism identified by Wolfe and Hollowell, is the authors' intensive and time-consuming commitment to the topic at hand. For example, the best to be quoted here is Truman Capote who studied thoroughly the events surrounding the murders of a Kansas farmer family for six years before giving a final shape to *In Cold Blood* (1966).

Thus journalistic fiction involves exhaustive research and a closer and in-depth experience of the events. It is based on accuracy i.e. verifiability of the subject matter. It uses subjectivity and rhetorical approach towards reality. It employs scene-by-scene detailed description and attempts to give structure to otherwise transient and inexplicable events of past or current times. It, further, tries to provide motives and closure to otherwise frenzied experiences and presents live examples of individuals' fates over a long period of time before and after the event. Its authors' priority is educating the reader.

There is no shortage of works devoted to praising the literary charms of journalistic fiction. Several books about this genre appeared like Harold Hayes' collection of *Esquire* pieces, *Smiling Through The Apocalypse: Esquire's History Of The Sixties* (1969); Michael Johnson's *The New Journalism* (1971); Tom Wolfe and E.W. Johnson's

canonical anthology *The New Journalism* (1973); Charles C. Flippen's *Liberating the Media: The New Journalism* (1974). Further Ronald Weber's (Ed.) *The Reporter as Artist: A Look at the New Journalism Controversy* (1974) remains the best collection of contemporary pieces. Some of the essays in, *Literary Journalism in the Twentieth Century* (1990) by Norman Sims (Ed.) also deal with the journalistic fiction. One can find biographical and critical profiles of a number of new journalists in, *A Sourcebook of American Literary Journalism: Representative Writers in an Emerging Genre* (1992) by Thomas Connery. John C. Hartsock shows in his revealing study, *A History of American Literary Journalism: The Emergence of a Modern Literary Form*, that the roots of this distinctive form of writing can be traced at least as far back as the late nineteenth century.

In *Post War American Writing* (1991), Suresh Chandra has discussed themes of such fiction, summarizing some American authors' texts like Tom Wolfe's *Electric Kool-Aid Acid Test*, Norman Mailer's *Tough Guys, Ancient Evenings, Miami and the Siege of Chicago, Advertisements*, and Truman Capote's *Other Voices Other Rooms. The Political Imagination of Norman Mailer* written by Dr. Reetinder Joshi, as the title indicates, examines the political aspect in the fiction as well as nonfiction of Norman Mailer. Another work entitled '*The Poetics of Norman Mailer's Nonfiction*' by Markku Lehtimaki, deals with a survey on the nonfictional features visible in Norman Mailer's texts.

For decades, author Truman Capote has been praised for the resonant and literary quality of his book *In Cold Blood: A True Account of a Multiple Murder and its Consequences*. It is a seminal example of the strengths and weaknesses of journalistic fiction. A fitting comparison to

In Cold Blood is John Hersey's *Hiroshima*, which recounts the experiences of six survivors of the first atomic bomb attack. Hersey's dramatic reconstruction of events, which was published twenty years before Capote's book, is probably closer to the accepted conception of being immaculately factual. Marc Weingarten believes that what makes Hersey's *Hiroshima* an "antecedent" to the genre, "among other things, is the way Hersey assiduously describes his characters' internal reactions, the thoughts racing through their heads when the 'noiseless flash' makes its appearance over Hiroshima" (Weingarten 24).

Wolfe in *New Journalism*, states that 'Capote's success after publication of ICB gave the New Journalism, an overwhelming momentum' (26). In his biography, *Capote,* Capote argues, "journalism is the most underestimated, the least explored of literary mediums" (1974: 188). Capote also argued in Newsweek, "I've always felt that if you brought the art of the novelist together with the technique of journalism-with the added knowledge that it was true-it would have the most depth and impact" (59). F. W. Dupee designated *In Cold Blood* as "the best documentary account of an American crime ever written"; a reviewer from Newsweek called it "the product of one of the most astonishingly sustained acts of will and hard work in the life of any writer." William L. Nance remarked about Capote's work being judged as a nonfiction novel, "ICB is certainly one of the finest specimens of that 'impure genre' and quite possibly the best piece of artistic journalism ever written." (qtd. in *Contemporary Literary Criticism* 1990: 85). Like Capote, Mailer was also a novelist before being a journalist. Being a novelist gave him the background to write the premier examples of New Journalism, in the form of *The Armies of the Night, Of a Fire on the Moon*

and *The Executioner's Song*. An entry in the Encyclopedia Britannica about him also states, "American novelist and journalist, best known for using a form of journalism—called New Journalism—that combines the imaginative subjectivity of literature with the more objective qualities of journalism" (2007).

Journalistic fiction takes as its subject a broad social portraiture difficult to define topically. Hollowell observes that the new journalists often wrote about personalities and phenomena unfamiliar to the average, middle-class American reader. The subject matter revolved around "emerging patterns of social organization that deviate from the mainstream culture," such as subcultures, gangs, artists, celebrities, and criminals (40). In order to recognize "society as a tableau of *interesting* races, age groups, subcultures, and social classes," new journalists wrote with a "*detachment* of the self from various conventional sources of identification" (Eason 191), showing that New Journalism was essentially a personal commentary on diversity in society. Mailer's success through the publication of *The Armies of the Night*, two years after Capote's *In Cold Blood*, was in its own way quite spectacular. It improved Mailer's reputation which was deteriorating at the time due to his two inept novels, *An American Dream* (1965) and *Why Are We in Vietnam?* (1967). Later, Mailer dealt with the whole panorama of society in *The Executioner's Song*: Gary Gilmore's family and friends, the prisons, the criminal justice system, Gilmore's victims and their families, Schiller and the account of how the press helped create the story, the state of Utah and the Mormons who figured centrally in Gilmore's upbringing and crimes. Mailer persisted in seeing Gilmore as "another major American protagonist"

who encompassed "a deep contradiction in this country and lives his life in the crack of that contradiction," a man who was "malignant at his worst and heroic at his best" with enormous desire for "revenge upon the American system" (Rollyson 287).

The debate around journalistic fiction is about giving attention to detail and presentation of facts. For Connery, literary journalism rather than just relating the informational who, what, or where, depicts and conveys moments in time, behaviour in society and culture. It broadly and subjectively explores how and why (1992: iv). Jon Franklin says "literary journalism does more than shovel data at readers. Instead, it uses carefully selected data from which it constructs patterns" (1987: 10). Literary journalists make available the facts and particulars which are more accurate and verifiable. Alan Palmer also refers to "the basic reality of our lives that we do not have direct access to the thought of other people" (2002: 29). Nonfiction is different from fiction in the sense that the former includes its sources and references and stresses on how these mental images and inner thoughts of another person have come to the knowledge of the author, whereas in the latter the author invents any thought or vision about his or her imaginary character. So in nonfiction the thoughts of another person are available to the reporter mainly through narrative acts like interviews, possible letters, diaries, testimonies, and so on. For instance, *The Executioner's Song* is based on a large amount of documentary material, especially on taped interviews of real-life people. It displays self-conscious novelistic and "fictionalizing" techniques.

It is important to note that what is somewhat ignored as a piece of information for the conventional journalist

is usually the most crucial evidence for the literary journalist. For instance, Twain's book *Innocents Abroad* was about "the realities of human life everywhere" (Anderson 1971: 28-29). Similarly, Stephan Crane was interested in depicting human life, and said that in his writing he wanted "to give readers a slice of life" (1960: 158). This desire to capture people as they are was also crucial to the new journalists of the 1960s and 1970s. According to Wolfe, the new journalists were motivated by "that rather elementary and joyous ambition to show the reader real life-'Come here! Look! This is the way people live these days. These are the things they do!'"(Wolfe 1973: 33) Connery suggests that literary journalists make judgments and interpret by showing and dramatizing, as the fiction writer does, and by selection and arrangement of detail and imagery. Seabrook (2000) says that literary journalism stories give writers a chance to become part of the audience, which in turn makes the reader feel a part of the story. He also says:

> The writer's authority is now going to be based not on having a greater knowledge at the beginning, but rather your authority is going to be based on establishing a connection with the reader saying, I'm just like you. I'm an average Joe, and I want you to listen to me and believe me because in the course of this story, we're going to share some experiences that we both perhaps would have in common as we encounter whatever the subject is going to be. (qtd. in Kenny Boudreaux 2010)

Literary journalists use precise description as a means of comprehension. For instance, John Hersey achieves a sense of authenticity by adopting an almost clinical tone in his prose. In *Hiroshima,* Hersey provides spare and meticulously documented details assembled from close observation and careful research. The exact location of the center of the blast, for example, is identified as "a spot a hundred and fifty yards south of the torii and a few yards southeast of the pile of ruins that had once been the Shima Hospital" (*Hiroshima* 96). This detail exhibits to the reader that much about the bombing can indeed be ascertained and communicated in familiar terms.

The authors of journalistic fiction include voice or an individual point of view in their works, causing them to become a character in their own story, casting a new light on the events. In any narrative an author's "voice" affects a reader's perspective of looking at the characters and situations, thus presenting the author as an actual presence within the body of the text. The author becomes as much a character as any player in the story which he or she has written. Point of view, Tom Wolfe explains, is used by the journalistic writer to "present every scene to the reader through the eyes of a particular character, giving the reader the feeling of being inside the character's mind" (Hollowell 28).

In *Armies,* Mailer participates as a character, in addition to being the narrator and author of the text. The reader also finds a glimpse of the real writer who has written the text and whose image is self-ironically described and analyzed by the narrative. This inclusion of voice and the author's perspective is an important feature when classifying a work as journalistic fiction. Such fiction written in the third person includes the

presence of an outside narrator being the author who has initiated the research, conducted interviews, assembled notes, established a narrative, and witnessed the life of their subjects. Often, the manners in which characters and events are presented are extremely telling of the author's position regarding the content of his or her narrative. According to Stephen Minot, author of *Literary Nonfiction: The Fourth Genre, literary journalism*:

> reflects the feelings of the author, the emotions that in varying degrees make it a personal account …. [The author's] writing has to convey subtle reactions and responses to the subject regardless of whether that subject is a person, a place, an event, or a conviction. To earn the title of 'literary,' it must communicate not only direct meanings but overtones, shades of meaning. (35)

Because authors choose to include their own perspective in a work, they become a character. If the authors intrude upon their narratives, it affects the reader's conceptual vision of any given character or event, turning the author into an omnipotent character himself.

In the same way, Capote used a third-person, omniscient point of view in writing the account of the Holcomb, Kansas, victims, and murderers. He tried to keep himself out of his manuscript so as to provide a more flexible point-of-view presenting the thoughts and actions of the characters. Capote remarked to George Plimpton in an interview, "For the nonfiction novel to be entirely successful, the author should not appear in the work. Once

the narrator does appear, he has to appear throughout, all the way down the line, and the I-I-I intrudes when it really shouldn't" (1966: 38).

An author of journalistic fiction uses a variety of tools and techniques to develop a character. To depict a rich picture of the subject of his work an author not only describes the physical attributes and appearance of a character, but also develops implicit thematic concepts about that character. The journalistic aspect of literary journalism is actually the genre's observance of truth, accuracy, and reportage. A common technique for character development is physical description, used effectively by these writers. For example, Capote in *In Cold Blood* wrote that Herb Clutter's teeth were "unstained and strong enough to shatter walnuts" (6) to highlight his personality. He portrays Mrs. Sadie Truitt, the town's mail messenger as "A stocky, weathered widow who wears babushka bandannas and cowboy boots" (66). Likewise, Hersey wrote descriptively with each detail appearing to have been meticulously documented and gathered from close observation and careful research. Basically these authors' aim was to let the story speak for itself through description. Boynton asserts that the newest generation of journalist-authors more stringently adheres to reportorial standards, and ideals of objectivity and accuracy: "[T]heir most significant innovations have involved experiments with reporting, rather than the language or forms they used to tell their stories" (2005: xii). Most of the writers find creative ways to become "part of [the] lives" of their subjects.

Authors of journalistic fiction also wrote effective dialogues which not only acted as a means of reporting but also as a means of establishing character's motives, mood,

and other personality traits that help in developing the theme of the narrative. According to Wolfe, Capote was employing "the technique of presenting every scene to the reader through the eyes of a particular character, giving the reader the feeling of being inside the character's mind and experiencing the emotional reality of the scene ..." (1973: 53). Mailer is a character in *The Armies of the Night* and an omniscient narrator in *The Executioner's Song*. In *The Executioner's Song* he used "very little invention" because the interviews with the witnesses were so detailed. In providing symbolic details to the narratives, the author purports to convey greater meaning with every word or phrase. Literary journalists sort through, select the perfect symbol, and pride themselves on making the most obscure references. In 1980, Ronald Weber concluded that the author strengthens his credibility by including within the finished work some account of how he went about this effort (163).

Benjamin Harris, the America's first newspaperman, wanted to publish truth as it was, with accurate reporting (Sloan 4). Similarly, in their search for truth and its representation, Wolfe and the New Journalists engrossed themselves in their subjects, often spending months, and sometimes, years with their subjects. Since, the truth is always all too complex, the search for it may be "well served by inventions, exaggerations, and other transformations of fact" (Heyne 486).

So new journalists coalesced all the techniques mentioned above to present a unique and sophisticated style which requires extensive research and even more careful reporting than done in the typical news articles. The subject and themes of journalistic articles and fiction reflected the social and political climate of the decade,

which was usually unfamiliar to middle-class readers. Hollowell has classified four main categories of the subjects of new journalism: (1) Celebrities and personalities; (2) the youth subculture and the still-evolving "new" cultural pattern; (3) the "big" events often violent ones such as criminal cases and antiwar protests; and (4) general social and political reporting (1981: 40).

Famous interviewers like Gay Talese and Rex Reed portrayed movie stars and heroes. Lillian Ross's infamous sketch of Hemingway and Capote's treatment of Marlon Brando were visible on the pages of *New Yorker* "Profiles." Many authors also emphasized the lives of petty criminals like Perry and Dick in *In Cold Blood*, and Gary in *The Executioner's Song*. Another category which caught the attention of the journalistic writers was the new pattern of social organizations and trends i.e. the shifting patterns of life-style, and leisure pursuits. Wolfe's article in *Kandy-Kolored Tangerine-Flake Streamline Baby* was one such work which threw light on new life-style patterns of the time.

The third category of the new journalistic exploration was the highlighting of violent events, for instance, Hunter S. Thompson's *Hell's Angels: A Strange and Terrible Saga* (1967), John Hersey's *Algiers Motel Incident* (1968) and Truman Capote's *In Cold Blood* (1965). Further, in the fourth category, authors represented the political and social subjects, ranging from the Civil Rights Movement to political conventions. The popular examples of this category are Norman Mailer's *The Armies of the Night, Of a Fire on the Moon*, and *Don DeLillo's Libra*.

These authors show the lives of their stories' protagonists through a sociological lens on peculiar subjects, by themselves getting dirty and living amongst

their subjects, as done to develop the themes of the atomic detonation in *Hiroshima*, the assassination of President Kennedy (1963), the march on the Pentagon (1967), the Apollo 11 moon flight (1969) by Hersey, Mailer and DeLillo, respectively. One of the important journalistic criterions is currency i.e. getting on the events soon after they happen. The facts are, however, arranged afterwards, involving both scrupulous evidence and constructed interpretations usually in the form of texts and images. The longer the gap, the more the resulting work edges into the realm of history. Due to this, the reporters have been, sometimes, accused of tampering with the truth, making up facts or creating subjects in their stories. Sometimes the writers are also criticized for their ability to recreate extended dialogue or recount situations. Thus the facts such as those pertaining to past historical events are always open to negotiation, revision, correction, and interpretation. These facts have been used and interpreted in different manner by the authors and readers, respectively.

Thus the tired readers after World War II wanted to divert from the rigid conventions and over spent narrative techniques in literature. They needed the themes and subjects which were close to life, concerning the societal culture and milieu. Journalistic fiction satisfied this need.

CHAPTER 2

American Writings and Literary Journalism

CHAPTER 2

American Writings and Literary Journalism

Literature is an essential carrier of cultural happenings forward and spreading them worldwide. The writers themselves being intensely aware of the realities want to awaken the readers, by promoting a positive influence. They change their way of writing from strict realism to fabulation, depicting the influence and destruction caused by wars. A brief excursion through American literature shows a lot of transition in the nature of writings since the beginning of twentieth century. Great dramatists of this century, Arthur Miller and Tennessee Williams, started representing an individual as an 'alienated' being. These writings were sources of social and political themes. This was followed by 'the literature of fact' whose representatives were Truman Capote, Tom Wolfe and Norman Mailer. They are the representatives of a new mode of blurring fictional techniques into journalism. Truman Capote has been called the 'precursor of documentary novels'. Another important literary genre of the time was 'detective fiction' whose best exponents were Edgar Allan Poe, Dashiell Hammett and Raymond Chandler.

We also find 'novel of manners' in the literature after WW II. The finest known representative of this kind of novel was William Wharton. American literature attained a new maturity in the post war era. The war gave not only a new generation but a new kind of protagonist quite different from the preceding type. Although the social environment was somewhat conservative in that period, but the experimental writers were known to be homosexual, bisexuals, open minded writing about dark themes, like Tennessee William, Truman Capote, Paul Bowles, Gore Vidal and James Baldwin. Norman Mailer's *The Naked and the Dead* (1948) and Irwin Shaw's *The Young Lions* (1948) were realistic war novels heralding about the destructive side of technology. John Hersey's *Hiroshima* explored the aftermaths of an atomic bomb attacks on the city of Hiroshima and war's nightmarish implications. These writers were prompted by the reality and cultural clashes that had grown inaccessibly by the traditional fiction.

Later writers of the period came under the pressure to portray a new kind of fiction, which was followed by post-modern novels by William Gaddis, John Barth, John Hawker, Donald Barthelme, Thomas Pynchon, Robert Cooner, Paul Auster and Don DeLillo. The nature of these writings was self-conscious and had an element of 'reality' in them. The themes dealt with were paranoia and imposture. There was heightening of realism of violence, cyberworld, amassing documentation, commercialization and consumerism. After 1970s, fictional writers like Mailer turned once again to 'nonfictional fiction' by writing *The Armies of the Night* (1968), *Miami and the Siege of Chicago* (1968) and the Pulitzer Prize winning 'true life novel' *The Executioner's Song* (1979) written

about real events and real people. These writers turned towards literary journalism as a way of situating their own intellectual outlook and infusing personal expression into their works.

Some more names to be reckoned in the context of 'the literature of fact' are Eliot, Hemingway, and Faulkner. These writers have contributed to the literature through their canonical texts and have been admired throughout the world. They have experienced the facts and realities themselves, by either personally participating in the action or through numerous interviews with the witnesses. Their basic concern is to provide utmost psychological depth and portrayal of societal reality.

These writers have taken up the responsibility of narrating, from their observation and experiences, the factual data for enduring literary creation. Their aim is to transcend the limitations of journalism and present the information in an appealing style. These writers believed that reality could best be presented through the application of fictional techniques. For them, form and structure were indispensable elements of narratives. As Hellman states:

> Norman Mailer asserted that there is finally no way one can try to apprehend complex reality without 'fiction'. He has followed that statement with literature marked by the refusal to abandon the goal of dealing with contemporary reality, but at the same time displaying an awareness of the inapplicability of conventional realistic strategies to that task. (*Fables of Fact* 35)

Mailer was an optimist who had spiritual hope, even in the communication of dark picture of reality. Mailer believed that values are strongly related to human desires and intelligence. Through his writings he has universalized his concepts of the common man being under stress of competition with the fellow members in a strange complexity of modern life. Bertrand Russell very commendably states in this context: What people mean, therefore by the struggle for life is really the struggle for success. What people fear when they engage in the struggle is not that they will fail to get their breakfast next morning, but that they will fail to outshine their neighbours' (*The Conquest of Happiness* 35).

These modern journalistic texts lay before us the role of media in accessing the information sometimes manipulating it for their own benefits. They create some fantasies as well at times before presenting the facts, as it will sell for popular and daily consumption. The truth is that everything even values have commercialized in this horrible and brutal world of communism. But these literary journalists have explored the truth behind many real events, at the same time, reflecting their own consciousness too.

There came a transition which left journalists who reported facts only to move to literary personages, a kind of non-fiction. As the audience was also responsive to this new literary form, more writers experimented with linguistic expression in search of a suitable, vivid style. When journalism pierced into literature, it became 'journalistic mode' and aimed at serving some significant purpose. A little experimentation in the lengthy write-ups of the newspapers found favour of the reading public

and created a peculiar status for itself in the artistic form pursuing truth beyond ideas.

This book in particular provides insight into the literary journalistic works not only of Norman Mailer, but also of John Hersey, Truman Capote, and Don DeLillo. In American literature, these selected writers occupy a position of distinction and eminence for their particular choice of style and subjects. The texts dealt with in this book, comprehensively, are *Hiroshima* (1946) by John Hersey; *In Cold Blood: A True Account of Multiple Murder and Its Consequences* (1966) by Truman Capote; *The Armies of the Night: History as a novel/ The Novel as History (1968), Of a Fire on the Moon (1970)* and *The Executioner's Song* (1979) by Norman Mailer; Don DeLillo's *Libra* and *Falling Man*. These narratives vary in form and the use of new journalistic techniques to portray different aspects of the American counterculture.

John Hersey was the celebrated writer of fact and fiction, best known as the author of *Hiroshima* (1946) and *A Bell for Adano* (1944), which won him the 1945 Pulitzer Prize for fiction. Hersey was the author of more than twenty books, and many magazines and newspapers articles. He was best known for the passion and simplicity of his prose, and variety of subject matter. His other works include *The Wall* (1950), a fictional achievement of the life in Warsaw Ghetto during the World War II, *The War Lover* (1959), a novel about the World War II American airman who loved dropping bombs on enemy cities, and *The Algier's Motel Incident* (1968), which described the killings of three black youth in Detroit's Algier's Motel during the 1967 riots.

Hiroshima, the most famous of all, awakened Americans to the horrors of atomic warfare and threw

light on the beginning of a nuclear age. It is a literary classic in which Hersey wrote a straightforward account of what happened on the day of the attack, and in the year afterwards, to the city's inhabitants, especially to six survivors chosen by Hersey for in-depth study. *The New York Times* ran an editorial calling attention to the piece, and Lewis Gannett, writing in *The New York Times Herald Tribune*, called Hiroshima "the best reporting" of the war. According to Richard Severo, "From the beginning of his career, Mr Hersey won praise for the directness of his style, his eye for detail and his ability to get to the heart of any situation" (qtd. in *Contemporary Literary Criticism* 1994: 333). Thirty-nine years later, Hersey updated his original in "Hiroshima: The Aftermaths," published again in *The New Yorker* on July 15, 1985, when two of his six original subjects died; one had become a prosperous physician; the other mother superior; another had won aid from the Japanese government after years of struggle; and the fourth had toured the United States seeking help for his Protestant church.

Earlier most of the material written about the bombing tended to focus on the science and engineering like the force of the blast, the physical principles governing the explosion, but by contrast, *Hiroshima* depicted the impact of the bomb on human beings, leading everyday lives. *Hiroshima* was actually a relatively objective, non-judgmental account of the bombing, recreating the entire experience from the victims' point of view. Hersey moves from one personal narrative to another so that the time sequence of all the six stories is carried forward simultaneously.

Hersey's journalistic agenda in *Hiroshima* is thus not only to report the facts, but also to accommodate the needs

of his American readers by providing a perceptual frame within which the events assume significance. The true achievement of *Hiroshima* is that its journalistic credibility is not flawed by the injection of moralistic sentiments. *The Algiers Motel Incident* represents Hersey's only other significant attempt at extended literary journalism. Unlike *Hiroshima*, in which the author remains invisible, and *Here to Stay*, in which he appears only in the preface and the introductions to individual stories, Hersey enters directly into the telling of *The Algiers Motel Incident*. *Hiroshima* represents Hersey's most successful blending of literary techniques with journalistic content, largely because it is one of his least self-conscious works. The novel provides an honest and compelling account of a morally ambiguous event in a journalistically credible fashion, as well as in aesthetically and dramatically effective terms. Perhaps unwittingly, Hersey has provided in *Hiroshima* one of the seminal examples of contemporary journalistic fiction.

Truman Capote was one of the postwar era's leading American writers. He was unusual and observant as a child, who was determined to become a writer. Known for being the most controversial and colorful, Capote was very intelligent and highly focused on writing. He contributed some literary classics like non-fiction, stories, novels and plays to American literature. Capote, in 1942, published his first short story, "Miriam", in the magazine *Mademoiselle*, which brought for him the 1946 prestigious O. Henry award for Best First-Published Story and also gained him a contract with Random House. *Other Voices, Other Rooms*, published in 1948, was widely publicized. *Breakfast at Tiffany's* and its accompanying short stories, "House of Flowers", "A Diamond Guitar", and "A Christmas

Memory" define Capote's distinctive spare, direct prose style; minimal, linear plotlines, and a thematic obsession with eccentricity and the diversity of human love. This period also marks the development of what critics often call the "Capote narrator", the author's distinctive narrative persona who, while periodically participating in plotlines, remains conspicuously "objective", external to the story's narrative and emotional focus.

Capote had a struggling and nightmarish family life which finds impressions in *In Cold Blood*. In 2005, the biographical film Capote, which dramatized the author's often difficult process of researching *In Cold Blood*, was nominated for numerous awards. It secured the Best Actor Academy Award for actor Phillip Seymour Hoffman's nuanced portrayal of the writer's struggle to maintain professional integrity in the face of his growing affection for the subjects of his work. Capote spent his later years pursuing celebrity and struggled with drug addiction. He died in 1984 in Los Angeles, California.

Truman Capote's *In Cold Blood* claimed to have invented the style or inserted it into a larger historical context. It took two decades for another author to apply, on a broad scale, the innovations of John Hersey's *Hiroshima*- that is, to write a book of journalism in the form of a novel. Truman Capote is regarded by many as the founding figure in the 1960s movement referred to as the "New Journalism," which sought to apply fiction–writing techniques to news reportage. Capote, in 1959, read a short newspaper story about a brutal murder in Kansas and decided to investigate it. The result was *In Cold Blood*. Like *Hiroshima*, it was first published in *The New Yorker* and made even more of an impact. The long middle section of the book is cinematic as well as novelistic, as the

narrative cuts back and forth between the killers: Hickock and Perry Smith- and their pursuers, agents Alvin Dewey and Harold Nye of the Kansas Bureau of Investigation. For a journalist to recreate events require a prodigious amount of reporting, and Capote could not have written *In Cold Blood* had he not met the two men after their capture, obtained their sympathy and cooperation, and interviewed them for hours and hours, for a long period of six years.

It was the iconoclastic Norman Mailer, an outstanding figure in the artistic scene of America, who became the next major author to recognize the value and power of writing in this tradition. Mailer, by using journalism, kept his work rooted in the real world, and through literature he transcended the simplistic objective/ subjective dichotomy of news reporting. He particularly used this genre for keeping himself connected to the rapid changes of the sixties, and afterwards, it also kept literature relevant in this emerging postmodern world.

Mailer wrote plays, novels, screenplays, newspaper articles, and directed movies. His first novel, *The Naked and the Dead* (1948), was a bestseller and made this 25 years old author famous and financially well-off. After his next novels, *Barbary Shore* (1951) and *An American Dream* (1965), he wrote many fictional and nonfictional works. Mailer was a central countercultural figure, often sharply criticizing the American society in his writings and public speeches. In 1955 Mailer co-founded the magazine *Village Voice*, an alternative weekly newspaper featuring politics and arts. From 1952 to 1963 he was also the editor of *Dissent*, a magazine concerned with culture, society, and politics. He was a Democratic candidate for Mayor of New York in 1969, but failed to be elected. Mailer

won the Pulitzer Prize twice: in 1968 for *The Armies of the Night*, and in 1979 for *The Executioner's Song*.

First famous as a novelist, then as an essayist-celebrity-provocateur, Norman Mailer became a journalist in 1964, when he was assigned by *Esquire* to cover the national political conventions. His choice to refer to himself in the third person can be seen in many articles and most of his subsequent journalistic works- including *Of a Fire on the Moon, Miami and the Siege of Chicago* and *The Armies of the Night*. A person like Mailer was not a mere reporter, but a man of immense talent and imagination. The basic concern in his work was to provide great psychological depth to the portrayal of social reality. To achieve these ends, he fused the journalist's concern for detail with the novelist's personal vision.

The Armies of the Night is Mailer's first celebrated piece of journalistic fiction, published in 1968. It is Mailer's participant-observation of the 1967 march on the Pentagon to protest against the Vietnam War. *Miami and the Siege of Chicago* and *The Armies of the Night* are the clearest and most successful of Mailer's journalistic fiction. Both utilize the literary devices of realistic novels adopted by new journalism. Each book comprises of a series of short chapters depicting, scene-by-scene, the author's observation and experiences of the context under scrutiny. The characters and the nature of scenes are developed through careful and complete recording of dialogue that the author overhears, or in which he participates. Furthermore, the details of the characters' appearance, manners, and surroundings in which the author finds himself are described in almost obsessive detail. While the other techniques are important elements of Mailer's style, it is his use of multiple narrative personae

that distinguishes his literary journalistic works from those of others associated with the genre.

Another important work of journalistic fiction by Mailer is *The Executioner's Song* (1979) that depicts the events surrounding the execution of Gary Gilmore by the state of Utah for murder. The most striking aspect in *The Executioner's Song* is that Mailer's personal voice is here largely replaced by flat and banal language. The style of the book appears to be quite different from that of the earlier books. Mailer tells the story from different perspectives.

Mailer's *Of a Fire on the Moon* was serialized in *Life* magazine in 1969 and 1970, and later published in 1970 as a book. It is an intensive documentary and reflection on the Apollo 11 moon landing from Mailer's distinctive point of view. After spending time at the space center and mission control in Houston, and witnessing the launch of the colossal Saturn V rocket at Cape Kennedy in Florida, Mailer began writing his account of the historic voyage at his home in Provincetown, Massachusetts during marathon writing sessions to meet his deadlines for the magazine. Before being published as a book, his epic account was published in three long installments: *A Fire on the Moon* (*Life*, 29 August 1969), *The Psychology of Astronauts* (*Life*, 14 November 1969), and *A Dream of the Future's Face* (*Life*, 9 January 1970).

Don DeLillo is one of the most celebrated contemporary American novelists. His works have established him as a talented novelist often associated with Thomas Pynchon and William Gaddis, for the sense of social and political paranoia visible in his fiction. His works have covered subjects as diverse as television, nuclear war, sports, the complexities of language, performance art, the Cold War,

mathematics, the advent of the digital age, and global terrorism. His first novel, *Americana* (1971), depicts the odyssey of a television executive through the late 1960s America. DeLillo uses fast-paced, fragmented presentations, and other stylistic techniques. He is also known for experimenting with the form and structure, and also for deemphasizing plot. DeLillo first gained attraction with *End Zone* (1972), in which a young man has two consuming passions: football and nuclear warfare.

His next major success is *Ratner's Star* (1976), depicting a condition where verbal ideas cannot compete with the clarity and order of mathematics. It has been observed that in DeLillo's novels knowledge is not static but always in flux. *Players* (1977) and *Running Dog* (1978) focus on the urban America with pawn-like characters, lost in a surreal nightmarish existence. *Amazons* (1980), discusses the first woman to play the National Hockey League, and it was written under the pseudonym of Cleo Birdwell. In 1982 came *The Names*, which continues to examine the language and accurate characterization of American cultural values. *Libra* (1988) depicts the assassination of John F. Kennedy which inaugurated the era of media spectacle. DeLillo depicts Lee Harvey Oswald as the first truly postmodern figure, desiring his ten minutes of media fame. In 1991, DeLillo published *Mao II*, which was influenced by the events surrounding the fatwa placed upon the author Salman Rushdie, and the intrusion of the press into the life of the reclusive writer J. D. Salinger (Passaro).

Of his numerous works *Underworld* (1997) is arguably the most ambitious. The title "underworld" portrays many things like the underground nuclear waste, the graffiti artist who lives and works in the New York subway system,

the mafia underworld that is reported to have infiltrated the waste management industry, the desolate urban landscape of the Bronx with its population of underclass dwellers, and parts of the Cold War history. In other words, the "underworld" stands for things hidden, buried underground either because they are disagreeable, filthy, dangerous or criminal, but nevertheless, unavoidable in every society.

He wrote *The Body Artist* (2001), *Cosmopolis* (2003), and his fourteenth novel, *Falling Man* (2007) describes a family's attempt to rebuild their lives in the dim weeks and months following the September 11 attacks. Instead of creating a documentary styled account, DeLillo charts impressionistically the complex psychological and existential rearrangements wrought by the attacks. His main characters are Keith and Lianne Neudecker, and their son, Justin. DeLillo published *Point Omega*, his fifteenth novel, in February 2010, dealing with an important theme. The 'Omega Point' of the title "... [is] the possible idea that human consciousness is reaching a point of exhaustion and that what comes next may be either a paroxysm or something enormously sublime and unenvisionable" (Alter).

Few writers have been as effective at conveying the mood of ennui and menace that underlines the modern era. Alter argues, in an article, "Don DeLillo on Point Omega and His Writing Methods - WSJ.com," that for doing so DeLillo even marked a shift '... away from sweeping, era-defining novels such as *White Noise, Libra* and *Underworld* to a more "spare and oblique"' style. DeLillo's works are very much suited to the uncertainties of the time. His list of awards is extensive, including the PEN/Faulkner Award (for *Libra*), the National Book

Award (for *White Noise*), a PEN/Faulkner Award and a Pulitzer Prize finalist nomination for *Mao II* in 1991 and 1992, respectively. *Underworld* earned nominations for the National Book Award and the New York Times Best Books of the Year in 1997, and a second Pulitzer Prize for Fiction nomination in 1998. The novel also won the 1998 American Book Award, the 1999 Jerusalem Prize, and both the William Dean Howells Medal and "Riccardo Bacchelli" International Awards in 2000. It was a runner-up in *The New York Times'* survey of the best American fiction of the last 25 years (announced in May 2006). On April 25, 2009, DeLillo received another significant literary award, the 2009 Commonwealth Award for Literature, given by PNC Bank of Delaware. DeLillo received two further significant literary awards in 2010: the St. Louis Literary Award for his entire body of work to date on October 21, 2010. Recently DeLillo received the 2012 Carl Sanburg Literary Award on October 17 2012 on the campus of the University of Illinois at Chicago. During an April 2012 interview promoting the release of David Cronenberg's adaptation of his 2003 novel *Cosmopolis*, DeLillo revealed that he is currently at work on a new novel (his sixteenth), in which "the [main] character spends a lot of time watching film footage on a wide screen, images of a disaster."

The new journalism which came afterwards was deviating from the track, for instance, Don DeLillo's *Libra, Underworld,* and *Falling Man.* Though these are not fitting examples of journalistic narratives, yet they have been selected for representation. The purpose here is to understand and verify as to what extent they have applied the fictional and journalistic techniques used by reporters, making them fit into the category of journalistic

fiction. These authors have taken up journalistic fiction as a means to emphasize the artist's role in society. For Capote, this kind of literature was a "new art form." William L. Nance in *The Worlds of Truman Capote* holds that the ingredients of this new form for Capote were: (1) the timelessness of the theme; (2) the unfamiliarity of the setting; and (3) the large cast of characters that would allow him to tell the story from a variety of points of view (qtd. in Hollowell 161). Capote has allowed the "facts" to speak for themselves by keeping the narrator i.e. himself, out of sight while describing the Clutter murders. According to Hollowell, it gave Capote's narrative a "you-are-there" immediacy (Ibid. 91).

Mailer, on the other hand, wrote *The Armies of the Night*, instinctively, and in an autobiographical manner. His talent for social observation and his passion for understanding the sources of political power contribute to his effectiveness. Richard Gilman, in an article 'Mailer's Vision,' explains that Mailer is a novelist primarily because novelists command the largest audiences. His more profound ambition is to be a kind of psychic president, a moral leader, the country's savior (qtd. in Hollowell 89). *The Armies of the Night* is Mailer's protest against the Vietnam War which blends art and life, journalism and the novel, and most importantly, Mailer the man and Mailer the would-be prophet. Basically, at the heart of *The Armies of the Night*, lies Mailer's deep concern for the individual in a society increasingly governed by bureaucratic and totalitarian impulses that threaten personal responsibility.

So the first task of a journalistic fiction writer, whether he works within the forms of fiction or the journalistic report, or combination of the two, is always to convince the reader that his work is adequate as history. He does

this by his reporting and research, by asking all the questions that can be asked, reading all the documents, and evaluating all his material by applying usual means of verification. He further strengthens his credibility by including within the finished work some account of how he went about this effort. His primary task, at any event, is always to persuade the reader that he has indeed come to sufficient terms with what Michael Arlen called "the actuality, the nonstory book element in life" (254).

The goal of all great art is to provide a picture of reality in which the contradiction between appearance and reality, the particular and the general, the immediate and the conceptual, is so resolved that the two converge into a spontaneous integrity. According to Barbara Foley, the borderline between nonfictional and fictive discourse is an arbitrary boundary because "reality is amenable to any construction that is placed upon it" (qtd. in *Telling the Truth: The Theory and Practice of Documentary Fiction* 10). According to Mas'ud Zavarzadeh, "...[The nonfiction novel] is a narrative which is simultaneously self-referential and out-referential, factual and fictional, and thus well equipped to deal with the elusive fusion of fact and fiction which has become the matrix of today's experience" (56-57). Zavarzadeh also argues that the "bizarre" and "fictional" nature of contemporary reality is a result of "runaway contemporary technologies" (21).

The purpose and aim of a journalistic writer is to search for truth as well as its sources. He wants to raise his voice and the means he has is the 'pen'. While studying about a criminal he aims at investigating in-depth the becoming of a criminal's mind and life. He is not biased, because for him a criminal is also a good human being.

His purpose is to affect the minds and hearts of the characters as well as readers.

In *Fables of Fact*, John Hollowell suggests that the apocalyptic mood of the sixties, with the political protests, televised assassinations, and hippie counter culture, resulted in a "blur ... of the comfortable distinctions between reality and unreality, fantasy and fact" (5). He further states that because of the "added force" of "mass-media journalism," the individual American "found himself daily confronted by realities that were as actual as they seemed fictive" (2). The forthcoming chapters would deal with how, and to what extent these narratives depicted the real historical atmosphere and events of their time, and added to the knowledge and awareness of their readers. With the aim to know these writers' relevance to the context of literary journalism, this book is written. Simultaneously, the purpose is to know their intentions as artists and communicators of socio-cultural realities of the modern age through the medium of literature.

CHAPTER 3

Theory of Narratology: An Introduction

CHAPTER 3

Theory of Narratology: An Introduction

A narrative means anything that tells a story-it can be a literary book, picture, ballet, newspaper or movie. "Newspaper, reports, history books, novels, films, comic strips, pantomime, dance, gossip, psychoanalytic sessions are only some of the narratives which permeate our lives" (Rimmon-Kenan 1). Narrative is omnipresent. It can be verbal or non-verbal, true or untrue, realistic or unrealistic, fictional or non-fictional, and literary or non-literary. Moreover, according to Doctorow, narratives eradicate the borderline between the two (fiction and nonfiction) by an admission of the fictionality of reality (qtd. in *Telling the Truth: The theory and Practice of Documentary fiction* 10).

Narrative can be studied from a variety of perspectives. The term 'narratology' was introduced in 1969 by Tzvetan Todorov (1977), originally in its French version 'narratologie.' In general, narrative theories are, after the World War II, divided into three main strands. According to the first strand, narrative is a sequence of events, and the theorists focus on the narrative itself independent of the medium used. These are followers of

the formalist Vladimir Propp (1968) and the structuralists Claude Lévi-Strauss, Tzvetan Todorov (1977), and early Roland Barthes (1977). The second strand sees narrative as a discourse, its representatives being the successors of Gérard Genette, Mieke Bal (1985), and Seymour Chatman (1978). The final strand presents narrative as a complex artifact, the meaning of which is endowed by the receiver. It has been supported by the later Roland Barthes (2004), Umberto Eco (1979), and Jean Francois Lyotard (1991b), who used poststructuralist approach.

Mieke Bal has been listed amongst the most important theorists of narrative, through her work, *Narratology: Introduction to the Theory of Narrative* (1985). She defines a text as

> finite, structured whole composed of language signs. A narrative text is a text in which an agent relates a narrative. A story is a fabula that is presented in a certain manner. A fabula is a series of logically and chronologically related events that are caused or experienced by actors…. (8)

Roland Barthes (1977), the French critic, is another significant narrative theorist, who broadens the realm of narrative theory by employing the methods of structural linguistics and anthropology, and moves from a structuralist approach towards post-structuralist understanding of narrative. Barthes recognizes the existence of narrative communication, claiming that there is no narrative without a narrator and a listener or reader (Barthes 1977: 84- 96). According to Peter Barry's perception of structuralist theory, "things cannot

be understood in isolation – they have to be seen in the context of the larger structures they are a part of" (2002: 39). The selected authors' views are not explicitly present in the texts. The narratological analysis is essential to look deeper into the texts for a content-based analysis.

As said earlier, the study of narrative has become institutionalized. Different theorists have attempted to define narrative in different ways. Gerald Prince defines narrative as "the recounting (as product and process, object and act, structure and structuration) of one or more real or fictitious events communicated by one, two or several (more or less overt) narrators to one, two or several (more or less overt) narratees" (1982: 58). According to this definition, narrative, being the process of recounting the events, intrinsically involves two subjects i.e. speaker or teller, and the listener. It can be told to a single person or a group of persons; or it can be told by a single person or a group of persons. Narrative can "exist for one person at a time"… it can also be "for a community" (Branigan 2). Narrative is a set of events told by a narrator or narrators to a narratee or more narratees.

Michael J. Toolan defines narrative as "a perceived sequence of non-randomly connected events" (2001: 7). The phrase "non-randomly connected events" means that narrative is not an amorphous amalgam of events but an organized set of events. For Gerald Prince it is "the study of form and functioning of narrative" (1983: 4). He also claims that to understand a narrative is not only to be able to answer questions on its contents, but to be able to understand its message, its point. He further adds that the term narratology may be new but not the discipline "and in the Western Tradition, it goes back at least to Plato and Aristotle" (qtd. in Barry 224). In his

Poetics, Aristotle has stated that 'character' and 'action' are the major constituent elements of a tragedy and has also stated that 'character' is revealed through 'action.' He also identifies three key elements in a tragedy namely, *hamartia*, *anagnorisis*, *peripeteia*. *Hamartia* means a sin or fault, *anagnorisis* means recognition or realization or self-realization and *peripeteia* means a turn-round or a reversal of fortune' (Ibid. 224). No doubt Aristotle spoke largely on drama, but all these elements can be found in any narrative form irrespective of its mode of communication.

M. H. Abrams defines narrative as "a story, whether told in prose or verse, involving events, characters, and what the characters say and do ... are explicit narratives that are told by a *narrator*" (1999: 173). The modern theorist, Seymour Chatman has used a two-level model to study the relation between 'what is told' and 'how it is told.' He calls them 'Story' and 'Discourse' respectively. He opines that story and discourse constitute the ingredients of narrative. Story element constitutes 'what' is told and discourse constitutes 'how' the story is told. Narrative is all but a matter of 'what' (content) and 'how' (expression). As Porter H. Abbott points out, some require at least two events, one after the other, for example Barthes and Schlomith Rimmon- Kennan (2002: 12). Others, such as Mieke Bal, also insist that the events be causally related (12). Still others call for a narrator (Gerald Prince 13). Abbott himself defines narrative rather broadly as "the representation of an event or a series of events" (12).

For Genette, a narrative is comprised of three basic components: the *Story* (the signified/the narrative content); the *Narrative* (the signifier, that is, the statements that comprise the discourse in the text itself); and *Narrating*

(producing the narrative action/the entire real or fictional situation in which the action/plot of the narrative takes place) (1980: 27). Genette has concentrated on how and in which way, a textual matter is presented. He has further divided the aspect of narrative into three categories- *Tense*: the temporal relationships between narrative and story; *Mood*: the modalities of the narrative 'representation' in a given narrative; and *Voice*: the narrating – the relation with the subject of the enunciation. Tense has three sub-categories: *Order, Duration,* and *Frequency.* The second of these categories deals with the span of the whole of, as well as, parts of a narrative. The third category delineates how portions of a narrative are, or seem to be, unique, or iterative events in a narrative.

Order, in a narrative, or otherwise, is the chronology of its plot. The chronological order of real events, especially in journalistic fiction, is not generally like those of fictional events. The reader has no way of knowing if the events are in a chronological order, unless he has a source with the actual chronology of the events. If not, the reader has to take the writing as the correct order. Pace, both in fictional as well as factual narratives, is its speed of narration. It can be used for efficiency, in the form of pauses and ellipses. It is governed by the narrator's judgments regarding the importance of events. For example, if one event in a story is more significant to the reader than other, the narrator will quickly describe the less significant event and slowly describe the more important event. When the narrator lets his presence appear in the story he is telling, this is known as voice. The narrator, because he is revealing his thoughts and opinions throughout the story, may take on a particular status. This status may be *heterodiegetic*, if the narrator is absent from the story he is telling, and

homodiegetic, if the narrator is present in the story as a character (Guillemette 3).

The use of different terms for almost similar concepts seems to be quite intricate and confusing. As Barthes also said, 'narrative is international, transhistorical, transcultural: it is simply there, like life itself' (qtd. in Bowman 2006). At the heart of narratology lies the assumption of a dualism within every text: that there is, on one hand, story and, on the other, plot. Before considering the implications of this division it is necessary briefly to define its two elements. The distinction between story and plot is fundamental to narratology. Barry explains that the 'story' is the actual sequence of events as they happen, whereas the 'plot' is those events as they are edited, ordered, packaged, and presented in what we recognize as a narrative (2002: 223). *Fabula* (story) also means 'the raw material of narrative fiction,' its underlying structure and *sjuzhet* (plot or discourse) means the aesthetic arrangement of that material, its 'surface structure' (Waugh 265).

Story is simply, 'what happens.' It is the sequence of events that lie somehow 'behind' the text, or rather it is the sequence of events that can be abstracted, or constructed, from the text. In this context an event can be defined as 'something that happens' (Rimmon-Kenan 1983: 2). Plot is the particular presentation of the story in the narrative, a sequence that need not parallel the temporal sequence of the story events, but that supplies information about the causal relations between them. Accordingly, plot introduces causality to what becomes a chain of events. In this scheme of things story corresponds to the actual or real story that is supposed to have happened and is told in the narrative in a certain way.

Presenting the story in a certain way is called text, and the act of narrating the story is called narration. It is implied that events in a narrative are not arranged the way they are supposed to have happened in the fabula. Events in a narrative are packed, arranged and presented in a particular way. This is one of the different ways of constructing different narratives from the same fabula, and in the case of real events, different facts to present different perspectives of the same incident. Gerard Genette, while studying the arrangement of the events, studies the sequential order, duration and frequency. Whereas, Mieke Bal, while studying story, besides looking at sequential ordering and frequency, also looks at rhythm, relation between place and space, and focalization.

However, Genette opines that the rise of different types of experimental texts, which began to occur from the 1960s onwards, gave rise to a confrontation with this relation especially in journalistic fiction. In such texts the author often goes to great lengths to sabotage the relationship between story and discourse. So the relation between story and plot in terms of time cannot be ignored. In respect of time, Genette's actual terminology on anachrony, includes two concepts: *Analepsis* and *Prolepsis*. The prefix of the term analepsis is derived from the Greek 'ana' which means through, back, over, or again. The prefix of prolepsis is the exact antithesis of analepsis. The Greek root of the word 'pro' means to be ahead of, or be in front of. Genette notes that the final part of the word, 'lepsis,' is a play on two different Greek words: 'lepse,' which Greek root refers to the fact of taking, taking responsibility for, and taking on; and 'lipse,' where the root refers to the act of leaving out or passing by without any mention (Genette 1980: 40). Toolan defines analepsis

as "an anchronological movement back in time, so that a chronologically earlier incident is related later in the text; a prolepsis is anchronological movement forward in time, so that a future event is related textually 'before its time,' before the presentation of chronologically intermediate events" (2001: 50).

The second type of anachrony is 'prolepsis' or flash-forward which Mieke Bal calls "anticipation." Prolepsis is a treatment of anachrony which tells about an event or events that will happen in future of time of fabula from the point of intervention. It has been observed that anticipation, or temporal prolepsis is clearly much less frequent than the analepsis. Conversely, proleptic statements are generally made by an omniscient narrator who, in a small phrase, tells us about an event that will happen later in the narrative. Such statements play a major role in what Barthes calls "weaving" of a narrative. Through such canonical phrases like "one will see later" or "we shall find," an expectation is created in the mind of the reader. The expectation created thus may be fulfilled sooner or later. The possibility of prolepsis provides a useful insight into narrative structure, laying bare the assumption that an end will be reached, and that the sequence of events moves towards an end point.

Joe Rhodes in his book, *Rhetoric and Civilization*, puts forth a collection of definitions of rhetoric given by critics. In the Classical age Aristotle defined rhetoric as "the faculty of discovering in any particular case all of the available means of persuasion" (2011: 5). For Plato, rhetoric is the "art of enchanting the soul" (Joe Rhodes 5). In the Medieval age, the definition given by Boethius is that "By genius, rhetoric is a faculty; by species, it can be one of three: judicial, demonstrative, deliberative

These species of rhetoric depend upon the circumstances in which they are used."

Moving further, in the Enlightenment age, Campbell says that "[Rhetoric] is that art or talent by which discourse is adapted to its end. The four ends of discourse are to enlighten the understanding, please the imagination, move the passion, and influence the will" (Joe Rhodes 6). Erasmus states that "Elegance depends partly on the use of words established in suitable authors, partly on their right application, partly on their right combination in phrases ... style is to thought as clothes are to the body. Just as dress and outward appearance can enhance or disfigure the beauty and dignity of the body, so words can enhance or disfigure thought." Finally, in the Modern and Postmodern age, Corbett defines rhetoric to be "The art of the discipline that deals with the use of discourse, either spoken or written, to inform or persuade or motivate an audience." Knoblauch argues that "Rhetoric is the process of using language to organize experience and communicate it to others. It is also the study of how people use language to organize and communicate experience. The word denotes ... both distinctive human activity and the "science" concerned with understanding that activity" (Joe Rhodes 7).

Aristotle suggests in *Rhetoric* that the most famous of these theories are the artistic proofs: speaker credibility (ethos), the use of reason (logos), and the manipulation of emotion (pathos). Ethos is described as those proofs that depend on the speakers' ability to be believable. Pathos is designed to affect listeners' feelings. And logos proofs "demonstrate that a thing is so." In fact, Aristotle defines rhetoric as "the faculty of discovering the possible means of persuasion in reference to any subject whatever"

(Honeycutt). It's important to ask here- How is an audience influenced by a means of persuasion? The answer is that it is persuaded by means of arguments that they are familiar within everyday thinking and discourse.

Moreover, Gerard A. Hauser's definition of rhetoric is much more closely aligned to the way we use rhetoric in argumentation or a debate class. He states that rhetoric is

> an instrumental use of language. One person engages another person in an exchange of symbols to accomplish some goal. It is not communication for communication's sake. Rhetoric is communication that attempts to coordinate social action. For this reason, rhetorical communication is explicitly pragmatic. It's goal is to influence human choices on specific matters that require immediate attention. (qtd. in *Argumentation, Logic and Debate*)

This can be correlated with the authors dealing with social reality and issues, whose aim is to share the experiences, and make aware the readers. Rhetoric has enjoyed many definitions over the centuries, but there are a couple of key traits consistently found in those definitions; first, it concerns not only *what* is being said, but also *how* it is being said; second, it is persuasive in nature.

Aristotle also contributed to what is now termed as the five canons of rhetoric: invention, arrangement, style, memory, and delivery. Rhetoric was divided into these categories, and it is currently the most accepted template for rhetorical education and pedagogy. Invention

is concerned with *what* is said rather than *how* it is said, thus invention is associated closely with the rhetorical appeal of logos. Invention comes from the Latin word *"invenire"* which means, "to find," because the first step in the rhetorical process is to find the persuasive argument. Arrangement dictates how a speech or writing should be organized i.e., introduction, statement of facts, division, the proof, refutation, and conclusion. Further, style is the artful expression of ideas. There are seven pure types of style: clarity, grandeur, beauty, rapidity, character, sincerity, and force. It is concerned with how something is said. Style is meant to align the appropriate verbal expression to the orators' given intentions. 'Memory' implies the degree to which a writer remembers his/her speech, and the methods used to ensure that the audience retains the speech and persuasion. Delivery is essential for appealing to the audience's emotions (pathos), and is critical in establishing a speaker's credibility (ethos). It also deals with body language, gestures, and tonal fluctuations. Aristotle wrote that delivery "is of the greatest importance ... it is a manner of voice ... used for each emotion" (*Rhetoric* 1403b 20).

Thus rhetoric is a persuasive language which is honed and crafted to accomplish a purpose for a specific occasion and audience. Historically, philosophers, rhetoricians, and educators alike have argued the relevance of rhetoric and its relationship with logic. Many argue that rhetoric is more concerned with the stylistic devices, the *how* of the communication. Rhetoric does attend to style and delivery, but it also considers other important elements. Rhetoric also deals with meaning and symbols, persuasion and argumentation, which means it is also about truth. Peter Ramus (1986) redefined rhetoric: he transferred

invention and arrangement to dialectics. Invention and arrangement were the first two "cannons of rhetoric," more simply understood as the first key elements of rhetoric. Invention was the persuasive core of rhetoric, the stage where the rhetor finds something to say on a given topic, nowadays known as brainstorming. Arrangement is the basic organization of a given speech, where a rhetor strategically places arguments in order to have the greatest effect.

Rhetoric is basically the art of verbal influence, for Aristotle this art is "the counterpart of dialectic" (Roberts 1996). But this act has been, in this century, meant to be for persuasion and manipulation (xi). Rhetoric can be oral or in written form. The efforts of rhetoric are visible in the tropes and figures used in describing anything in a text, characterization, and any kind of emotional outburst. It is more visible in the fictional style of the text. A rhetorical perspective implies a concern with communicative acts, which in Booth's terms meant the "glorious meeting" of authors and readers in texts (403).

Rhetorical discourse was defined by Aristotle in his *Poetics* as the art of "discovering all the available means of persuasion in any given case," and he further discussed the means and devices that an orator uses in order to achieve the intellectual and emotional effects on an audience that will persuade them to accede to the orator's point of view (Abrams 268). It can also be said that the concern of rhetoric is with the type of discourse whose chief aim is to persuade the audience to think and feel or act in a particular way. Rhetoric is the study of language in its practical uses, focusing on the persuasive and other effects of language, and on the means to achieve those effects on readers.

Later classical theorists categorize rhetorical discourse into three components: invention (the finding of arguments or proofs), disposition (the arrangements of such materials), and style (the choice of words, verbal patterns, and rhythms that will most effectively express and convey these materials). For rhetoricians, there are three kinds of oratory: (1) Deliberate- which persuades the audience to approve or disapprove of a matter of public policy, and to act accordingly, (2) Forensic- which means to achieve either the condemnation or approval of some person's actions, (3) Epideitic- "display rhetoric," used on same appropriate occasions to praise a person, or a group of persons through the orator's own talents and skill in rising to the demand of the occasion.

After the 1950s came Rhetorical criticism, according to which, there has been a revival of interest in literature as a mode of communication from author to reader. Moreover, a number of recent critics of prose fiction, and of narrative and non-narrative poems have emphasized the author's use of a variety of means- including the authorial presence or voice that he or she projects- in order to engage the interest and guide the imaginative and emotional responses of the readers to whom, whether consciously or not, the literary work is addressed.

The means of communicating, expressing, and influencing have changed with time. Earlier people used to gain information through newspapers, listened to radio, but now they search for video as well as literature for information and entertainment. In time and space, the distinction between a public's significant rhetorical event and its other activities seem to be blurring. Booth argues that 'through rhetoric the reader learns to know where, in the world of possible values, he stands- that is, to know

"where the author *wants* him to stand"' (73). David Lodge says that for Booth "rhetoric is a means by which the writer makes known his vision to the reader and persuades him of its validity" (1990: 147). It can be interpreted that Booth's "communicate to impose" becomes Lodge's more specifically rhetorical "persuades," and Booth's "fictional world" becomes Lodge's "vision" (James Phelan, *Reading Narrative* 45).

Similarly in Journalistic fiction, which is based on real events and their narration, authors are more concerned with stressing upon the truthfulness of the content represented and the techniques used in doing so. For instance, the story of Oswald as narrated by DeLillo in *Libra*, is real because the author's use of language, details, scenes, are those that aim to reflect the truth and culture of that time. So the rhetoric actually is the use of stylistic techniques to depict the expected effect of a narrative's end. Similarly, in the case of *The Executioner's Song*, Mailer, while narrating the story of Gary Gilmore, effectively uses Gilmore's dialect to show that he is a 'mormon,' has spent most of his life behind the bars, and has not lived in a cultured atmosphere. It has also been observed that though both the rhetoric of fiction and the rhetoric of history (dealing with real events) use narration, but only the latter make us believe that its stories are true.

Moving further, the word narration implies not only the act of narrating, but also the presence of one or more narrator(s) and one or more narratee(s). In every narrative we find one, or more than one narrator who tells the story. As Mieke Bal says, 'As soon as there is language, there is a speaker who utters it; as soon as those linguistic utterances constitute a narrative text, there is a narrator, a narrating subject' (1985: 121-2). If a narrator tells us the story, the

second obvious question that comes to our mind is from whose point of view the story is being told.

By making a distinction between who sees and who speaks Genette opens the debate of focalization in the narrative. 'Rather than being added as an appendage that will transmit the plot to an audience, narrative point of view creates the interest, the conflicts, the suspense, and the plot itself in most modern narratives' (Martin 1986: 131). Genette decides to use a more abstract term *focalization* "which corresponds, to Brooks and Warren's expression, "focus of narration" (Genette 189). Prince defines focalization as "the perspective in terms of which the narrated situations and events are presented" (31). Depending upon the position of the focalizer and its relation with the focalized objects, broadly three types of focalizations have been classified — zero focalization, external focalization, and internal focalization. Narratives with zero focalization are also called "*nonfocalized*" (Genette 189). Gerald Prince describes zero focalization as a type of focalization whereby "the narrated is presented in terms of a non-locatable, indeterminate perceptual or conceptual position" (103). It is associated with omniscient narrators. It is written in the third person.

External focalization is when the focalizing position is outside the fabula and cannot be associated with any character. Mieke Bal uses the abbreviation of EF for "external and non-character bound focalization" (148). "External focalization is felt to be close to the narrating agent," (Rimmon-Kenan 74) and the agent is also called narrator-focalizer. In such cases, the distinction between narrator and focalizer tends to dissolve. In external focalization what characters do and say are narrated. It can be found in first-person narration, "either when the

temporal and psychological distance between narrator and character is minimal (as in Camus's *L' Etranger*, 1957) or when the perception through which the story is rendered is that of the narrating self rather than that of experiencing self" (Rimmon-Kenan 74). In the opposite, internal focalization focuses on what the characters think or feel. It reveals unspoken thoughts and feelings of the characters. Internal focalizers appear, as characters in the story displaying partial knowledge of the story, which can be written in either the third, or the first form ('I said'). In the English novel, James Joyce made use of unreliable first person narrators (in *The Turn of the Screw*) or sustained focalization of the narrative through the perspective of characters whose perceptions are narrowly limited, with minimal authorial comment and interpretation (Henry James' novella 'In the Cage' and novel *The Ambassadors)*; Conrad used a multiple framing via multiple narrators, none of whom is invested with ultimate interpretive authority as in *Lord Jim* and *Nostromo* (qtd in David Lodge, *After Bakhtin* 33).

The selected authors in this study use both techniques in their books with varying effects. As a literary journalist, Capote uses both forms of focalization in *In Cold Blood*. On one hand, he has the ability to write what the characters have said and done, and also about how they feel, on the other. It is thus often through Perry, that the views and intentions of Capote, the author, come through, and a sense of shared identity with Capote is revealed. Genette would also classify Capote as an effaced narrator in one sense due to the fact that he does not reveal his presence as a "true voice," or distinct character in the book (qtd. in Bjärstorp 8). Nevertheless, as previously stated, due to the nature of Capote's narration, there is indeed a very strong

ghost-like presence of what Genette calls an "authorial persona" exposed in the text. Finally, Capote chooses to use to great effect, the range of "representations of speech in [his] narrative" between adding and omitting, as a signification of his movement in and out of the narrative. Free indirect speech and direct speech are also definitely favorites of speech representation for Capote (Ibid. 9).

Further in narratology, besides understanding the nature of a character's existence, what interests a narratologist more, is how the characterization has been done. Shlomith Rimmon-Kenan and Jacob Lothe both seem to agree on the issue, asserting that the primary ways of characterization are two- direct definition and indirect presentation. The direct presentation of characters involves use of adjectives or abstract nouns which can be found only in a narrative with "most authoritative voice" (Rimmon-Kenan 60). Such overt technique of characterization hardly leaves anything for the reader to decipher; but in case of narrative with unreliable narrator, it can be an interesting phenomenon to trust the narrator for the characterization. In case of indirect presentation, characterization is done through action, speeches, external appearance, environment, and analogy. These are different character-indicators through which various traits of characters can be indicated.

Our need for narrative structuring is based on our need for order and linking events in temporal sequences as well as through cause and effect, which are the two kinds of ordering techniques. In *The Cambridge Introduction to Narrative*, Abbott expresses, "We are made in such a way that we continually look for the causes of things. The inevitable linearity of story makes narrative a powerful means of gratifying this need" (37). Furthermore,

Kermode has noted in *The Sense of an Ending* (1966) that we long for the sense of an ending. Since the world does not have beginnings and endings the way, for example, novels do, we use narrative techniques to create the sense of it.

According to Abbott, closure is the narrative effect which 'has to do with a broad range of expectations and uncertainties that arise during the course of a narrative and that part of us, at least, hopes to resolve, or close' (2002: 53). While closure is not obligatory to a narrative, and certainly many well-known narratives end without it, closure is an important part of the satisfaction of literature and the way in which individuals are able to organize stories as coherent and meaningful. In classical terms, closure creates the narrative text as a self-contained unit (Barthes 33). Because the narrative must end, the narrativization of events allow them to become 'endurable because finite' (Herman 173), enabling the 'desire to have real events display the coherence, integrity, fullness, and closure of an image of life that is and can only be imaginary' (White 1996: 284). By creating the illusion that any event, no matter how traumatic, has a definitive end, narrative becomes a means for individuals to quickly process, and progress from the past and its disturbances. Since we long for closure, which fiction often provides, we structure our world through narrative, leading to satisfaction and consolation.

It is assumed that a literary narrative necessarily has the classic structure of beginning, middle, and end. It does not necessarily order events in chronological order, and while it moves towards closure, it does not necessarily provide it. A narrative carries the "sense" of, or longing for, an ending, but some literature, especially

postmodern literature, often refuses to provide a clear sense of closure. 'We end a story when something has finished happening, when a new condition prevails and is, for the moment at least, stable' (Brooks 192). An end may be the reconciliation of forces, or the fusion of previously opposing forces to create a new force. As a matter of fact, the end of an action may simply be a new awareness on the part of a person involved, directly or indirectly, in the action. It is the point at which the reader is willing to say, "Oh, yes, I see what it is all about" (Ibid. 200). The technical term for the end of a narrative is denouement which means an "untying," and that the complications are finally untangled and resolved (Ibid. 201).

According to many psychoanalysts, we not only use narrative to make sense of our world but also to form an identity. In an attempt to explain who we are, we need to tell our own story, our experiences, by selecting key events which characterize us, and organize them according to the formal principles of narrative. Like a literary writer, we use narrative techniques to shape memories into narratives that define our identity. We select events to remember, and facts about them, to include. We exclude certain facts and events, but we also fill in gaps where information is missing by speculating about how events must have happened. We then arrange the facts into a sequence of events in order to create a coherent structure. In short, we interpret our experiences, analyzing causes and effects, and write a story that fits into an overall idea of who we think we are. It is similar in the case of a literary journalist, who represents real events in such a manner to make them plausible and credible.

For instance, the inability to create narrative seems to lead to an inadequate sense of identity, which has

been portrayed by Oswald (the main protagonist) in Don DeLillo's *Libra*. Though he tries to create narrative by writing a diary, he fails because his split personality denies him a stable voice, and his dyslexia complicates his ability to use language. Oswald's inability to form a coherent narrative of his life and his subsequent lack of a sense of identity compel him to join Everett's assassination plot, a structured narrative with a clear role for him to play.

Hayden White takes the argument a step further by maintaining that the work of a historian is similar to that of a literary writer. Like the literary writer, the historian must fashion the "facts" in such a manner as to create a narrative, and only then will it make sense. Similar is the way of expression by the literary journalists in the works of nonfiction, where often the famous real events are depicted. The historian, Nicholas Branch, in *Libra* refuses to apply any narrative technique to the data he has collected, and, therefore, he is unable to make sense of what might have happened when Kennedy was assassinated.

Branch's main problem in *Libra* is that he refuses to be selective. Since the historical record, according to White is "both too full and too sparse," the historian must exclude certain facts that are not relevant to his or her story, and must also fill in gaps where information is missing in the record by deducing what must have occurred (*Libra* 1978: 51, 60). Just like the reader of fiction, the historian must search for clues in the text and form hypotheses for filling in the gaps in order to make sense of the events represented, which are otherwise chaotic and seem uncertain.

When the historian has selected which facts to include in his or her narrative, he must arrange them in

such a manner so as to create logical meaning using the techniques discussed above. The order of presentation need not be the chronological order in which the events originally occurred. As narratologist Seymour Chatman explains, referring to a narrative in literature, the purpose of the order of presentation "is to emphasize or de-emphasize certain story-events, to interpret some and to leave others to inference, to show or to tell, to comment or to remain silent, to focus on this or that aspect of an event or character" (1980: 43).

In journalistic fiction, where the real events are depicted, the "truth" value of any historical account depends upon our belief that an account is plausible if it is coherent in its structure. As White points out, since we assume that reality is coherent, if an account is *not* coherent, we consider it implausible or inaccurate (*Tropics* 122). Abbott in, *The Cambridge Introduction to Narrative*, calls these cases "masterplots," stories that are told over and over again to such an extent that our values and identities as individuals and cultures become connected to them, and are *formed* by them. For this reason, we tend to find credibility in narratives that contain such "masterplots" (42), like the masterplot of the selected texts in this study depict that there are a couple of petty criminals in the plot, who commit crimes, are caught and punished at the end. In addition to being journalistic fiction, the selected literary works are also narratives, as they contain both storytellers and stories.

Important for this study is the work of the Russian formalist Vladimir Propp, who developed a list of thirty-one constants that are detected in folktales, and form the structure of the narrative. Propp published his findings in his book, *the Morphology of the Folktale,* in which he

states: "[t]he word 'morphology' means the study of forms" (1928: 1). Propp calls these constants 'narratemes' which are narrative functions necessary for all narratives and form the building blocks of stories; for example, as a result of realizing a 'lack,' or as the result of misfortune (step 8), the hero has to leave home (step 11). Then, obstacles are placed before the hero as he struggles to obtain his goal (step 12). Fortunately, a magical agent is obtained or a helper appears (step 14). The initial lack is resolved (step 19). The hero returns home (step 20), and marries, ascends the throne or publishes his new book (step 31). The steps are not precise; however, they have the feel of consistent points. Many of these steps have also been found in the journalistic fictions written by John Hersey, Truman Capote, Norman Mailer, and Don DeLillo.

These authors' main concern is with literature and its evident abandonment of what they see as the novel's role in providing understanding of their chaotic and rapidly changing world.

Furthermore, journalism alone does not have the power or scope to bring meaning to people, although it is good at providing information at times. As stated earlier in Chapter I, it is a novelist who arranges information so that the reader can see patterns and shapes in the chaos of life. Through the use of language, symbols, narrative, metaphor, character and all the other literary tools, he allows the reader access to meaning and truth. Discussing the role of the novel, Philip Roth said in a recent interview:

> It is the form that allows a writer the greatest opportunity to explore human experience …. For that reason, reading a novel is potentially a significant act.

> Because there are so many varieties of human experience, so many kinds of interaction between humans, and so many ways of creating patterns in the novel that can't be created in a short story, a play, a poem or a movie. The novel, simply, offers more opportunities for a reader to understand the world better, including the world of artistic creation. That sounds pretty grand, but I think it's true. (Caesar)

Mailer puts it in this way "the novel […] is, when it is good, the personification of a vision which enables one to comprehend other visions; a microscope- if one is exploring a pond; a telescope upon a tower if you are scrutinizing the forest" (*AN* 219).

So it is narrative, either as a novel or reporting or a seamless combination of both, that gives moments their meaning and allows one to comprehend what has happened. In an attempt to find a way to work through what had happened, the individuals, for instance in *Falling Man*, turn to others who have undergone the same experience. *FM* is a narrative centered around 9/11, and concerned with how to narrate this traumatic experience. The communities try to heal themselves through the narratives. They tell each other of what had happened and how the collapse of the towers affected the community, not the individual alone. Similarly in *In Cold Blood*, the inhabitants of Kansas are sensitized due to the murders of the Clutters, which is inconceivable to them. This study aims to find a better understanding of how fiction and fact combine to form the narratives of trauma, shock and other emotions, and what there is to learn from these occurrences.

It is not the historical account to which we turn to verify what has happened but rather to the recreation of the event, no matter how second-hand and fictitious it is. When we read a true account or journalistic fiction, we have a different approach towards its comprehension and we tend to generalize the experience, and gain knowledge of the mindset of someone who has become a part of the trauma. The distinction between reality and fiction can easily be collapsed in such a reading, and thus the totalizing narrative becomes not only more believable, but also real. Fiction is an important word to use. It invokes literature, and especially the novel, as a tool used for creating belief and knowledge.

It can be concluded that different theorists and their theories direct our attention towards how the story is told, how it sets about achieving its designs. We have also discovered that in a narrative, different elements are too closely associated to be studied in isolation. It has been found that by introducing a character-narrator in a narrative that begins with third person narration, not only the status of character can be changed; it also changes the temporal arrangement of events and at the same time, also changes the overall structure of the narrative which, eventually, changes the discourse and rhetoric. Thus, to study a narrative is to study all parts of narrative in relation with each other. The motivating factors in the worlds depicted, like the famous social, political events and their direct or indirect effects on the authors as well as the readers after reading these literary works of art, are revealed in an artistic sequence and climaxing. The forthcoming chapters show how this has been achieved by the selected authors in the texts under study.

CHAPTER 4

Blurring of Genres by Norman Mailer: Literature Retelling Contemporary Events

CHAPTER 4

Blurring of Genres by Norman Mailer: Literature Retelling Contemporary Events

The two texts, *The Armies of the Night* and *Of a Fire on the Moon*, have been clubbed together in this chapter because in them Norman Mailer uses 'self' as the protagonist. He participates in contemporary events and expresses his own feelings, views, and experiences. Mailer, one of the major American authors, was from the very beginning of his career, painfully conscious as well as apprehensive of the major incongruities of the age such as: the hoarding of doomsday weapons to keep the world safe, the brutalities of the World Wars, the quest for God through material acquisitions, and technological advances.

Norman Mailer's particular genius had been to penetrate the façade of contemporary events, even science, to show us who we are, where we are, and where we are likely to go, pointing up the significant in the most trivial of events, and conversely placing in perspective the truly momentous acts of our time. Mailer always had an urge to comment on psychological, social, and political conditions in the United States. For instance, the Army in *The Naked*

and the Dead, the March to the Pentagon in *The Armies of the Night*, and a discussion of the Space Program in *Of a Fire on the Moon* serve as a microcosm of American life and are the basis for Mailer's vision of America, its people and institutions (Ehrlich141-143).

Some of the major works of journalistic fiction written by Mailer are the long essays like *The Faith of Graffiti* (1974) and a brilliant recreation of the 1968 conventions in *The Idol and the Octopus (1968).* Eleven of his 27 major books came during this period. *The Armies of the Night* is one of his master pieces, about the march to the Pentagon to protest against the Vietnam War. The Apollo 11 flight to the moon is the subject of *Of a Fire on the Moon* (1971). In 1971 he also wrote *The Prisoner of Sex*, about the debate with the feminists and in 1979 he published, *The Executioner's Song*, his huge Western epic about the life and death of Gary Gilmore, which he subtitled "a true life novel." This chapter deals with *The Armies of the Night* and *Of a Fire on the Moon*, being the best examples of blurring of genres. Norman Mailer was popular for the style known as new journalism. Robert Lowell once called him the 'best journalist in America' (AN 33). These two texts provide literal examples of Mailer's transforming journalistic material (dealing in real past events) into novels.

This chapter is concerned with how Norman Mailer, in *The Armies of the Night* (*Armies*), and *Of a Fire on the Moon* (*Fire*), has employed the tools of narratology, especially character and narration, for the verbal and visual presentation of actual events of his time. These texts have been chosen because they are the most successfully experimental, certainly the most ambitious, and most innovative examples of Mailer's journalistic fiction. *The*

Armies of the Night won the Pulitzer Prize for General Non-fiction, and the National Book Award in the category of Arts and Letters. Mailer has, in *Armies*, emphasized the self-conscious manipulation of the authorial role and narrative convention, casting himself as a protagonist able to bridge self and event through action and metaphor. In *Fire*, being unable to capture the meaning of man's first flight to the moon, he responds by presenting Part II as a book about his writing the book on the moon flight through a subsequent process of intense research and imaginative meditation. In these texts, Mailer discusses the failures, difficulties, and successes faced by him in the representation of 'reality.'

March of demonstrators including radicals, liberals, black nationalists, hippies, professors, women's groups, and war veterans toward the Pentagon on 21st Oct' 1967, is the subject of *The Armies of the Night*. It was a rally at West Potomac Park near the Lincoln Memorial followed by a march to the Pentagon, another rally to be held in a parking lot, further followed by civil disobedience on the steps of the Pentagon itself. There occurred a clash of demonstrators clash with the soldiers and U.S. Marshals who were protecting the Pentagon. In this demonstration more than 10,000 people participated, accompanied by street violence. By the early hours of October 23, 683 people, including novelist Norman Mailer and two United Press International reporters, had been arrested. Norman Mailer chronicled these events in his non-fiction novel *The Armies of the Night*. Following the Pentagon demonstration, a demonstrations was planned and held at the 1968 Democratic National Convention, in Chicago, Norman Mailer wrote a non-fiction novel about

both the 1968 Democrat and Republican Conventions entitled *Miami and the Siege of Chicago.*

It was a touchstone event in American history, one that pitted U.S. citizens against "the true and high church of the military-industrial complex," *(Mailer, Washingtonpost).* It occurred as a consequence of the growing frustration with the political system of the antiwar leaders. It reflected a shift in the public opinion.

Apollo 11 finds representation in Mailer's *Of a Fire on the Moon.* It became the privileged spaceflight for manned lunar landing on July 20, 1969 by Americans, Neil Armstrong and Aldrin Buzz, Michael Collins being the pilot of the spacecraft. They spent about 21 hours on the lunar surface and returned on July 24' 1969. Armstrong in a TV broadcast stated: 'one small step for [a] man, one giant leap for mankind' (Wikipedia). This landing was the fulfillment of a proposal put forth by U.S. President John F. Kennedy in 1961. *Of a Fire on the Moon* written by Norman Mailer is an attempt to understand the moral and philosophical reason behind this landing.

Some more writers contributed to write about this mission. *Moonshot: The Flight of Apollo 11* (2009) is a nonfiction children's book by Brian Floca introducing, apart from other details, the equipment the astronauts, Armstrong, Collins, and Aldrin, use in order to go up in space. *Earth: An Alien Enterprise - The Shocking Truth Behind the Greatest Cover-Up in Human History* (2014) by Timothy Good is about extraterrestrial beings visiting earth. It is based on a conversation between one of the member of Military Intelligence, Section 6 and Neil Armstrong about the Apollo 11 moon mission in 1969. These books have been written from varying point of views.

Norman Mailer's experiences and texts illustrate various methods for describing modern American reality. The aim here is to study in depth the nature of personalization of the contemporary events, and the use of third person narration. This study also explores Mailer's reactions and presentation of the gained experience, during the march to the Pentagon and Apollo 11.

Mailer has stated in *Twentieth Century Authors*, that his goal as a writer is nothing less than "to revolutionize the consciousness of our time" (Kunitz 1955: 658). In his works, distinction between fiction and reality, persona and face, fantasy and confession become uncertain. Through these writings, Mailer is recording man's quest for identity which goes in two directions, one being the concern for the socio-political sphere, and other being the individual as author. The theme of Mailer's fiction has remained: the impact of certain events upon a single shaping consciousness. Like Walt Whitman, Ralph Waldo Emerson, and Ernest Hemingway, Mailer senses that his troubled soul emanates from the troubled soul raging within America. According to Emerson, Mailer in *Armies* tries 'to prove that the creative writer can exercise a determining influence on the social-political arena' (Bufithis 89). Similarly, as Jake Barnes in *The Sun Also Rises* goes to Pamplona to participate in the running of bulls, Mailer goes to the Pentagon to participate in the march.

While writing *Armies*, Mailer felt that traditional reporting rarely gets at the truth of a situation such as the march to the Pentagon. He feels that reporters do not simply list facts, but retell stories and thereby insert, consciously or not, their own bias and subjective view into their reports. Mailer explains, "Journalistic information

available from both sides is so incoherent, inaccurate, contradictory, malicious, even based on error that no accurate history is conceivable" (*Armies* 255).

In 1967, Mailer had remarked, "I feel I'm all washed up. I feel I'm out of it now, it's passed me by" (Rollyson 202), as he felt dejected when his self-directed movie went unnoticed by the public. Then he received a phone call from his longtime friend Mitchell Goodman inviting him to take part in a proposed march on the Pentagon. First being skeptical, and then flattered to speak before a group of 20,000 people, Mailer agreed to participate. He signed a 25,000 dollar book deal, and began writing his personal experiences in book form. As he had done many times before, Mailer decided to write himself out of a low point in his life. But ultimately *Armies*' style and form resulted in one of the first great works of New Journalism. For Mailer, the goal of writing about the march was to help break the complacency of 'middle of the road' Americans, and alert them to the increasingly authoritarian nature of their government. *Armies*' style communicated that message more successfully than any previous book because of the balance between Mailer's style and content.

Armies is an on the spot account of the march to the Pentagon (the October 1967 anti-Vietnam War rally in Washington DC) experienced personally by the protagonist Norman Mailer making it novelistic in nature, and historical by making an effort to describe the facts. This book is different from other works by Mailer because of its 'strict enclosure within the limits of a particular event place' (Bufithis 87), giving it a classical sharpness. In *Armies* 'the events are shaping the book instead of novels shaping the events' (Bufithis 87). The book is divided into 'The Steps of the Pentagon' (History as a Novel) and 'The

Battle of the Pentagon' (The Novel as History). It suggests the dual level of Mailer's interest in composing this work. Book One is concerned with the story of Mailer taking part in the Pentagon demonstration, which is seen by him from "inside." He describes the whole event profoundly, fully and eloquently, giving a detailed account not only of the demonstration itself but also of his involvement in it.

Armies depicts the problematic relationship between human experience and an actual event which leads to a problematic relationship between report and event. Mailer makes use of a number of narrative concerns. He presents his personal view on what happened on the weekend of the demonstration in the first part, which is about two-third of the length of the book. It begins with Mailer giving a speech at the Ambassador Theater, moving on to depict the burning of draft cards at the Department of Justice, and finally, the march to the Pentagon and Mailer's arrest. The second part is a more objective account of the event, containing several excerpts from newspapers and eye witness reports. It functions as an overview of the demonstration, and as an assessment of how it was treated in the mainstream media.

Just like the other long narratives of Mailer, the structure of *Armies* is complex. Book One is more extensive than Book Two consisting of four parts: Thursday Evening (subdivided into six sub-parts indicated by numbers and names), Friday Afternoon (four sub-divisions), Saturday Matinee (six), Saturday Night and All of Sunday (eleven). The form and style Mailer chooses are dependent on the character of the object or the event he describes. The documentary elements consist of events, characters, organizations, which are real in the book, like: the peace demonstration in Washington and

the Pentagon in November 1967 (the action, space, time), the people taking part in it (Mitchell Goodman, Robert Lowell, Dwight Macdonald, Noam Chomsky, the leaders of the peace movement, e.g. the Chaplain at Yale, William Sloane Coffin, Jr., Dr. Spock, David Dellinger, Jerry Rubin, and demonstrators Mailer meets and all the politicians he speaks about), peace groups and organizations (socialist splinter parties, the Revolutionary Contingent, trade unions, the Communist Party, etc.), the social and political background to the event, negotiations of the Mobilization Committee organizing the march on the Pentagon with the government and the author's thoughts presented to the reader.

Many famous people who have been referred to in this book are: H. Rap Brown, William Sloane Coffin, Ella Collins, John, Mellot, Noam Chomsky, David Dellinger, Paul Goodman (writer), The Fugs, Abbie Hoffman, Lyndon B. Johnson, TuliKupferberg, Nelson Algren, Robert Lowell, Sidney Lens, Dwight Macdonald, A.J. Muste, Robert Nichols, Dr. Benjamin Spock, Dagmar Wilson, Cassius Clay (named Muhammad Ali in 1964), Mitchell Goodman, Donald Kalish, Malcolm X. Robert Merill claims, "the structure of *Armies* is unique" (1984[1974]: 128) and the book represents "the most powerful synthesis of Mailer's artistic and prophetic ambitions" (1992:107).

The fictional elements in *Armies* include: two descriptions of the whole march, each handled in a different way; the constant interruption of the narrative continuity by thoughts and meditations; the presentation of the narrators. Bufithis states, in *Contemporary Literary Criticism*, 'Armies is novelistic because it sensitively describes the effects of the march on a participant-protagonist, Norman Mailer, and historical because it

scrupulously describes the facts of the march' (1979: 343). The subject-matter of *Armies* is entirely represented by the facts drawn from reality while fictional features can be found mainly among the structural devices.

Mailer has been constantly changing ways of referring to "himself" in the third person: "Mailer" in *Armies*, "the reporter" in *Miami and the Siege of Chicago*, and "Aquarius" in *Fire*. Mailer has placed himself at the centre of his narrative action. He has attempted to become the personification of America himself. He depicts his reactions to one of the vast anti-Vietnam demonstrations of various peace groups. Using his own character, which is filled with funny representations, Mailer gives a more detailed, complex, and truthful account of his experiences. The first section of *Armies* is more of a novel than history and of greatest literary interest depicting Mailer's artistry rather than reporting ability. *Armies* shows the events of history and television screen, and at many places, we find ourselves as other minor real life characters. Here Mailer is trying to answer the question that: Can a mid-twentieth century man maintain a semblance of integrity and hope in the midst of brutalities and absurdities that surround him?

Mailer in the form of a Historian or the Novelist offers the facts to the reader. He sometimes, comments on some formal elements, but usually remains behind the scene and behaves as an omniscient narrator and self-conscious writer. Book One, History as a Novel, is narrated by the Novelist, while Book Two, The Novel as History, is presented by the Historian. Mailer's narration seemed so credible because he dealt with all the important aspects of his character in conjunction with the complexity of events surrounding the march to the Pentagon. In other

words, his original aim in *The Naked and the Dead* to show the convergence of character and society was amply demonstrated in a mature, comic, and subtle way through *Armies*. Mailer played many roles in *Armies*, first as an author or novelist, then as a participant, historian, observer, and the Beats (name for his temperamental self). Characterization of Mailer as 'Mailer' in *Armies* is most extraordinary and engaging. To describe his personality in *Armies*, he uses many adjectives: foolish, vain, inspired, deluded, imaginative, energetic, generous, and quixotic.

The choices he made, using language as his tool, show the smooth transition of sentence patterns, narrative rhetoric, and meta-discursive features. These attempts were in order to create two characters, the participant and the observer, each with his own level of involvement in the events and with readers. Through a number of characters such as "the Beats" (*Armies* 30), "a poor man's version of Orsen Welles" (*Armies* 32), "Prince of Bourbon" (*Armies* 33), "fatally vulgar" (*Armies* 44), Mailer has proved that his public personality is an artificial construction. Forster states that the character of Mailer in *Armies* is "a gallery of sharply intimate verbal cartoons" (1968: 30). In *Armies*, Mailer has constructed a colorful collection of character sketches and memorable portraits; giving real-life characters both comic and symbolic dimensions. Joseph Wenke also argues: "of greatest significance is Mailer's ability to develop out of the character sketch a series of associations that reveal with lyrical brilliance the character of contemporary America itself" (1957: 153).

Armies has no doubt, constructed its historical and political scene as an allegory of America itself, but it has also not lost its sense of the harsh realities of the march to the Pentagon. The plot of *Armies* is believed to be a

real plot which shows Mailer changing into a politically active participant who understands that he should write reportage about what he saw and experienced. Urinating on a bathroom floor, taunting an audience, confronting an American Nazi, all are expressions of Mailer's 'Beast' in *Armies*. Mailer also shares his personal experience of the fears and temptations of the protesters who remained at the Pentagon. He feels that their number is reduced to hundreds from thousands, as they are fearful of being beaten after arrest. Mailer describes his experience as "a rite of passage ... a black dark night which began in joy, near foundered in terror, and dragged on through empty apathetic hours while glints of light came to each alone" (*Armies* 120).

This transformation in his character can also be proved by an argument given by Phelan, who states: "Mailer's book represents a thematic character progression, where a comic, inept, and unreliable protagonist grows, in the course of the narrative, to be a more mature and intellectual character whose political opinions should be taken seriously" (1989: 194). According to Laura Adams's *Existential Battles: The Growth of Norman Mailer*, *Armies* is the story of the "growth of Norman Mailer." Also according to Phelan's reading, the narrative of Book one of *Armies* tells the story of Mailer's alteration from the egotist to the more modest man who is transformed by the event, and in this way Mailer the character makes the passage from ignorance to knowledge (ibid.: 195).

Characters fulfill different roles in a narrative, and it is useful to distinguish between characters in terms of these functions (Prince 1982: 72). Different labels and concepts have been used in the discussion of literary characters: "There are round characters, flat characters,

the stock characters, the fool, the protagonist, the hero, main characters, minor characters, static characters, developing characters and so on" (Olsen 1978:109) and most of these types are represented in *Armies*, being both psychologically "round" and allegorically "flat," and "developing," according to Phelan. Zavarzadeh in *Mythopoeic Reality* asserts that E. M Forster's concept of "flat" and "round" characterization, the notion of plot, and the effect of suspense can have no relevance to a work that is about actual people (80). Moreover, to support his assertion about characterization, he opposes William Gass's observation that characters are "made by words, out of words" to Oscar Lewis's statement that in the nonfiction novel they "are not constructed types but are real people" (80-81).

Mailer in an experimental way uses third person for himself as seen in, Thackeray's novel *Henry Esmond*, Pynchon's short story "Entropy," and Henry Adam's autobiographical *The Education of Henry Adams. Armies* uses a similar theme and devices as used by Nobokov in his novel, *The Eye*, in which the themes throw light on the narrator's self-conscious observation of his own activities. In writing about himself in the third person, Mailer creates two versions of himself: Mailer as character, and Mailer as author. Mailer gives the fictional 'Mailer' a full breadth of emotions as well as a complexity that makes him more than just a literary tool. Through the 'Fictional Mailer' we are given an insight into the moods of Mailer like how he felt while he was drunk, how he felt being hung over, his feelings at seeing the young men turn in their draft cards, or what it is like to be in jail.

Armies is a hybrid combining the features of autobiography, history, journalism, and the novel. For

Estelle Jelinek, *Armies* is "an effort to combine history and autobiography" (1986: 179). Jelinek finds Mailer's experimental way of referring to himself in the third person to be a disturbing sign of masculine egotism, but it can be a sign of a "different" kind of men's autobiographical writing in tune with Mailer's own philosophy.

Mick Short mentions *Armies* as the typical example in which blurring the borders between fiction and reality has come to be referred to as 'faction.' Although the march really took place, and Mailer was in it, he adopts a third-person narrator and refers to himself in the third-person (1996: 260). The range of style Mailer uses in *Armies* also proves that the book is on the borderline between journalism and fiction, because of the use of character in a creative manner. Other accounts of the events, whether from other participants or from the mass media, temper the author's opinions and allow the accounts to take the form of what Geertz calls "documentaries that read like confessionals"-- a case of genre blurring (1983: 20).

Critically, Mailer was receiving much better reviews for his journalistic pieces, and being considered as a journalist. Mailer while keeping himself at the centre of the text, attempts to examine the varying merits of the novelistic and historical forms of writing. In the final paragraph of Book One, Mailer discusses the problem with his historical account:

> It insisted on becoming a history of himself over four days, and therefore was history in the costume of a novel. He labored in the aesthetic of the problem for weeks, discovering that his dimensions as a character were simple: blessed had

been the novelist, for his protagonist was
a simple of a hero and a marvel of a fool
Yet in writing his personal history of these
four days, he was delivered a discovery
of what the March on the Pentagon had
finally meant, and what had been won
and what had been lost. (1968 a: 241)

In 'The Novel as History' the whole event is watched from
outside, at a great distance, and from the point of view of a
journalist, or a documentary-prose writer called by Mailer
as the Historian. The role of the Historian is to concentrate
upon the work of many organizers and reactions to
the demonstration in the newspapers, then analyse the
fragments of the reportages he quotes, compare them,
and try to search for the truth. In 'History as a Novel,'
on the contrary, the Novelist concentrates upon Mailer,
a participant in the demonstration, and the four days he
devotes to it, who is a sensitive observer and a witness to
the peace demonstration. This absorbing narrative is at
times interrupted by the protagonist's inner thoughts, and
creates a commentary to things depicted.

Mailer cautiously presents his goal as the observer.
He gives an insight into the events and at the same time,
introduces us to the historical aspects of the march, yet
remaining objective and informing us. Although Mailer
shifts his attention from one person to another, from
one object to another, he never forgets to remain on the
outskirts of the situation as an observer. Yet when he is
the participant, Mailer positions himself closer to the
audience, giving an insight into his character and his
mind frame. The personal tenor of discourse becomes
obvious through statements he makes about himself, like

"he knew suddenly then he had less fear now than when he was a young man," that "in some part of himself at least, he had grown," and he "felt a confirmation of the contests of his own life" (*Armies* 113-114).

The first person account used by Mailer clarifies reasons for such accounts of historical events being limited and flawed. From his position on the frontline of demonstrators during the Saturday March, Mailer feels helpless as he cannot see what is happening, and acknowledges his state of ignorance to his readers. Being thrown into jail so early that weekend, he cannot report on subsequent events. Jennifer Bailey describes Mailer's approach in theatrical terms: "Like a good actor, the personae of Mailer's writing must be able to sift and select from the context of their acting in order to convey the truth of a situation" (1979: 88). The melting down of literary forms is an essential quality of the style of *Armies* --the narrative voice is inextricably linked to the form of the book and, in Bailey's terms, the narrator is able to "sift and select" from the contexts in which he finds himself. In a review of *Armies*, Alvarez concluded that

> [Mailer] has taken a fragment of contemporary history in which he played a part, presented it with all its attendant force, muddled argument and jostling power plays, and made it an internal scenario in which all the conflicting, deadening facts take on new consciousness as an artist. (1968: 362 - 63)

Mailer's authorial narrative voice conveys his social reality. He is not an invisible narrator, but one who is intrusive, who insists on his view of the world.

Armies is a social and political mirror reflecting the views of those who were against the Vietnam War, and also citing reasons for the same, like the increased tax rates to fund the war. Along with social significance, historical significance is prominent throughout the book. It is visible when the plan to march into Washington is explained. Mailer gives details of the plan and also explains what occurred during the march. The Vietnam War was a very significant point in United States' history and those on the home-front like Norman Mailer and other key persons were equally historically significant. Alfred Kazin in an article, "The Trouble He's Seen", in *The New York Times Book Review*, called it "A work of personal and political reportage that brings to the inner and developing crisis of the United States at this moment admirable sensibilities, candid intelligence, the most moving concern for America itself. Mailer's intuition in this book is that the times demand a new form. He has found it."

Mailer through journalistic fiction also wants the public to understand that the real events cannot be reduced to newscast or to newsprint. His literature provides the multiplex nature of experience. His prose is convoluted, filled with continuous rise and fall of soul, and quite energetic. *Armies* is a counter thrust against mass media. Mailer's thoughts have also transformed as he believes the celebrity and the common man to be equally interesting. This book is rich with brilliantly discerning portraits of the American character. In the last paragraph, Mailer expresses his concern for America now being horribly diseased because of her involvement in the Southeast

Asia war, which earlier was a beauty of magnificence unparalleled (Bufithis 94). Mailer sees the Vietnam War as a way for the "insane [...] center of America" to work out its tacit need for brutal expression (*Armies* 188). This battle is for Mailer a contest of the right of expression against the brutality of the war. *Armies* is thus an example of moral individuals confronting centers of power both as a physical protest and literary dissent.

Because *Armies* describes an actual event using the novelists' tools like metaphor, imagery, and dialogue, the potential for readers to remember the event the way Mailer describes is greater, than the dry "objectivity" of traditional print sources. Instead of just passing over the event as a small hiccup in history, Mailer chooses to describe, the march as important as the Civil War, so that in a few decades, "the event may loom in our history large as the ghosts of the Union dead" (88). Mailer rewrites the history of the event in the way he wishes, claiming that his account, although subjective, has as much validity as the other more supported accounts of the march. Mailer felt that by his literary style he could do more for the cause against the war. This tradition, of a well-researched writing and keeping self in the center by Mailer, was continued in his next work of journalistic fiction.

After a few years, in July 1969, Mailer's attention was drawn to another historical event - the first step of a man on the moon, which lead to the writing of *Of a Fire on the Moon*. This text is most basically described as an account of Apollo 11 from the perspective of an author-journalist Norman Mailer. The book concentrates on the events of the mission as well as on Mailer's own thoughts and questions brought up by Apollo. It was written in a deal with *Life* magazine to allow him to cover Apollo

11. To make the book more interesting, and so as to add a distinctive element non-existent in the vast majority of books on Apollo, Mailer uses a completely different perspective than the personnel at NASA. The book is more a source for the opinions of one man than for technical information on the mission itself as he focuses much more on his own thoughts and views.

Fire is about the poet Aquarius, Mailer's persona, commissioned by a magazine to write a factual description of the moon-shot. Mailer is respectful to the power of the event and 'NASA-land,' "the very center of technological reality" (47) which is almost overwhelming in its power, its complexity, and its effectiveness. But at the same time, he is more repelled by than attracted, to the marvels of science and its technological creations. Mailer calls NASA land to be "an empty country filled with wonders" (103). This book is another example in which he thrusts his egotism, self-display, and his shortcomings upon the readers, both to show his essential honesty as well as his unexpected strengths.

In a very unique way, discussing his reaction to the death of Hemingway, Mailer starts this book with details about the space program, and refers to events of his own personal life, including his divorce, Vietnam, and his experience with marijuana. This is quite distracting and takes the reader away from the focus of the book. But it is equally important to provide context, and add an interesting outlook on a story that has been told many times before in a more traditional manner.

In *Armies*, Mailer is quite 'visible,' exposed and central to his fiction, but at times it seems that he is exhausted because of his style of focusing himself at the front. 'He had been left with a huge boredom about himself. He

was weary of his own voice, own face, person, persona, will, ideas, speeches, and general sense of importance' (*Fire* 5). In works like *Miami and the Siege of Chicago, Fire* and *The Prisoner of Sex*, Mailer makes use of third person narrative where the artist is 'like the God of creation, remains within or behind or beyond or above his handiwork, invisible, refined out of existence, indifferent, pairing his fingernails' (qtd. in Radford 120).

Fire, of which three sections have appeared in *Life*, continues the third-person narrative device in the figure of "Aquarius." In this context, Mailer writes

> If we approach our subject via Aquarius, it is because he is a detective of sorts, and different in spirit from eight years ago. He has learned to live with questions. Of course, as always, he has little to do with the immediate spirit of the time, which is why Norman on this occasion may call himself Aquarius. Born January 31, he is entitled to the name, but he thinks it a fine irony that we now enter the Aquarian Period since he has never had less sense of possessing the age. (*Fire* 184)

Mailer is somewhat pessimistic here. For him the "fine irony" is that as the United States is moving towards its greatest achievement, the conquest of the moon and the country seems to be disintegrating. In this regard, Mailer recounts his own battles, the unsuccessful one for Mayor of New York, and the financial pressure which led him to accept a lucrative offer from his old enemy, *Time-Life*.

Usually in Mailer's fiction a structural division and reflection between separate parts happens inside a work which contains two or three books. In *Fire* Mailer has constructed the plot into three major parts: the second middle part, the largest, is accompanied and supported by two other parts, the first and the third. So as to make a temporal and thematic sense, the first and third parts even being separate stories, have an integral role in the narrative. The first part, "Aquarius," defines Aquarius' position as a journalistic observer and the would-be writer of the book; the third part, "the Age of Aquarius," is the last part in which Mailer depicts coverage of the mission, written sitting in front of the television, presenting his thoughts about the meaning of it all. Mailer gives about 300 pages to describing the mechanics of Apollo 11 in the second part, which is supposedly the longest ever description of an event. The long middle part, "Apollo," tells the main story about the Apollo 11 mission to the moon. It contributes more in baffling and amazing the reader who is not a space engineer (Bufithis 101). There is a change in the perspective of Mailer as soon as he is in the belly of NASA (National Aeronautics and Space Administration) and becomes a technocrat who details the reader about the intricate mechanical grandeur of the Apollo-Saturn rocket.

When critically juxtaposing *Fire* with *Armies*, Robert Merrill also finds certain "superficial" self-reflexivity in "this [three-part] structure [which] seems to resemble that of Mailer's better essays, in which he begins and ends with his own relation to an event described in the middle" (1992: 137-138). Chris Anderson, on the other hand, stresses that the narrative of *Fire* is constructed progressively, which

means that the work as a whole provides three "growing" viewpoints and versions of the subject matter:

> Each of the three parts is a different approach to the same material, as if Mailer starts over three times and offers us three different versions of the same book- the first, "Aquarius," an account of his writing of the piece; the second, "Apollo" a more conventional, journalistic account of the mission itself; the third, "The Age of Aquarius," a poetic meditation on what the mission in the end might mean. [...] each section is progressively tighter and more synthetic, an increasingly more satisfying mastering of the material. (1987: 90)

The plot of *Fire* is the plot of NASA-land i.e. to go to the moon and return. But the inability of the NASA and astronauts to explain the reasons of their landing on the moon itself suggests the failure of this plot. This failure was felt by Aquarius as well as the people who looked at its climax on television. The actual plot emerges as a conflict between science and poetry, NASA and Aquarius. *Fire* is a stunning achievement due to its most impressive and detailed description of the sections dealing with the Vehicle Assembly Building at Cape Kennedy, the blast- off of Saturn –Apollo, and the craters of the moon.

This book is abundant with technological details of the complexity, power, and realities of the NASA-land. Mailer shows the NASA-land to be full of machines, rather computers, which have millions of parts, with prefect

designs for smooth conduction, buildings being gigantic like cathedrals, and other minute descriptions making the chapters all the more interesting. Mailer tries to put in every detail of the flight he has monitored. The poet Aquarius believes that no one can remain unimpressed when the great rocket leaves the launching pad to journey into space. Mailer makes use of both technical details as well as his imagination so as to link it to the human world.

The second plot of the narrative, apart from the moon flight, is the process of becoming of the book. Mailer believes that the writing of scientific events "begins with legends and oversimplifications" but then "the same ground is revisited, details are added, complexities are engaged, unanswerable questions begin to be posed" (*Fire* 155). Mailer "goes through the most crucial events of the moon voyage and landing twice, first imaginatively outside and then inside the events" (Landow 1986: 147). So Mailer holds that a nonfictional story can be told again and again, without ever being completed; with details to be added every time it is told. Similar to this, Mailer's notion in *Armies* is that "an explanation of the mystery of events at the Pentagon cannot be developed by the methods of history – only by the instincts of the novelist" (*Armies* 255). In the long middle section of "Apollo," Mailer is "insisting that the strangeness and complexity of the world can never be adequately accounted for by a strictly rationalistic epistemology" (Wenke 1987: 178). Aquarius also concludes that to cope with the large variety of confusing daily experiences, "the services of the Novelist" must be added to the Navigator (*Fire* 157).

The ending of *Fire* leaves the reader unsatisfied. Aquarius is in the Manned Spacecraft Center at Houston sniffing away at a small moon rock hermetically sealed

within two layers of glass, giving no conclusion. Mailer seems to have discovered more about astronauts than about the moon. Astronauts are pioneers but at the same time their language is stale, cliché-ridden, infused with 'computerese' (Bufithis 103). They are 'saints' as well as 'robots' and have become living tools of NASA. They are not rebellious and unalienated. Mailer here has imaged the Devil as the embodiment of "electronic, plastic, surgery and computer" *(Fire* 469).

Describing astronauts, Mailer says that these astronauts are kept behind the glass screens so as to protect them from germs, and could be seen always from a distance. They interchange their roles with the others and function effectively, and can change their parts like machines they design and operate. The decisions taken are of the group and not the individuals. There is a vast bureaucracy, a host of contractors, an army of scientists and engineers, who work day and night like machines devoid of emotions, not giving space to any kind of friction between them. Mailer even calls them 'WASPs.' One of the astronauts, Neil Armstrong, is the type-character, coming from a small town of Ohio, being poor in the beginning, hardworking, full of determination, having courage to face all difficulties, and who now has become the biggest of all pay-offs and the first man to walk on the moon. These astronauts wear plastic helmets and protective space suits being the ultimate impressions of the scientific man.

Further, Mailer talks about the language used by the astronauts which is the language of the 'impersonal world of technology.' Kernan calls this language to be 'so neat, so flatly delivered, so patently manufactured on Madison Avenue for the event that it reverberated with not even the slightest heartfelt spontaneous delight of a man doing

something truly extraordinary' (qtd. in Harold Bloom 149). Mailer focuses on the use of jargon in NASA-land i.e. "computerese." The use of "we" is discouraged. "A joint exercise has demonstrated" becomes the substitution. "Other choices" becomes "peripheral secondary objectives." "Doing our best" is "obtaining maximum advantage possible." "Confidence" becomes "very high confidence level." "Ability to move" is "mobility study." "Turn off" is "disable," "turn on" becomes "enable." Some other technical terms used are EVA for "extra-vehicular activity." PTC meant "passive thermal control." VAB stood for Vehicle Assembly Building. Computers were at the heart of Apollo 11. Finally, Mailer has to agree that NASA being so consistent and coherent intensely is in a condition of Homeostasis and needs no purpose outside itself.

Not only Mailer but Collins (the astronaut) also has doubts about why they are landing on the moon, "It's been one of the failings of the Space Program ... that we have been unable to delineate clearly all the reasons why we should go to the moon" (*Fire* 243). Thus turning towards its own composition and meaning-making, *Fire* tries to make sense of our "unreal" reality, foregrounding the problems of representing it, and implying its own failures to succeed completely in this complex project.

In this work the central dramatic struggle is Mailer's attempt to transform the event into his book. The effort is to bring the world of fiction to a factual event, that is, re-creating and exploring an event in one's consciousness and finding a meaningful shape and substance. Part I of the book indicates that Mailer finds the Apollo mission particularly suitable to his character and methods. As a journalist "It would be as easy to go to the Amazon to

study moon rocks as to write a book about these space matters, foreign to him, which everyone would agree is worth a million dollars" (*Fire* 6-7).

Fire is the result of reconstruction from the secondary materials, NASA manuals and transcripts, interviews, and television. Mailer says "Aquarius was in no command module preparing to go around the limb of the moon, burn his rocket motors and brake into orbit, no, Aquarius was installed in the net of writing about the efforts of other men" (*Fire* 260). It is a novel told entirely in an unrelentingly close first-person narrative. Some sections include no reference to who is currently being referred to as the protagonist.

It was the subject he had not thought about since graduating in aeronautical engineering from Harvard. Many critics thought that Mailer's personal philosophy was not ready to easily accommodate the role of technology. Hillary Mills, in *Mailer: A Biography*, states that Mailer was reluctant to write on this subject as it was "beyond the boundaries of his own first-hand observation, and the closest he ever came to the moon was, as we all know, his television screen (354).

Like *Armies*, *Fire* searches for an appropriate form and vision in order to communicate its complex idea and message, although it also never achieves any final answer or closure. In the last pages of *Fire*, Aquarius experiences a kind of metamorphosis or transformation in himself, finally turning technical and scientific explanations into poetic and metaphorical ones. As John Hellmann puts it, Mailer constructs the third part of the book, "The Age of Aquarius," as "the search of its author-protagonist for an ending, a final meaning, to the book and its subject" (1981: 55). On the last page of the book Mailer-Aquarius

is seeking some starting point, some coherence, and a clarifying metaphor which would work as a "key" to the whole. This last part of the text also suggests that it is an age of endings and new beginnings. This is symbolized when Aquarius and his old friends gather for the burial of an old car, a representative of the technology of the past, of this age, and of the space program, but that car is painted to be "an artifact," and is entitled "Metamorphosis" (*Fire* 464), still in a hope for both the past and the future.

To make it more practical and realistic, Mailer modifies his romantic vision of heroism turning towards accommodating it to the astronauts, and the purposes of the space program. But by the end of writing Mailer is about to transform "After the moonshot, this was the first time I thought that maybe they were gonna win because they deserved to win, because they have been working harder at their end of the war, than we have" (Mills 352). Aquarius has a feeling that it is "a meaningless journey to a dead arena in order that men could engage in the irrational activity of designing machines which would give birth to other machines which would travel to meaningless places ..." (*Fire* 260).

Fire has represented science in the forms of NASA and Apollo 11. Here Mailer's aim is to give a lively as well as factual detail of the moon landing, which he has done very perfectly but can't help criticizing the mission for its meaning and banality. For him, "something was lacking, some joy, some outrageous sense of adventure" (*Fire* 260). The interesting aspect of this book is that Mailer makes an attempt to give the form of literature to otherwise non-romantic, flat, facts of science. Actually, it is the coming together of a poet and the technicality of the mechanical

world lacking in mystery and any kind of subjectivity, all these features being strange to prose writing.

No doubt Mailer has dealt with many real events in the past in his nonfiction like *Armies, The Naked and the Dead, Why are We in Vietnam*, but dealing with this kind of reality handicapped him since the beginning of writing this assignment. Because he couldn't avoid the facts of NASA preventing the use of his own fictional world as well as his literary techniques, so he calls this book and this mission of its writing 'the Armageddon of Poetry" (*Fire* 150). Mailer impresses upon the difficulty he is finding in the expression of the subject. For him all what is happening in *Of a Fire on the Moon* is ineffable. He writes that the reporting on this process is "too complex to be reported for daily news stories by passing observers" (*Fire* 88). When this happens the actual demonstration of Mailer's subject shifts to the subject of writer, and his relationship to the audience. Mailer finds himself in a difficult rhetorical situation. The experience of moon shot is "almost impossible to write about," (*Fire* 4) being so peculiar and complex. Mailer also feels that conventional journalistic techniques like interviewing "could be misleading." Mailer will "approach" the astronauts "via Aquarius" (*Fire* 4). Mailer discusses such problems in *Armies* also. For him, the march to the Pentagon is "an ambiguous event whose essential value or absurdity may not be established for ten or twenty years, or indeed ever" (*Armies* 67).

It is observed that his narrative is eschewed by the hard facts in forwarding the verbatim transcripts of the research in the NASA-land. Mailer puts in an artist on the scene, a persona of the poet Aquarius who has "learned to live with questions" (*Fire* 4). Aquarius is very old-fashioned,

very standard romantic poet, who has landed in a world although real but for him, full of mystery and uncertainty. He is quite suspicious of reason and science, and has a great distrust of machinery. Mailer describes the people in and outside NASA-land, giving a careful description of the objects with variety and accuracy, using his excellent craftsmanship. Along with that he also analyses his own thoughts and feelings so as to give meaning to the landing on the moon, and bind the abstract world of science to the world of men.

To Christ Anderson, *Fire* appears to be the most representative of Mailer's journalistic fictions as it is his most self-reflexive work. He also comments "rather than write about his subject, [Mailer] writes about his writing about the subject," and "[t]he process of writing the book becomes the subject of the book" (1987: 92). Anderson also observes that Mailer "often tells the story of his effort to word the wordless; unable to describe the event itself, he describes himself in the act of description" (1987: 89).

His skepticism is visible from the very first question he asks the first person to be interviewed at NASA, Dr. Robert R. Gilruth: "Are you worried, Dr. Gilruth that landing on the moon may result in all sorts of psychic disturbances for us here on earth?" (*Fire* 350) The buildings of NASA are bleak and windowless, usually placed in some barren setting, its atmosphere air-conditioned, its procedures developed from abstract rules rather than from human needs. Mailer contemplates often on "the psychology of machines," and what this infusion of technology means to humanity on a metaphysical level. This question captures Mailer's imagination, and therefore this is generally what he focuses on during the novel.

In *Armies*, Mailer suggests that America has lost its soul to "a worship of technology," for Vietnam is a technological war which aims paradoxically to destroy the mystery that is at the core of America itself as a Christian nation- America is burning "the bleeding heart of Christ" in Vietnam (*Armies* 188). Similarly, Aquarius contemplates before the launching of the rocket: "Man was voyaging to the planets in order to look for God. Or was it to destroy Him?" (*Fire* 79) Mailer also writes "was the voyage of Apollo 11 the noblest expression of a technological age, or the best evidence of its utter insanity?" (*Fire* 382) Hilton Kramer in 'Book World' wrote "This fundamental ambivalence about the role of technology in the future of human culture is the crux of Mailer's book." Alfred Kazin also perceives that *Fire* is "a book about a novelist trying to write instant history" (238).

Moreover, it is clear that a muted autobiography of Norman Mailer runs through his works. *Armies* is a big novel about America, a work which has been his proclaimed ambition to write for the last 10 years. It is a successful and reaffirmed attempt of the novelistic approach to experience. 'Mailer' in *Armies*, gives a subjective vantage point to express his concerns about America. He has enriched the narrative with various novelistic devices and creative reconstruction. Mailer departs from the 'fetish with factology' (*Armies* 99).

While appreciating the writing style of Mailer, David Lodge, in *Contemporary Literary Criticism*, says that 'the effect upon his style is to open his paragraphs to a great variety of tones and vocabularies, each modifying and competing with the others …' (1975: 322). Mailer's presentation of himself as a character in *Armies* and *Fire* has been interpreted by Charles Nicol: 'he was not so much

trying to establish the importance of art and the artist in the public imagination as he was trying to create self-recognition in that imagination' (*Contemporary Literary Criticism* 1980: 323).

In the process of altering the contemporary consciousness, Mailer changed his method and started writing about himself as a central character. According to Laura Adams, as stated in an article in *Contemporary Literary Criticism*, 'To attempt to separate Mailer's art from his life is to invite the question, "What is his art if not the creation of himself?"'(1979: 340) It can be interpreted that during this period of growth, Mailer's life and art grew together significantly. Mailer's hero or the hero of the age we are living in, is a normal human being 'who rises above the beast in himself, to outweigh and redeem his failures' (Ibid. 341).

It has been observed that these narratives have, through the use of tools of character and narration, concentrated on the man vs. machine dilemma, not in the autonomy vs. manual operational aspect of this class, but in the core metaphysical ramifications of this battle on the future of mankind. Mailer first discusses the political event of the march to the Pentagon in *Armies*, then brings Apollo 11 into the context of the counter-culture 60's, and lets us know exactly what he thought about it. Mailer's ego seems to get in the way and his thoughts are quite disdainful. The questions he raises are valuable, and the reader cannot help but contemplate his or her own responses. Through this way of depicting things it can be interpreted that the events are developing a style and structure almost impossible to write about. In each of Mailer's journalistic work, the focus on the consciousness of characters as they view facts, rather than

the objective view of facts, provides an underlying unity to this literature.

Mailer has tried to bridge the gap between journalism and literature. In *Armies* Mailer reiterates his sense of the importance of literary contributions in shaping the events of the day and in the power of imagination as a source of transcendence. For instance, early in *Armies*, he tries to dismiss the need for his own active involvement in the protest activities by pointing out that "one's own literary work was the only answer to the war in Vietnam" (*Armies* 9). Summing up his life-long new-journalistic writing in a sentence, Mailer says that "it's all fiction," and further contends that "the historian and the novelist are both engaged in writing fiction," with the only difference being "that the historian uses more facts, although they can never be numerous enough to enclose the reality" (*The Spooky Art* 154). It was also true that after *Fire*, Mailer gave up the style of third person writing, as he was worn out by it and says "I didn't like my own person in it-I felt I was highly unnecessary" (qtd. in *Mailer: A Biography* 355). He also, after *Fire*, didn't make any attempt at journalistic writing.

CHAPTER 5

A Critique of Crime and Execution in Modern Society

CHAPTER 5

A Critique of Crime and Execution in Modern Society

Post-World War II non-fictional literature included many authors who began as fiction writers but later made successful attempts at writing real life narratives. This gradually led to the blurring of boundaries between the genres of literature and journalistic writing as well as fiction and non-fiction in a number of works. James N. Stull argues that this development is an expression of the post-war writers' desire to define the world around them and their own place in it (54). Moreover, there was a boom of true crime novels at that time. This chapter focuses on Truman Capote's *In Cold Blood* (1966) subtitled 'A True account of multiple murder and its consequences,' Norman Mailer's *The Executioner's Song*: 'A True Life Novel' (1979) and Don DeLillo's *Libra* (1988), being the popular texts dealing with the highly sensational theme of murder and true crime.

These works of art have marked a watershed in contemporary American literature in their attempt to mingle factual reportage with novelistic style. These authors have kept in mind that the way to a criminal is through his mind. They are enriched with an extensive

research of the criminal minds and their backgrounds. Authors in these texts use actual crimes and real criminals. They can be fairly factual or highly speculative and heavily fictionalized. Some works are written as "instant books" so as to capitalize on popular demand while others reflect years of thoughtful research and inquiry. It is a distinct feature of the modern genre, focusing on murders, to highlight the biographical treatment of criminals and victims. It attempts to explain criminal psychology, and descriptions of police investigations and trial procedures in narrative form.

In narratives different views about elements like narrator, plot, description, and characters given by different theorists, are so closely intertwined that one can never be studied in isolation. It is only through comparative analysis of narratives that one can find convergences and divergences. The main theme dealt with in *In Cold Blood* and *The Executioner's Song* is the multiple murders, and the subsequent execution of the murderers. *Libra* deals with the basic themes of conspiracy related to the assassination of the American President, John F. Kennedy, by Lee Harvey Oswald, and the role of the media in highlighting this contemporary event. Various elements of narratology have been used for better understanding these themes.

As an example of novel-length case studies of the journalistic fiction genre, Truman Capote's *In Cold Blood* (ICB) could not be ignored. Capote calls his work the first of its kind: a "true account of a multiple murder and its consequences" that is not only factual, but also interesting to read. This novel has combined the awesome power of truth with the techniques of fiction writing and is an attempt at creating a genre that can accomplish

more than either fiction or nonfiction could accomplish independently. This chapter aims to study Capote's use of simple journalistic techniques in his dialogue, selection of description, choice of detail, and his use of symbols, along with his most prominent technique of omniscient narrator's perspective in *In Cold Blood*. In his biography, *Truman Capote*, Gerald Clarke quotes Capote as saying:

> Journalism always moves along a horizontal plane, telling a story, while fiction-good fiction-moves vertically, taking you deeper and deeper into characters and events. By treating a real event with fictional techniques (something that cannot be done by a journalist until he learns to write good fiction), it's possible to make a kind of synthesis. (qtd. in Hamilton 3)

The assembling of ideas, organization of thoughts and events, and the order in which a character's perspective is included and events unfold, are all key parts of a narrative structure. Capote had thought of writing a book incorporating novelistic techniques in a nonfiction narrative for several years before the Clutter murders. He claimed that even from the time he began writing professionally, it seemed to him that "reportage could be forced to yield a serious new art form: the 'nonfiction novel'" and that "journalism is the most underestimated, the least explored of literary mediums" (qtd. in Plimpton, *The Story* 2). Capote felt that journalism was unable to accurately articulate truth on the specific scale, so he turned to literature to find some meaning in these

murders on an artistic as well as universal level. Clarke also observes about Capote: 'Another writer might have laid emphasis on Holcomb's small-town closeness and the warmth and good-heartedness of its citizens. Truman chooses instead to pick up a thread from his fiction and to dwell on its isolation' (Clarke 358). In *In Cold Blood*, Capote was attracted to the story of crime and also the area and people.

In Cold Blood, on its release in January of 1966, became an immediate international bestseller. Earlier, it had appeared in installments in *The New Yorker* magazine in the September and October issues of 1965. Sale of these issues broke all records for the magazine. Readers were mesmerized, in spite of the fact that there were no surprises. Through painstaking accumulation of minutiae, *In Cold Blood* agonizingly anatomized a multiple murder, and in the process brought literary life to six dead people. They were the four members of the prosperous Clutter family of Holcomb, Kansas, and their killers, Perry Edward Smith and Dick Richard Hickock, who were executed in 1965.

In Cold Blood begins with a glimpse of the Western Kansas landscape, its stark beauty and remoteness. Capote gives a description of Herbert Clutter, who was quite intelligent, organized, and efficient. He had progressive ideas, and had amassed a tidy fortune in an honest way by toiling hard and using his wits. Capote shifts back and forth from the Clutters to the killers as the climax builds up towards the terrible November night in 1959 when the murders took place. Herbert Clutter's family included good looking children, each with a definite and interesting personality, Nancy being loved by everyone; Kenyon is smart, but an introvert. Bonnie is the matriarch

of the family. Capote introduces the entire Clutter family and provides a layout of the Clutter home place. Other important characters are Susan Kidwell, Nancy's best friend, who would be the first to find the Clutters' bodies, and Bobby Rupp is Nancy's boyfriend, who was the last to see them alive on Saturday night. Then Capote shifts to the killers, Perry Edward Smith and Dick Hickock, who were occupied with their terrible plans. Capote unveils the killers, who are as opposite of the Clutters as persons could be. They have chaotic lives because of the scattered families that they had abandoned.

In Cold Blood was a literary sensation both critically and commercially. Because of its overwhelming success it was translated into twenty five foreign languages and even made into popular and highly regarded films, *Capote* (2005) and *Infamous* (2006, an American drama film). Capote is a 2005 biographical film about Truman Capote, following the events during the writing of Capote's non-fiction book *In Cold Blood*. Philip Seymour Hoffman won several awards, including the Academy Award for Best Actor, for his critically acclaimed portrayal of the title role. The movie was based on Gerald Clarke's biography *Capote*. *Infamous* covers the period from the late 1950s through the mid-1960s, during which Truman Capote researched and wrote his bestseller *In Cold Blood*, a subject which was covered a year earlier in the film Capote. In comparing *Infamous* to *Capote*, David Thomson of *The Independent Review* asked, "What does it have that's different? ... [It] has a gallery of Truman Capote's Manhattan friends, people who adored him without ever quite trusting him These cameos give a tone-perfect sense of Capote's life before *In Cold Blood*. He is placed

as the phenomenon of culture, celebrity and outrage that he was."

Capote highly relied upon his memory so as to take notes of interviews afterwards. Because of this people doubted the authenticity of the information provided. Capote had investigated extensively the lives of victims, killers as well as the crime. He met a number of murderers to gain a better understanding of the criminal mentality. Capote described his work to be an imaginative narrative reporting, new both to journalism and to fiction (Garson, *Truman Capote* 143). The narrative read "like a novel" largely because of the use of scene-by-scene reconstruction instead of historical narration, the ironic heightening of dialogue, and the skillful manipulation of point of view (Hollowell 70). He chose the scenes and conversations with the most powerful dramatic appeal.

In this rigorous research, Capote was also accompanied by his childhood friend, Nelle Harper Lee, an author and research assistant. Regarding the research Capote conducted, he tells, 'to train myself, for the purpose of this sort of book, to transcribe conversations without using a tape recorder After doing these exercises for a year and a half, for a couple of hours a day, I could get within 95 percent accuracy, which is as close as you need' (qtd. in Plimpton, *Truman Capote* 202). He had to "relive the experience with the participants in order to acquire the necessary depth of perception" (Nance 169). He spent a lot of time with both the criminals, especially with Perry. Capote traced the entire escape route that Smith and Hickock had taken in the six weeks following the Clutter massacre, driving from Miami to Acapulco. He compiled "six thousand pages of notes and an accumulation of boxed and filed documents bulky enough to fill a small

room to the ceiling" (ICB 176). With the execution, the story had reached its climax. Capote finished writing and published the results of his labor in four successive issues of *The New Yorker*, September 25 through October 16, 1965. In 1966, the material was gathered together in book form. Whatever Capote thought he was attempting to do, he did not believe he was describing a "contemporary reality invested with fictive power" (Zavarzadeh 222).

In Cold Blood also won the Edgar Allan Poe Award from the Mystery Writers of America in 1966. The public embraced this book enthusiastically. It depicts that the writer must balance the occasionally competing claims of aesthetics and ethics, blending factual accuracy with artistic expression without damaging either. *In Cold Blood* represents a change in point-of-view that grows stronger throughout Capote's career: "[Capote] had gradually shifted ... from the role of protagonist to that of a highly detached narrator. He had moved from a private dream world to one that was identifiable, topical, even journalistic" (Nance 124).

Quite similar to *In Cold Blood, The Executioner's Song* (1978) by Norman Mailer depicts the events surrounding the execution of Gary Gilmore by the state of Utah for the murder of two innocent people. It is a 1980 Pulitzer Prize-winning novel that presented the criminal life of Gary Gilmore and the resulting execution which was the first in America since the Furman v. Georgia decision. The book is an account of the last nine months in the life of Gary Gilmore, representing the period between the day in April of 1976 when he was released from the United States Penitentiary at Marion, Illinois, and the morning in January of 1977 on which he was executed by having four shots fired into his heart in the Utah State Prison at Point

of the Mountain, Utah. The title of the book may be from a play on "The Lord High Executioner's Song" from Gilbert and Sullivan's The Mikado. "*The Executioner's Song*" is also the title of one of Mailer's earlier poems, published in Fuck You magazine in September 1964 and reprinted in *Cannibals and Christians* (1966). This book of Mailer has also been made into a famous film, *The Executioner's Song* in 1982. The film is directed by Lawrence Schiller. Tommy Lee Jones won an Emmy Award for his searing performance as wanton killer, Gary Gilmore, in this film. Like *In Cold Blood* and *Libra*, it is a novel which takes for its incidents and characters real events from the lives of real people.

The narrative begins when Gary Gilmore is paroled after having spent eighteen years behind the bars. He settles down in Provo, among relatives, who help him live a normal life. But he rebels and his rebellion is initially socially acceptable as he indulges in petty crimes like stealing, fighting, excessive drinking. He wrestles, brags about stabbing a black man and picks fights that become increasingly brutal. He even attempts to kill Pete Galovan, because Pete accuses him of fostering unacceptable sexual impulses when he befriends a teenage girl. Then finally he kills two residents of Provo: Max Jenson (service station attendant) and Bennie Bushnell (motel clerk) on July 19, 1976. He is arrested on July 21, 1976 and sentenced to death, but in response he demands that the sentence be carried out. He refuses to cooperate in any attempt to appeal his death penalty sentence and even challenges the system to put actions to their words. He opens up the flood gates for implementation of death penalty in the decades that were to follow. *The Executioner's Song*

captures the life of a man determined to murder, and to eventually demand the end of his life.

Don DeLillo's *Libra*, named after the astrological sign symbolizing balance and harmony, became a high hit, making *New York Times* Best-seller list in the summer of 1988, and was also chosen as a main selection by the Book-of-the-month Club. It also won the Irish Times-AerLindus International Fiction Prize and was nominated for the American Book Award. It recreates the traumatic moment in Dallas, the "seven seconds that broke the backbone of the American century" (*Libra* 181). It is "a work of the imagination" based on the real life of Lee Harvey Oswald, the events surrounding America's 35th President, John F. Kennedy's assassination on 22nd Nov 1963 in Dealey Plaza in Dallas, and thereafter the murder of Oswald by Jack Ruby. *Libra* is also "a way of thinking about the assassination without being constrained by half-facts or overwhelmed by possibilities, by the tide of speculation that widen with the years" (*Libra* 458). The Kennedy assassination by Oswald is an event that has generated an astounding amount of conspiracy theories. Oswald died when on 24th Nov' 1963, he was being led through the basement of Dallas Police Headquarters to be transferred to the County Jail, when a Dallas club operator, Jack Ruby shot him.

Libra 'is meant to suggest how uncertain "reality" becomes as a result of the media's penetration of life' (Douglas Keesey 10). Oswald killed Kennedy in anticipation of the attention he would receive from television and press. Actually by making such sensations out of men who commit violence, like Gilmore in *The Executioner's Song*, Perry and Dick in *In Cold Blood,* and Oswald in *Libra*, the media encourage others to take the same route to fame. In

many ways, the Kennedy assassination can be defined as a postmodern event, an occurrence that has defied closure by generating a mass amount of data without a narrative to structure it. The search for "truth" has left us with a profusion of literature espousing conflicting versions of what might have happened. Apart from *Libra*, the same facts also became the background of Oliver Stone's film *JFK* (1991) and two of the famous novels, namely James Ellroy's crime fiction novel *The Cold Six Thousand* (2001) and *Reclaiming History: The Assassination of President John F. Kennedy* (2007) by attorney Vincent Bugliosi.

In an interview, DeLillo says, "fiction rescues history from its confusions" by providing "a hint of order in the midst of all the randomness" (DeCurtis 294). In other words, fiction can provide comfort through narrative structuring and closure. *Libra* has provided this comfort in that it has structured an event that otherwise seemed to defy structuring, and given an ending to an event that otherwise seems to defy endings. History too can provide the comfort of narrative structuring if it applies literary techniques, but it cannot provide any final answers, as it claims to do. *Libra* emphasizes the importance of narrative for making sense of historical events.

Libra was Oswald's sun-sign, and through the author's masterly treatment, it serves to symbolize Oswald's precarious search for balance in American society, a search that ends with a tilting of the scales towards excess and destruction. The book begins with Lee Oswald as a boy in Bronx who is a misfit and a chronic truant. Then there's a brief intermission of a glimpse into the book-filled, document-choked study room of Nicholas Branch, who is writing a secret history of the assassination of President Kennedy. David Cowart in *Don DeLillo: The Physics of*

Language, writes that the Kennedy assassination has been read as "the first postmodern historical event" that "changed America, put an end to its innocent conviction of invincibility, give birth to the culture of paranoia" (2002: 95). It is followed by an introduction of Win Everett, a C.I.A. man semiretired, so-called, on account of his overzealousness in the matter of Cuba. In April 1963, we find Everett framing his plan for an "electrifying event" that will bring the anti-Castro movement back to life. This novel (like the other two under study in this chapter) blends historical fact (the events in Dallas in 1963) and fiction (the details of the plot to scare the President into attacking Cuba). The real-life characters intermingle with DeLillo's own creations.

The narrative structure in *In Cold Blood* was well chosen from both journalistic and artistic point of view. It is written in small sections. The abrupt scene-shifting often has the effect of an up-to-the-minute news bulletin. The most obvious advantage of vignette structure, cinematic or not, is the way it enables Capote (also Mailer and DeLillo) to reinforce the contrast between victims and killers by repeated jolts from one group to the other, especially in the section preceding the murders. By doing so, both groups are fully introduced to the reader and character development is presented at the same pace. By allowing the reader arbitrary a piece of information, Capote foreshadows the eventual meeting of Mr. Clutter and Perry Smith, who are the main protagonists.

In Cold Blood is a narrative divided into four parts. First, 'The Last to See Them Alive,' describing the scenery of Holcomb in Kansas, characters like the Clutter family (the victims), Bobby Rupp, Perry Smith and Dick Hickock. and the murder of all the members of Clutter family;

second, 'Persons Unknown,' showing the beginning of the hunt for the killers, going into the past for studying the backgrounds of the criminal minds; third, 'Answers,' about confession by murderers and uncovering the details of the murder; and lastly, 'The Corner,' which is named after the prison in which these murderers were kept during the trial and the execution. These headings, like the title of the book itself, have a journalistic flavour and are, indeed, taken from verbal matrix of the content rather than from Capote's imagination.

Order is the relationship between the sequence of events in the story and their arrangement. The narrator may choose to present the events in the order in which they occurred. It can be either analepsis or flashback (introduction into the narrative of material that happened earlier in the story) or prolepsis or flash-forward (introduction into the narrative of material that comes later in the story). Analepsis is more prominent in the texts under study. In chapter II, the author takes the reader back to the past lives of Dick and Perry, showing in detail the kind of childhood they had gone through. As Capote's book was constructed cinematically, with swift cuts from the killers, to the family, to the police, flashbacks from the trial to the crime itself, soprolepsis is rarely visible in these texts. Instead Capote uses the technique of foreshadowing to infuse meaning into the real life facts and actions, and also to strengthen the theme of death. This technique is seen in part one, where Capote repeatedly foreshadows the Clutters' imminent deaths: '[t]hen, touching the brim of his cap, he headed for home and day's work, unaware that it would be his last' (ICB 13) and 'she set out the clothes she intended to wear to church the next morning: nylons, black pumps, a red velveteen dress- her prettiest, which

she herself made. It was the dress in which she was to be buried' (Ibid. 56).

In Cold Blood's plot is a subject that deserves discussion. The novel is not written in complete chronological order as Capote refers to events taking place before the date on which the novel begins. Like Capote discusses occurrences in the killers' childhood after the murder has taken place. These out of place events supply the novel with a nice flow making them more interesting. References to past events help the reader to more easily comprehend the sometimes complex storyline. The way in which Capote relays key happenings in the novel is interesting. For example, the first time the reader is informed of how the Clutters are murdered is after the criminals are detained.

The Executioner's Song, on the other hand, is an extremely long, complex and fragmented narrative, involving different voices and conflicting viewpoints upon the subject matter. Mailer makes use of mosaic structure and multiple scenes. Mailer structures it into two halves i.e. Book I, "Western Voices" and Book II, "Eastern Voices." "Western Voices" is a kind of mythical narrative of the romantic west as presented through effectively simplified figuration and rhetoric. Apart from introducing the novel with a very brief one page long reminiscence of Gary from childhood by Gary's cousin Brenda, Mailer initiates his story when Gary is released on parole from a prior robbery charge, and is returning to the city of Provo to start afresh.

The first tenth of 1075-page novel is dedicated to Gary's attempts and consequent failure to adjust in the society of his new hometown: one chapter is devoted to a brief retrospective followed by a thorough description of Gary from Brenda's point of view, succeeding with one

self-reflective chapter about Nicole (Gary's Girlfriend). A major part of the first half deals with the encounter and resultant relationship between Gary and Nicole. In the next two hundred pages Mailer briefly accounts for the murders followed by Gary's apprehension and arrest. Gary's time in prison, before and during his trial, is based on the letters he sent to Nicole. The remaining parts of the book introduce Mailer's ambitious reconstruction of the trial process. The "Eastern Voices" part of the novel throws light on the exploding media attention following Gary's decision to be executed and the ensuing trial. This structural technique creates for us the character of the convicted murderer, Gary Gilmore, dramatically, and is cumulatively effective.

Indeed the two works, *The Executioner's Song* and *In Cold Blood*, highlight the attempts made by novelists to investigate the details of brutal murders, and document the events surrounding the crime. But Mailer's work differs from *In Cold Blood* in that Mailer, unlike Capote, focuses much more on criminals than he does on victims. According to literary critic, Mark Edmundson, Mailer's scant treatment of Gilmore's victims reveals a bias in his work. Edmundson contends that Mailer "... makes [Jensen and Bushnell] seem small. They don't rate the tragic themes that Gary... get[s]" (ES 442). While Capote's *In Cold Blood* was catalogued under the Dewey Decimal System as a "Homicide Criminology," *The Executioner's Song* was listed under "Fiction" (Kellman 127). In her 1996 dissertation, "Courtroom as Forum," Ann Algeo asserts that the text is somewhere in between fiction and non-fiction and furthermore, that, "... all descriptions of trial proceedings are fictional whether completely imaginary

or based on personal observation, trial transcripts, or newspaper accounts" (3).

Libra is not as lengthy as *The Executioner's Song*, but divided into twenty-four chapters, of which half tell the story of Lee Harvey Oswald's life between 1956 and 1963. The chapters are entitled after the places where he spent these seven years. The remaining chapters cover the plot for assassination of John F. Kennedy, the then President of America, and are named after the dates that mark its development between April and November 1963. A temporal gap inevitably occurs between the two narrative strands that run parallel to each other, but is eventually bridged, as Oswald comes into contact with the conspirators in April 1963.

The first two chapters and the titles they bear are significant for both the content and narrative strategy of the book. Content wise the first chapter, 'In the Bronx,' clearly points to Lee Harvey Oswald as the protagonist of the novel, and to his status of a misfit, a figure of the underworld riding the subway daily in an attempt to meet other lonely frustrated people. The second chapter, '17April,' throws light on the main reason why Kennedy was killed, showing that it was Kennedy's failure to make amends for the Bay of Pigs Invasion of April 17th, 1961, which resulted in what was probably one of the greatest embarrassments of US foreign policy. These two chapters seem to make of *Libra* another novel with multiple beginnings. However, as the reading advances and the plot unfolds the two beginnings converge, towards the end, in a story that defies ultimate closure and invites the reader to re-think and look for further meaning.

In *Libra*, the assassination scene as a whole is not so much DeLillo's fictional creation as it is his

"meta-representation" constructed on the basis of existing representations and documentary evidences. It is an aesthetically complex blurring of fact and fiction. Oswald is a biographical subject and as a human being almost disappears in DeLillo's complex, ultimately textual "conspiracy metanarrative," in which he becomes "a shadowy figure who lurks in the high window of a book depository, literally and figuratively surrounded by texts" (Kerner 2001: 97, 103). For Stephan Baker, "in a sense, *Libra* is full of authors" (2000: 100). The metanarrative and "mirror plot" structure of *Libra*, therefore, places Oswald among those representations that have actually been produced after the event, in the fictional world of the novel.

Oswald's biography runs parallel to the former CIA agent Win Everett's attempt at "devising a general shape, a life" and constructing "a fiction" or "a plot" about Oswald from various materials, or that "the life of Lee H. Oswald" and "the conspiracy to kill the president" are "two parallel lives" in the mind of the notorious Davis Ferrie (*Libra* 1988: 50, 221, 339). Everett (a fictional character) and Ferrie (a real one) are constructing their plots concerning Oswald and the assassination, making DeLillo's combination of imagination and documentaries extend fruitfully not only to the material, but also to its narrative structuring. DeLillo's vision is closer to actual happenings and the conspiracy, of which Oswald was a part.

Oswald reappears as a high school dropout in New Orleans, as a marine at a U-2 base in Japan, as a factory worker in Russia, and finally as an order filler at the Texas School Book Depository in Dallas. Win Everett is shown surrounded by two former colleagues he trusts most and then other men less predictable, less controllable, as his

plan takes on a life of its own. Nicholas Branch is seen sinking ever deeper in a morass of eyewitness accounts, hair samples, chemical analyses, then the accounts of dreams of eyewitnesses and then 25 years of novels, plays, and radio debates about the assassination. DeLillo reveals his genius by using the same source materials available to anyone else - the Warren Commission report, the usual newspaper articles, and court proceedings. Zapruder film, an important source of information, is a silent, colour motion picture sequence shot by private citizen Abraham Zapruder, as President Kennedy's motorcade passed through Dealey Plaza in Dallas on Nov 22' 1963, unexpectedly capturing the President's assassination. It gave the clearest view and was an important part of the Warren Commission hearings, and the most studied pieces of films in history. DeLillo weaves all these sources into something altogether new, largely by means of inventing, with what seems to be an uncanny perception, and the interior voice that each character might use to describe his own activities. Here, for instance, is a summary of Jack Ruby's movements just before he killed Oswald - a matter of public record, no doubt, but the passage displays a vitality of its own:

> He was running late. If I don't get there in time, it's decreed I wasn't meant to do it. He drove through Dealey Plaza, slightly out of the way, to look at the wreaths again. He talked to [his dog] Sheba about was she hungry, did she want her Alpo. He parked in a lot across the street from the Western Union office. He opened the trunk, got out the dog food and a

> can opener and fixed the dog her meal,
> which he left on the front seat. He took
> two thousand dollars out of the moneybag
> and stuffed it in his pockets because this is
> how a club owner walks into a room. He
> put the gun in his right hip pocket. His
> name was stamped in gold inside his hat.
> (*Libra* 263)

The book is so seamlessly written that it is not merely lifelike but also, in the best sense, novel like. It narrates a story in a skillful manner, with much attention to character. DeLillo makes us familiar with some peculiar habits of the characters. Like Everett cannot make himself go to bed at night without checking that the oven is off, and then sometimes double-checking, and reminding himself as he climbs the stairs that he has in fact completed his check. No doubt DeLillo has chosen such a sensitive theme, that of the assassination of Kennedy, yet he hardly draws out the portrait of John F. Kennedy, the victim. This is because he is aware that most of the readers are already familiar with him. But he constructs a complex and convincing Oswald, rendering him as a "type" we've seen before. For instance, he wants desperately to change the world, but he can't hold a job. He seeks a utopian society of decency and equality, yet he beats his wife.

DeLillo feels that the events sometimes control life, and fate takes over from the chaotic intentions of all the characters involved. He writes:

> Plots carry their own logic. There is a
> tendency of plots to move towards death.
> He believed that the idea of death is woven

> into the nature of every plot. A narrative plot is no less than a conspiracy of armed men. The tighter the plot of a story, the more likely it will come to death. A plot in fiction, he believed, is the way we localize the force of death outside the body, play it off, contain it. The ancients staged mock battles to parallel the tempests in nature and reduce their fear of gods who warred against the sky. He worried about the deathward logic of his plot. (*Libra* 221)

In this narrative there are flashes back and forth in time, and jump cuts between the conspirators and Oswald, who is growing up to become exactly the kind of person the CIA renegades had planned to invent: a malcontent and misfit with a known fondness for Castro and guns. Slowly, dimly, Oswald begins to realize that he is being watched, and that people have designs on his destiny.

Christopher Lehmann-Haupt feels that *Libra* starts with less energy, but gradually gains momentum like thunder. The novel works so powerfully because of 'the seamlessness it creates between the known and unknown, between the actual record and what Mr. DeLillo has invented' (*Contemporary Literary Criticism* 1989: 86). Two threads which knit the facts together are the character of Oswald and the conspiracy theory. Robert Towers also finds that there are two plots that follow each other, the plot of the novel itself and the plot of the conspirators. DeLillo employs rapid shifts of scene and voice, creating the novelistic equivalent of the sixties European films by Godard or Antonioni, although without Antonioni's loose ends (*Ibid.* 90). But the jumps and cuts are so much that

one hardly has time to become absorbed in a particular scene before there is a sudden cut to a very different, equally unexpected scene. This results in a fragmentation of attention and sheer confusion to comprehend what is actually happening.

In an eloquent author's concluding note DeLillo throws light on the truthfulness of the literature in *Libra*: *Libra* is "a work of the imagination" that to many seem "one more gloom in a chronicle of unknowing." He also adds, "because this book makes no claim to literal truth, because it is only itself, apart and complete, readers may find refuge here -a way of thinking about the assassination without being constrained by half-facts or overwhelmed by possibilities, by the tide of speculation that widens with the years" (*Libra*, Author's Note). For Anne Tyler, *Libra* is the richest novel being most complicated, with dual state of characters and a plot line that might be described as herringbone-shaped (*Contemporary Literary Criticism* 1989: 86). Most of the events depicted are unrelated, but have been channeled together very effectively.

In simple words, the killing of Kennedy is the work of assorted anti-Castro activists who, by disguising it as a Cuban-backed effort, hope to provoke an American response more concerted and effective than the Bay of Pigs venture. But Eder writes that DeLillo not putting all this simply disassembles his plots with the finest of jigsaw cuts, scrambles the order about their missions. The chronology goes back and forth, disorienting us (Ibid. 89). This novel uses real names and repeatedly anchors itself in recorded fact because of fast-paced, fragmented presentations and continuous expansion upon the implications of his themes, DeLillo has been known for

deemphasizing plot, and so critics place him with John Barth, Thomas Pynchon, and Kurt Vonnegut.

Moving further, the study of point of view is another method of reaching into the depths of a narrative and to follow the author's aim in writing a text. *In Cold Blood* is told from two alternating perspectives, that of the Clutter family who are the victims, and that of the two murderers, Dick Hickock and Perry Smith. It is believed that Capote presents them without bias. But Perry Edward Smith is Capote's primary focus throughout his six year coverage of the murder investigation, and the story is consumed by this infatuation. Capote strongly identifies himself with Perry, and seeing himself in the protagonist, presents him as George Plimpton writes, "with deeply dimensional sympathy" (Plimpton). A childhood friend of Hersey, author and research assistant, Nelle Harper lee, relates how Capote could not keep from seeing himself in one of his own protagonists- Perry Smith. Lee relates: "Perry was a killer, but there was something touching about him. I think every time Truman looked at Perry he saw his own childhood" (qtd. by Matthew Ricketson).

Both men's (Capote and Perry) early years were nomadic: estranged from their fathers, neglected by their mothers, filled with a "primal hunger" to escape "poverty and obscurity," both possessing talents that "went unrecognized and therefore unencouraged" (McAleer). Not only is Capote and Perry's writing style similar, so is their structuring. Perry's first sentence ends at his birthplace in "Hunting, Elko Count, Nevada ... situated way out in the boon docks, so to speak" (273). Capote begins his testament with, "Holcomb ... western Kansas, a lonesome area that other Kansans call 'out there'" (3). Both have highlighted the desolate environments of their

areas. Perry even wrote him a ten thousand word farewell letter and kissed him goodbye before being hanged. It was also true that Capote gave him a lot of attention. Through his protagonist, the killers, Capote incorporates the reader in their lives at a level of comparison and sympathy, which when they don't get, leads to the circumstances which give birth to tragedy.

Capote masterfully utilizes the third person omniscient point of view to express the two perspectives. The text of *In Cold Blood* offers the reader a Capote absent from the narrative, eliminating all presence of the first person i.e. "me" or an "I" from the text. The non-chronological sequencing of some events emphasizes key scenes. The victims, the murderers, the victims, the murderers-- this is the way the plot moves in more than the first half of *In Cold Blood*. Though an alternating perspective is used, yet the reader is able to assimilate both sides of the story. In part one, for example, "Nancy and her music tutee, Jolene Katz, were also satisfied ..." (24), whereas the next section begins, "The two young men [Dick and Perry] had little in common, but they did not realize it, for they shared a number of surface traits" (30).

Capote is not judgmental for two reasons: it is important for the reader to draw conclusions about the "philosophical-sociological-psychological circumstances of the mass murder," and Capote concluded that there should be no interference with the readers' judgmental process (Reed 107). The narrator, up to the criminals' day of execution, shows no bias whatsoever. For example, about the death sentence, Capote writes, "In March 1965, after [Perry] Smith and [Dick] Hickock had been confined in their death row cells almost two thousand days, the Kansas Supreme Court decreed that their lives must end

between midnight and 2:00 A.M., Wednesday, April 14, 1965" (ICB 336). Being of the genre of journalistic fiction, and so as to fulfill the condition of objectivity, the perspective of *In Cold Blood* is also in a way complicated. David Guest claims that "there are no direct references to Capote in the narrative" (Guest 118).

Capote uses his power as the undetectable storyteller, mostly remaining unnamed while intermittently slipping into different characters' minds, and adding what he himself calls "the reality and the atmosphere of a novel" (Inge 120). This insight humanizes the killers. He chooses to give readers the inner dialogue at this point of the novel, when they are struggling to understand their crimes, rather than when they "couldn't stop laughing" when they "hit the highway and drove east" immediately after leaving the Clutters' house, which Capote does not reveal until two hundred pages after the murder (256). If Capote had dropped his narrator's voice and entered the minds of the killers in that disgusting moment when they acted savagely, readers would have known much sooner how the excited killers felt "very high" from the murders (256). Instead, after the pages in which the search for the killers begins, the author immediately skips to Mexico, where they have been planning the crime for days and can receive more sympathy from the reader.

In *The Executioner's Song*, Mailer's personal voice and language is flat and banal, being radically different from that of the earlier Mailer. The characteristic style and rhetoric of Mailer here becomes more a voice and style of "recording." The author's function appears to be limited to a purely technical gathering of documentary material, and the narrative as a whole sustains an illusion that the story is being told by the people who know Gilmore.

Mailer truly views Gary Gilmore as a self-confident man. When Gilmore is re-introduced to his cousin Brenda in the beginning of the novel, the narrator immediately compares him to a bear (12). His strength is incredible to his cousin, whom, even her husband "had never gripped Brenda that hard" (12). Sometimes Mailer bluntly states that Gilmore is "always so manly" (235). In order to tell many sides of the story, Mailer writes with multiple perspectives, adding the opinions of those he interviewed to his narrator's opinions.

It has been observed that Mailer is not much concerned about Gary Gilmore as Capote is about Perry Smith in ICB. Gary's conduct was violent and criminal even when he was quite young. 'At the age of twelve he was sent to Maclaren School for stealing a car' (ES 467). Even after being released from a correctional home, he indulges into criminal activities like robbery, leading him to be put behind the bars once again for fifteen years. His cousin Brenda and parents make lot of efforts for his rehabilitation so as to bring him back to normal life, but in vain. He is also desperate for 'sex' and he finds complete satisfaction and absorption in Nicole for it.

It is important to note that Gary was 36 years old when he was convicted for the murders. He spent 22 years of his life in correction houses, prisons, and penitentiaries. His nature is due to his abnormal development of his mind. He is not happy with the ways of functioning of correction homes. He states that the 'prison system was not doing what it was designed to achieve. For him it was a complete failure' (ES 303). He does not want to live in a prison, and so make a number of attempts to escape. He is actually in search for an existence which is free of all restrictions.

He loses his patience and faith in social norms quite easily. He is violent with Marge Quinn and Nicole when refused for 'sex'. He is incapable of availing the opportunities. So as to reassert his manliness, he commits murders. His ego has been hurt as he is unable to find Nicole, so kills those whom he finds on his way. Finally, there is a time when he loses the trust of all his well-wishers and is sentenced to death. Suresh Chandra in his book states that Gary seeks to establish himself for an American hero, for having a sound mind even after being in extreme stress; his unwavering readiness to face its consequences in this world; and his views on life, death and thereafter (52).

'Western Voices' is narrated from the point of view of secondary characters in Gary's surroundings. In 'Eastern Voices' the protagonist is the reporter and TV-producer, Larry Schiller, while the secondary characters consist of lawyers and journalists. To indicate different speakers and different points of view following each other, in the narrative, Mailer uses separate paragraphs. Mailer shifts to the salient aspects of the different characters' language while retaining an overall consistency in the spare, loose rhythms of the prose, avoiding any direct, clearly identifiable authorial comment. Occasionally, as in the passage below, it is not clear whether he is the source of the thought, or only of its selection and phrasing:

> Brenda took a good look into his eyes and felt full of sadness again. His eyes had the expression of rabbits she had flushed, scared-rabbit was the common expression, but she had looked into those eyes of scared rabbits and they were calm

and tender and kind of curious. They did
not know what would happen next. (16)

Here the perceptions are all clearly identified as Brenda's
until the final sentence. In the beginning of this passage
it is not clear whether Mailer is reporting Brenda's
articulation of the expression in Gilmore's eyes, or whether
he is articulating what he believes she is indicating by
her reported observations. In such passages the authorial
point of view seems to emerge slightly, without ever quite
separating from that of the character.

On the other hand, many of Mailer's critics such as
Diane Johnson, Judith A. Scheffler, and Joan Didion have
noted the absence of authorial voice in *The Executioner
Song*. Richard Stern remarks in his *Missingeria and
Literary Health*: "Mailer's absence is so pronounced that it
dominates the book like an empty chair at a family dinner"
(qtd. in Merrill 130). Christopher Ricks reflects that "[t]
he author of *Advertisements for Myself* is here advertising
nothing, least of all himself" (209). As already mentioned,
actually it is the presence of Mailer's autobiographical
self in the shape of existential philosophy which is most
noticeable in this "true-life" novel. Mailer himself states
that "[Gilmore] appealed to me because he embodied
many of the themes I've been living with all my life long"
(Merrill 141).

According to Anderson, "the rhetoric of silence is the
central strategy," (1987: 49) in these books. Anderson has
also suggested that in *In Cold Blood* the rhetorical effect
of the silence is twofold. First, we as readers are made to
"assemble" the text ourselves, generating meaning from
the "instructions" implicit in the narrative, and second,

silence requires reading and interpretation, "gapping," always calling for reader's participation. These effects have been far more powerfully used in *The Executioner's Song* than in Capote's book. These gaps in literary texts create suspense, shape the plot, and determine strategic ambiguities. Hellman writes:

> In *In Cold Blood* Capote sees fact as symbols and the portrays them as such; in The *Armies* of the Night Mailer sees a fact, consider any number of possible symbolic values, and then portrays that seeing and consideration. Capote portrays life as significant; Mailer portrays his search for significance in it. Capote presents actual objects that embody meaning; Mailer presents his attempt to elicit meaning upon them. (1981: 42-3)

Further in journalistic fiction, characterization transcends the conventions of traditional reporting with portrayal of people with psychological depth (Mark H. Mass 13). Wolfe described this technique as "... giving the full objective description, plus something that readers had always had to go to novels and short stories for: namely, the subjective and emotional life of the characters" (Tom Wolfe and E. W. Johnson 21). Norman Mailer described Capote's Perry as one of the great characters in American literature. Capote is credited with presenting in-depth characterization of the two killers, their victims, criminal investigators, and selected townspeople. Hollowell also observed that Capote's greatest accomplishment was his characterization of the murderer, Perry Smith.

Literary journalists, Kerrane and Yagoda, have also praised Capote's portrayal of Perry (Smith) and Dick (Hickock). According to them, "For a journalist to re-create events he did not witness requires a prodigious amount of reporting, and Capote could not have written *In Cold Blood* had he not met the two men after their capture, obtained their sympathy and cooperation, and interviewed them for hour after hour" (161). A detailed examination of the portrayal of Perry Smith reveals three things about the nature of this nonfiction novel: the affinity of Smith's character to the character of Capote's fiction; the methods of heightening dialogue and scenes; and the legitimacy of Capote's claims that *In Cold Blood* should be considered literature rather than journalism.

Capote's intimate portrait of the two killers truly breaks ground in the area of crime writing. According to a passage from Deborah Davis' "Party of the Century":

> Truman's interviews with Smith and Hickock transformed his journalistic piece into what he called a "Big Work". They supplied him with all the details he needed to make the story come to life. Hickock had an extraordinary memory that was almost photographic in its accuracy.... Smith offered metaphor. He was a dreamer who had a boyish obsession with buried treasure Truman, who had a talent for getting close to his subjects in the most routine of circumstances, became intimate with these men who had been cut off from every other kind of social contact. (qtd. in Shields 171-173)

Discussing the characters of *In Cold Blood*, Capote felt that some kind of secular predestination was at work:

> There is something so awfully inevitable about what is going to happen: the people in the book are completely beyond their own control. For example, Perry wasn't an evil person. If he'd had any chance in life, things would have been different. But every illusion he'd ever had, well, they all evaporated, so that on that night he was so full of self-hatred and self-pity that I think he would have killed somebody. (Clarke 211)

Nevertheless, to enlarge the scope of the narrative, Capote details the personalities of many secondary characters also, such as Al Dewey, the lead detective from the Kansas Bureau of Investigation, Susan Kidwell, Bobby Rupp, Mr. and Mrs. Hickock, Tex and Flo Smith, Willie Jay, and Floyd Wells.

In *The Executioner's Song*, Gary Gilmore is the central protagonist. The entire text of *The Executioner's Song* is written to lay open the life of Gary. Nicole is Gary's girlfriend. A majority of the secondary characters are static and Mormons who believe it to be their God-given duty to act as Gary's intermediaries, thereby bettering their own chances of inheriting life as gods. Earl Dorius, Cline Campbell, Pete Galovan, and Mike Deamer, the prison officer in charge of the execution, are all fettered by their faith: "He [Mike Deamer] liked to think he had been sent to earth as a person with a mission to do some good for the betterment of society. It was his hope he had

been foreordained to be part of a larger plan" (971). Their function in the novel is twofold: first, to serve as Gary's foils; second, to personify the atrophy that Mailer finds, accommodates, and represses human creativity.

It has been observed that Gary Gilmore is the most unknowable character because Mailer never lets the reader know his point of view. Gilmore "just sat on a piece of machinery off to the side and ate the food in all the presence of his own thoughts. Nobody knew what he was thinking" (55). Every character, with the exception of Gilmore, has free indirect discourse. Even at the time of the first killing in *The Executioner's Song*, Mailer does not indulge in any kind of speculation about thoughts of the killer about this murder, although from time to time he enters into the mind of every other character. In this way, Gilmore is presented as the most mysterious character. The narrative style of *The Executioner's Song* is ungrammatical and improvisational because of the material from the tapes of semiliterate people. According to Frank McConnel, the rhetoric in *The Executioner's Song* has been found to be very much moving (*Contemporary Literary Criticism* 1980: 353).

On comparing and relating *In Cold Blood* with *The Executioner's Song*, Mailer says "Of course I had read *In Cold Blood* and had obviously taken it into account" (qtd. in Plimpton, *Truman Capote* 214), and "Anyone assumed that I did *The Executioner's Song* with *In Cold Blood* in mind" (Grobel 116). On the other hand, Capote had this to say about Mailer's work:

> ES … as far as I am concerned, is a nonbook. He didn't live through it day by day, he didn't know Utah, he didn't

> know Gary Gilmore, he never even met
> Gary Gilmore, he didn't do an ounce of
> research on the book—two other people
> did all of the research. He was a rewrite
> man like you have over at the Daily News.
> (*Capote*, Grobel 113)

Defending the extent of being factually accurate in *In Cold Blood*, Capote himself succinctly puts in: "One doesn't spend six years on a book, the point of which is factual accuracy, and then give way to minor distortions" (Clarke 358). Yet he molds the truth at times. For instance, it was found that the physical appearance of the killers was altered. As George Garrett points out:

> There is the complex matter of fact and
> judgment. When pictures of the people
> involved appeared in the magazines, it was
> clear how much of Capote's descriptions
> and judgments are subjective, literary ...
> later it turned out that they did not do or
> say all the things attributed to them; and
> some things, neither he nor anyone else
> could have known. (473)

But at the same time an anonymous review of the book for the *Times Literary Supplement* noted that "witnesses are more and less reliable, and Mr. Capote gives the same weight to material taken from official records and that derived from things he was told long after the event by people who may or may not have been telling the exact truth" ("Stranger Than Fiction" 215).

Some of the characters are vivid, such as Nancy Clutter who is cheerful, scrubbed, and healthy daughter. The Clutters represented typical poignant victims. Their lives denied the possibility of evil, and thus were crucially diminished. The vignettes of minor characters were sharp and memorable. Gilmore's character in Mailer's book is mainly constructed through the viewpoints of the witnesses, as the author's own attitude to Gilmore remains quite ambiguous.

Characterization is perhaps the greatest achievement of *Libra*. Where other novelists struggle to form a plot and create real characters to move it towards its conclusion, DeLillo pares away the multitude of plots and conspiracies and a myth that surround the events of November 1963, and forms a central narrative around which Oswald's path to destiny can develop. DeLillo interweaves fact and fiction as he draws us inexorably toward Dallas, November 22. The real people (Jack Ruby, Oswald, his mother and Russian wife) are retrieved from history and made human, their stories involving and absorbing; the imagined characters are placed into history as DeLillo imagines it to have come to pass. *Libra* gives a crystal-clear, composite version of events.

The central protagonist, Lee Harvey Oswald, a marine who defected to the Soviet Union, lived in Minsk, married a Russian woman, is back in the United States, distributed "Hands off Cuba" leaflets, and made no secret of being a leftist. DeLillo chose him as the thematic center of the novel, rather than President John F. Kennedy. An excerpt from one of Oswald's letters to his brother, which DeLillo chose as an opening to the novel, suggests that Oswald's need to become integrated in the larger flow of History is a key theme of the story: "Happiness is not based on oneself,

it does not consist of a small home, of taking and getting. Happiness is taking part in the struggle, where there is no borderline between one's own personal world and the world in general" (*Libra* 1). Jonathan Yardly observes that Oswald even on being the instigator of "the seven seconds that broke the back of the American century," in *Libra*, has been portrayed as little more than an anonymous American of "mixed history" who sees himself as "a zero in the system" and longs "to reach the point where he was no longer separated from the true struggles that went on around him" (qtd. in *Contemporary Literary Criticism* 1980: 88).

Oswald is a public keyword from the outset, and here DeLillo's effort is to make afresh characters that are already notorious in the public mind, giving suspense to a narrative already detailed in various post-assassination reports, depositions, and journalistic accounts. Oswald is portrayed as an anti-hero who effuses an air of inevitable tragedy. More than just a victim of powerful secret forces, he personifies a larger American flaw. DeLillo follows the story through to the end, as a wave of discord ripples through the nation and the mourning of the dead President commences. He succinctly reworks the historical material, portraying the characters that investigate Oswald, such as Win Everett, Larry Parmenter, and T. J. Mackey: all renegade CIA men involved in an intricate plot to kill the President. The conspirators have created a "world inside the world" (*Libra* 13), which they think is more structured than "real" life. They believe that their plot is "a better-working version of the larger world Here the plan was tighter. These were men who believed history was in their care" (127). In other words, they believed that they had constructed a plot through which they could control

history, a plot that had the structure of a literary narrative with a clear beginning, middle, and end.

Another character, Win Everett, a demoted CIA agent, after the Bay of Pigs fiasco, is forced to leave the foreground and teach at the Texas Woman's University. He is unable to reconcile with being relegated to a petty job and searches for a solution to make the administration go back to Cuba. He needs an "electrifying event" and he finds it or rather, stages it: an attempt on the President's life, in Dallas, that would point to the Cuban Intelligence Directorate. He believes that Kennedy must be scared into overthrowing Castro: "We don't hit the President. We miss him. We want a spectacular miss" (*Libra* 27-28). But unfortunately, T-Jay Mackey, one of Everett's fellows, secretly alters the initial plan. He recruits Ramon Benitez and Frank Vasquez from the growing community of Cuban exiles in Miami, and Wayne Elko, a soldier of fortune, but fails to inform them that the shooting has to be a miss and not a hit. In *Contemporary Literary Criticism* (1980: 90), Towers writes that the portraits of Lee Oswald, his bewildered Russian wife, Marina, and his egregious mother, Marguerite, are in substantial agreement with those drawn by Priscilla Johnson McMillan, Jean Stafford, Robert Oswald (Lee's brother), and by Edward Jay Epstein in their several books on the subject.

DeLillo relied heavily on the Warren Commission's 26 volumes of testimony and exhibits, which he described as "an encyclopedia of daily life from those era-dental records, postcards, photographs of pieces of knotted string, report cards, the testimonies of hundreds of people, from nightclub comedians to workers in train yards to waitresses" (qtd. by Tyler, *The New York Times*). DeLillo in an interview with Herbert Mitgang observed that in

other books blending fact and fictional techniques, like Truman Capote's *In Cold Blood* and Norman Mailer's *The Armies of the Night*, all the people are drawn from real life and no fictional characters are introduced. In *Libra*, both real and totally fictional people are presented. There are about 125 characters in the book; some are only cameo appearances, others essential for the author's idea of what occurred during the assassination, which remains at the heart of this narrative.

Elaborated physical description lends validity and credibility to a work of literary journalism by developing characters within a narrative that is based solely upon reality. Literary journalists use physical description to develop specific themes around the characters in their narratives. The thematic implications of a character's appearance are evident in many works of literary journalism. Truman Capote's *In Cold Blood* is the classic retelling of a brutal murder. The story is told with rich journalistic details and events are recreated in as exact detail as possible. Capote has also included conversations in the sequence of events resulting in one of the first works to be classified as journalistic fiction and an instant classic. He has used physical description in his narrative, to his and the story's advantage. Two antagonists of the story, Dick Hickock and Perry Smith, are described in rich, vivid detail. Capote pays special attention to their appearance in order to develop the characters as sinister and evil. He feels that Dick was the most sinister, while Perry was simply following him. He introduces a dichotomy between both characters when describing their appearance in great detail.

Capote uses several images and words in an attempt to describe Dick's facial features to the reader, which "...

seemed composed of mismatching parts" (43). Dick's face is described as being manufactured or built from the parts and components of multiple faces. Capote also writes:

> It was as though his head had been halved like an apple, then put back together a fraction off center. Something of the kind had happened; the imperfectly aligned features were the outcome of a car collision in 1950--an accident that left his long-jawed and narrow face tilted, the left side rather lower than the right, with the results that the lips were slightly aslant, the nose askew, and his eyes not only situated at uneven levels but of uneven size, the left eye being truly serpentine, with a venomous, sickly-blue squint that although it was involuntarily acquired, seemed nevertheless to warn of bitter sediment at the bottom of his nature. (ICB 43)

Capote here introduces what is possibly a biblical reference in his description of the murderer, Dick, whose head has the appearance of a dissected apple. He also writes that Dick possessed a "serpentine" eye. The combination of an apple reference and a serpent reference imply images of the Garden of Eden, and the emergence of sin into the world of man. During the prison interviews with killers, Capote had admonished Perry in self-extenuating mood: 'I had one of the worst childhoods in the world, and I'm a pretty decent, law-abiding citizen' (Clarke 327).

In reality, Smith's appearance is just as maligned as Dick's. Capote writes, "Sitting, [Perry] seemed more than a normal-sized man, a powerful man, with the shoulders, the arms, the thick, crouching torso of a weight lifter ..." (26). However, upon standing, Perry is "... no taller than a twelve-year-old child" (*Capote* 26). Perry's body is maligned just like Dick's face. Perry is less menacing and, by implication, less evil as compared to Dick. When describing Perry's face, Capote writes:

> Each angle of [his face] induced a different impression. It was a changeling's face, and mirror-guided experiments had taught him how to ring the changes, how to look now ominous, now impish, now soulful; a tilt of the head, a twist of the lips and the corrupt gypsy became the gentle romantic. (26)

Perry, as evidenced by the way his features are described, is not as malevolent as his partner. He is an evil man, but not to the abominable extent that Dick is portrayed. Again, Capote chooses to accentuate facial features which imply characteristics that he wants to highlight in his characters. Nancy's eyes imply that she is trustworthy and make her "immediately likable" (*Capote* 30). It is interesting to note that Dick's eyes were also telling of his personality. His "serpentine" eye implies his deceptive nature. Nancy's eyes, on the other hand, imply the exact opposite.

Mailer's creative tool of description is such that it allows history to come alive. In *The Executioner's Song* he has described the criminal tendencies in the nature of Gary, who is tall, thin, and extremely provincial. He has

spent most of his life in reform schools or various prisons. His mother says, Gary "was in prison so long, he didn't know how to work for a living or pay a bill. All the while he should have been learning he was locked up" (ES 312). That is why Gary constantly fears not being able to "make those years up" (42). He is awkward when out of prison; he wears mismatched clothes; he drinks excessively, commits crimes, cannot make friends and is poor with women.

"At night, Bessie (his mother) would ask him, 'Where are you going?', 'Out to find trouble,' Gary would reply, 'find some trouble" (468). Gary is not only a troublemaker but also a trouble seeker. He admits this to his interviewer:

> I came out looking for trouble …. I had a tough-guy complex, that sort of smart aleck juvenile-delinquent attitude …. Nobody could tell me anything. I had a ducktail haircut. I smoked, drank, shot heroin, smoked weed, took speed, got into fights, chased and caught pretty little broads.... I stole and robbed and gambled …. (797)

When he is asked, "What did you want to make of your life?" he says "I wanted to be a mobster" (797). There are many instances which throw light on the criminal mind of Gary. Gary seemed to have an uncontrollable urge to commit crime. Mailer lets us understand that it is the psychopath in Gilmore who commits the crime, a crime that has a justification of its own. "I killed Jenkins and Bushnell because I did not want to kill Nicole," (691) says Gilmore in another attempt to rationalize his crime. Killing then is Gilmore's ultimate way of securing Nicole's

love. He repeatedly refers to his childhood dreams about being executed: 'When I was a child ... I had a nightmare about being beheaded. But it was more than just a dream Recently it has begun to make a little sense. I owe a debt, from a long time ago' (305, 137). Gilmore is convinced that he has committed a crime in a past life, and that this crime has repeated itself.

At some points the description of dialogues becomes droning because he repeats "said" and "asked" so many times. These tags emphasize the book's connection to nonfiction because they read like a newspaper article. Early in the novel, Mailer establishes this pattern of dialogue tags. On page 47 of the book, the author uses "said" or "asked" in nine straight lines of dialogue: "said Vern," "said Gary," "said Vern," the first part of the conversation reads. "Asked Brenda," "said Gary," "said Brenda," and so on, Mailer relates. He appears to remove himself from the writing because the dialogue tags are so straightforward, even lacking descriptors. Mailer chooses what the characters say, and Gutkind's argument attests that, "as in fiction writing, dialogue enhances action and characterization" (1997: 23).

DeLillo has also used the tool of description very effectively. In *Libra* the element of description is found to be quite impressive, as in the following passage:

> "It's not just Kennedy himself," Banister was saying on the other side of the door. "It's what people see in him. It's the glowing picture we keep getting. He actually glows in most of his photographs. We're supposed to believe he's the hero of the age. Did you ever see a man in

such a hurry to be great? He thinks he can make us a different kind of society. He's trying to engineer a shift. We're not smart enough for him. We're not mature, energetic, Harvard, world traveller, rich, handsome, lucky, witty. Perfect white teeth. It fucking grates on me just to look at him. Do you know what charisma means to me? It means he holds secrets. The dangerous secrets used to be held outside the government. Plots, conspiracies, secrets of revolution, secret of the end of social order. Now it's the government that has a lock on the secrets that matter. All the danger is in the White House, from nuclear weapons on down. What's he plotting with Castro? What kind of back channel does he have working with the Soviets? He touches a phone and worlds shake. There's not the slightest doubt in mind but that a movement exists in the executive branch of the government which is totally devoted to furthering the communist cause. Strip the man of his powerful secrets. Take his secrets and he's nothing." (68)

In the above passage, a detective agent, Guy Banister is talking to Mackey about John F. Kennedy. There is enough detail about criminal activities and conspiracy in Chapter '20 May,' in which Oswald has been found suitable, and is being finalized for the job of assassination. The narrative

mode used in *Libra* to emphasize this is in direct discourse form:

> "That's the one. He talked to the Dallas field office of the FBI about this Oswald. They finally got him an answer. He left Dallas April twenty-four or twenty-five."

> "There's a Russian wife."

> "Left Dallas May ten with their baby."

> "Nobody knows where."

> "That's right."

> "Which leaves us groping?"

> "I thought you had a line of communication."

> "George de Mohrenschildt. But he's in Haiti. Besides I don't want him to know how interested we are in Oswald."

> "How interested are we?"

> "He sounds right, politically and otherwise. Win wants a shooter with credentials. He's an ex-marine. I managed to get access to his M-1 score books and other records."

> "Can he shoot?"

"It's a little confusing. The more I study
the records, the more I think we need an
interpreter. He was generally rated poor.
But it looks like he did his best work the
day he fired for qualification. He got a
two-twelve rating day, which makes him
a sharp-shooter. Except they gave him a
lower designation. So either the number
is wrong or the designation is wrong."
(*Libra* 118)

The above talk is giving an impression of how and on what
basis Oswald has been selected, and how the conspirators'
plan would go on. The colour of Oswald's eyes seems to
be the product of interpretation, rather than a stable fact:

Oswald's eyes are gray, they are blue, they
are brown. He is five feet nine, five feet
ten, five feet eleven. He is right handed,
he is left handed. He drives a car, he does
not. He is a crack shot and a dud. Branch
has support for all these propositions in
eyewitness testimony and commission
exhibits. (*Libra* 300)

Everything is potentially true since everything is
supported through eyewitness accounts or evidence. Yet
everything cannot be true. The lack of certainty regarding
even basic physical qualities underscores the fact that it
is not possible for the historian to uncover the truth. He
must decide which of the potential truths seem most
plausible to him.

There are many prominent themes in *In Cold Blood*: the effect of environment and family on childhood; how a person of any locale can be a victim of hostility; and the presence of contrasting personalities. Capote gives the reader a detailed account of Perry Smith's and Dick Hickock's childhood. Smith's childhood was very problematic and scarred by years of abuse. He witnessed beatings of his mother by his father; as a result of the domestic violence, his parents divorced. Due to these problems he ran away from home, and was "in and out of detention homes many times" (277). These violent episodes compelled his bitterness towards other human beings. When Smith entered adulthood, he committed acts of thievery and acts of battery. While in the merchant marines, he once threw a Japanese policeman off a bridge, and into the water. All these events had an impact on Smith, and his adulthood provided him with the opportunity to avenge the experiences that enraged him.

As opposed to this, Hickock's childhood was marked by no signs of abuse or neglect, except that his parents were a little overprotective. He showed no real contempt for his parents, or his childhood. Dick's inception into adulthood reveals his abnormal "tendencies" (Reed 115), and in the novel it is proved when Hickock says: "I think the main reason I went there [the Clutter home] was not to rob them but to rape the girl" (278). The two killers' childhoods were obviously dissimilar, and their differences bring to question the formation of a killer's mind. Smith's lack of companionship during his childhood led him to search for companionship in Hickock. Hickock took advantage of Smith's need by promoting his fantasies. Hickock truly felt that Smith's fantasies were ludicrous, but he supported

his fantasies because he needed Smith's aid to commit the murders.

Another important thing to note in *In Cold Blood* is that Capote was not much interested in the lives of good people like Clutters' daughter and leader of the 4-H Club (which stands for 'Head, Heart, Hands, Health') (ICB 33), and took them as Soap-Opera characters. Capote's depiction of their lives was not as in the case of criminals, being penetrated by his intelligence. He finds Perry Smith more enigmatic than any other character. Josephine Hendin feels that 'Capote's despair over the ruined Perry Smith is the index of his distance from the Clutters …. Is it better to deep-freeze fury than to feel it or even see it?' (*Contemporary Literary Criticism* 1986: 5) In *In Cold Blood* lies Capote's vision of the American soul living, dying and murdering in cold blood. Phillips also believes that *In Cold Blood* must also be understood as a portrayal of society because its most characters are "so thoroughly stereotyped that their motives and their behavior scarcely belong to them. They belong to all of us" (qtd. in Helten 54).

The most important theme in *In Cold Blood* is the randomness of crime. The Clutter family lived in rural Kansas, hundreds of miles from a major city, and the people of this small community felt a sense of security. The Clutter family murders made national headlines because this crime fits no stereotype. The Clutters were successful financially; they lived as well as any other family in town. However, there was no jealousy of the family's success. This is another reason why this murder dismayed the inhabitants of Holcomb, the investigators, and the rest of the nation. The story of the murder of an exemplary American family, an act of apparently

'motiveless malignity,' carries a universal appeal for readers, no matter how they view its ultimate meaning; as a symbol of violence in America; as the failure of the American Dream; or as a social study of death-obsessed criminals (Garson, *Truman Capote* 143-43).

Another enduring subject among writers of journalistic fiction was 'murder.' Capote had once stated that the first step to write a nonfiction novel is to choose a subject that would not "date." Thus by writing on the theme of murder, a topic that will endure, Capote fulfills the first requirement for a journalistic novel, a novel based on facts. Moreover, 'Dick and Perry's stories create an impression of murder as an omnipresent threat in the society presented' (qtd. in Helten 54). Tom Wolfe's definition of this form must be kept in mind when studying this work. He explains that it

> is the use by people of writing nonfiction techniques which heretofore had been thought of as confined to the novel or to the short story, to create in one form both the kind of objective reality of journalism and the subjective reality that people have always gone to the novel for. (qtd. in Weber 67)

Moreover, the treatment of capital punishment in the courtroom allows Mailer to insert some subtle commentary on the issue. His discussion of the death penalty in *The Executioner's Song* implies that American public policies are flawed and hypocritical. In the absence of a fixed perspective, readers journey between various positions on murder, capital punishment, and media coverage in

The Executioner's Song. Readers are also witnesses to the execution, autopsy, and burial of Gary Gilmore. The entire body of the work serves to strengthen the reader's participation in the capital punishment process.

Mailer's interest in the death penalty and criminal responsibility is but one component of his fascination with the broader subject of violence in America. Mailer's narrative is an evidence of the way in which acts of violence can achieve mythic status in American history. Gilmore's role, as of Dick and Perry, is symbolic. He is, in one sense, a symbol of decaying American values, an example of what happens to a man raised without the support of a loving family, and thrust into a world that has been overrun by chemical stimuli and a disdain for authority. Mailer presents a surface world of North American life in *The Executioner's Song.* Before *The Executioner's Song* went into print, its author admitted his purpose in adopting a markedly lean style, reminiscent of reported speech: "The aesthetic imperative, if there was one, finally came down to: let the book be lifelike," Mailer told John Aldridge, "let it be more like American life than anything that's been done in a long, long time" (182).

Another issue that catches Mailer's attention is the nature of the modern-day trial as a site for media frenzy. The entire second half of the book (entitled "Eastern Voices") focuses on the arrival of journalists from the East Coast to Utah to cover the Gary Gilmore trial. Mailer himself did not take part in this mad rush to the West, though his collaborator, Lawrence Schiller, was said to be the "ringmaster" of the media carnival that occurred outside the ProvoCity courthouse. Although Mailer did not actually participate in the run, yet he was able to gain access to information about the coverage. His commentary

on the media here is particularly useful; he simultaneously plays the role of insider and outsider— inside enough to have valuable insight into the events, but outside enough to offer a more objective perspective (as he does in *The Armies of the Night*). With such a perspective, Mailer is able to expose the ways in which the overbearing media presence has a powerful impact on the carrying out of justice in America.

There is a perceptible change in the writing style and concepts used by Capote and Mailer in their later works. Actually through *In Cold Blood*, Capote wanted to point out that the Clutters were like us, the sort to whom the inconceivable does not happen. It is proved when Mr. Clutter spoke gently to the murderers, when he was awakened, and led them to the rest of the family members, and thereafter, allowed them to tie them up and tape his mouth. They didn't even scream and defend themselves because they assumed that the murderers were only after their money. But when Perry cuts Mr. Clutter's throat, he screamed with utterly shocked surprise. They experienced a true nightmare. The Clutters could not believe the sheer madness they faced.

In Cold Blood produces a stark image of the deep doubleness prevailing in American life, by juxtaposing the lives and values of the Clutters and the killers. It depicted the gangsters versus the family men, the terrible meeting of the cursed and the blessed of America. For Capote, it is the American dream turning into an American nightmare. The shot gun blasts echo the collision of "desperate, savage, violent America" with "sane, safe, insular, even smug America." Further, "old neighbors" are viewed as "strangers" and fear paralyses people's self-confidence, and upsets their life pattern. Holcomb has become a crisis

city (qtd. in *Contemporary Literary Criticism* 1990: 128). Once Norman Mailer wrote in one of *The Presidential Papers*, 'Since the First World War Americans have been leading a double life, and our history has moved on two rivers, one visible, the others underground' (n. p.).

It can also be concluded that behind this heinous crime committed by Dick and Smith, we can hold Smith's bad childhood responsible. He was a product of want and mistreated childhood. But Dick, on the other hand, had industrious, honest, loyal, loving, and supporting parents. So there is a controversy about the genesis of the psychopathic criminal. It can also be said that the crime they were destined to commit was pre-destined, and so out of their control. The narrative energy of the book is generated by that formative force which Capote thinks is "so awfully inevitable about what is going to happen: the people in the book are completely beyond their own control" (*Truman Capote: Conversations* 1987: 67). The killers never went to murder anyone in the Clutter House but just to rob them of some dollars.

DeLillo synthesizes elements of various conspiracy theories and crime, including the involvement of Mafia, anti-Castro forces, and a renegade CIA faction, all of which have a motivation and the means for killing the President. Through the author's artful portrayal of various stages of Oswald's life, we come to believe in this strange character that desperately searches for the meaning of his life. DeLillo is a great novelist of conspiracies that span the American experience. At times, DeLillo also talks about the philosophies of life. In "American blood," an article published by *Rolling Stone* magazine, DeLillo suggests that the John F. Kennedy assassination was a story about our uncertain grip on the world. A story exploded into life by

a homeless man who himself couldn't grip things tightly and hold them fast, whose soul-scared loneliness and rage led him to invent an American moment that echoes down the decades (1983: 23).

DeLillo amalgamates the conspiracy theories developed in the aftermath of the Warren Commission Report, basing his own theory on the findings of the 1970's Congressional House Assassinations Committee, which expressed the suspicion that elements of Mafia and anti-Castro activists may have taken part in the plot. At the same time the BBC journalist Anthony Summer's book Conspiracy, argued the possibility that "a renegade element in U.S. Intelligence manipulated Oswald" (qtd. in *Contemporary Literary Criticism* 1989: 93). *Libra* is more a study of the mystery of the life of Oswald than about why Kennedy was assassinated. Geographically and structurally, the novel takes Oswald all over space and time i.e. Texas, the Bronx, Dallas, Miami, Japan, and Russia.

Crime in *Libra* can be seen in the form of conspiracies being hatched to assassinate President John F. Kennedy. *Libra*, among other things, is a literary exercise on the subject of conspiracy, and the conspirators themselves are characters in a larger plot whose involutions they are unaware of. The element of conspiracy has been found at the start of the novel in the chapter entitled '26 April.' This plan is not actually to kill the president but just to give a 'spectacular miss.' Oswald, Parmenter and Everett, scheme away behind the scenes of history, planning an event so astonishing that it will in no way escape the clutches of history. They are the agents who actively bring about the monumental and historic event:

They wanted a name, a face, a bodily fame
they might use to extent their fiction into
the world. Everett had decided he wanted
one figure to be slightly more visible than
the others, a man the investigation might
center on …. Mackey would find this man
for Everett. They needed fingerprints,
a handwriting sample, a photograph.
Mackey would find the other shooters as
well. We don't hit the President. We miss
him. We want a spectacular miss. (50-51)

This paragraph shows a conspiracy being hatched and also shows how this plan would work. This is going on in the mind of Win Everett (*Libra* 55). Everett is surprised to find that the Oswald character he has created already exists in the real world, that the fiction he has been devising is "a fiction living prematurely in the world" (179). This character already has his own aliases and forged documents, and he ends up playing the role Everett has designed for him so well because he is the role already. In his article, "*Libra* and the Subject of History," Mott points out, "there is no difference between a scripted Oswald and the 'real thing'" (139). The "real thing" is also a construct. In fact, I would argue that in DeLillo's world there is no "real" Oswald as opposed to a "fake" one (1994: 145). Oswald is portrayed as a postmodern, unstable construct put together by texts.

Furthermore, it seems that Branch will never be able to "master the data" because of an excess of information, which includes photographs, eyewitness accounts, baptismal records, report cards, postcards, and tax returns. Branch also discovers that the texts contain

innumerable contradictions, so-called "facts" that are forever changing depending on who is interpreting them. However, DeLillo is careful to point out that *Libra* is only his fictional account:

> *Libra* is a work of the imagination. While drawing from the historical record, I've made no attempt to furnish factual answers to any questions raised by the assassination. I've altered and embellished reality, extended real people into imagined space and time, invented incidents, dialogues, and characters. (Author's Note in *Libra*)

This note draws attention to the constructed nature of *Libra*, emphasizing that it is neither a purely historical account nor is it fiction that merely reflects reality. Rather it is an amalgamation of both. It has also been observed that DeLillo does not lose sight of many simple truths. Like Branch examines a goat's head that has been shattered in a ballistic test, suggesting: "Look, touch, this is the true nature of the events …. Not your roomful of theories, your museum of contradictory facts. There are no contradictions here. Your history is simple. See the man on the slab. The open eyes staring. The goat head oozing rudimentary matter" (300). DeLillo here while describing the physical facts of Kennedy after death, wants to convey the horror of that violent death.

DeLillo also insists that he is "a novelist, not a private investigator," and says "I think diction rescues history from its confusions. It can do this in a somewhat superficial way of filling in blank spaces. But it also can operate in a

deeper way; providing the balance and rhythm we don't experience in our lives, in our real lives. So the novel which is within history can also operate outside it- correcting, clearing up and, perhaps most important of all, finding rhythms and symmetries that we simply don't encounter elsewhere" ("Oswald" 56; IDD, 56). DeLillo's fiction presents us with another conspiracy theory, and insists that his novel's mediated version of events is the truth. The Kennedy assassination had an effect on Americans from which probably they will never recover:

> The fact that it could happen. The fact that it was on film. The fact that two days later the assassin himself was killed on live television. All of these were psychological shock waves that are still rolling. The subsequent assassinations and attempted assassinations all seem part of the events of November 22nd. (*Warren Commission Report* 338)

Moreover, Branch also thinks of Oswald's act as "an aberration in the heartland of the real" (*Libra* 15).

Further the role played by the media to cover these disturbing events makes us feel even more lost in violence and crime. During an interview with Anthony DeCurtis, DeLillo agrees that television was an essential part of the significance of the Kennedy assassination:

> It's strange that the power of television was utilized to its fullest, perhaps for the first time, as it pertained to a violent event. Not only violent, but, of course, an

extraordinarily significant event. This has become part of our consciousness. We've developed almost a sense of performance as it applies to televised events. And I think some of the people who are essential to such events … are simply carrying their performing selves out of the wings and into the theater. Such young men have a sense of the way in which their acts will be perceived by the rest of us, even as they commit the acts. So there is a deeply self-referential element in our lives that wasn't there before. (1991: 48-9)

DeLillo reacts to the media's ability to transmit events almost immediately, and also to the experience the nation shared following the President's death. This video is famous not because the event itself is significant but "because it is on tape" (159). The Texas Highway Killer himself claims that talking to a television anchor while the famous video played "made him feel real" (269).

So these works are strikingly similar: their subjects being, violent, senseless crime; prison life; trials; and punishment by execution. The characters, especially, Perry Smith and Gary Gilmore were talented artists. Rigorous research on the part of these authors turned literary journalists, is seen in their use of documents, interviews, and transcripts to present the past history not only of the criminals, but of the settings (small towns in the West, Holcomb, Kansas, and Provo, Utah). In addition, these texts use conventions of several nonfictional forms: biography, autobiography, history, and journalism. The novels are vastly different in execution, effect, as well

as narration. The way of looking at the books seems to suggest that *In Cold Blood* and *The Executioner's Song* are attempting to interpret these killings as the inevitable clash between good and evil elements within American society. Moreover, it seems to be a clash between 'good' America versus 'bad' America.

The promise of closure has great rhetorical power in these narratives. It brings satisfaction to desire, relief to suspense, and clarity to confusion. It normalizes. It confirms the masterplot. In *In Cold Blood*, the last chapter 'The Answer,' as the name indicates, in which Perry confesses is very long and detailed. In some ways, it brings closure in the novel. It is told in present tense, while the rest of the book is recounted in past tense. This temporal shift highlights the significance of this chapter. The confession is a closure insofar as it represents the end of mystery and a chase that occupies the police for most of the novel. But actual closure comes when after a total of five years- the case has been to the Supreme Court twice, and finally Perry and Dick are hanged on April 15, 1965.

Capote ends *In Cold Blood* with a scene at the cemetery in which Susan Kidwell and Alvin Dewey meet and converse while viewing the Clutter graves. This scene did not happen and is one of the "events" in the book that are often cited when the veracity of the writing is called into question. It does, however, provide a feeling of peacefulness at the end of an emotionally wrenching book and does show the healing power of the natural Kansas landscape and climate with its strong blowing winds, big blue sky, and endless rolling prairies. The end of *In Cold Blood* shifts the narrative focus from the "rainy" darkness of the execution scene to the "sunny" peacefulness of the cemetery, and is strong in its symbols representing images

of life/death, sunshine/rain, cemetery/prison, future/past, hope/despair.

As expected, closure is achieved with the execution of Gary Gilmore by the shooting squad in *The Executioner's Song*, which takes place in a room where the stage properties suggest the exit of the hero. "The room was lit, not brightly like a movie set, but lights were on him, and the rest of the room was dark. He was upon a little platform. It was like a stage" (979). It is meaningful in the sense that it shows that Gary's pilgrimage is over. The speeches at his funeral are addressed to his memory, glorifying his virtues - dignity, charity, and love.

As a novel, *Libra* does not serve the purpose of providing any final answers. While it deals with historical events, it does not aim to "uncover" historical "truth." Literature has a certain advantage over history in the sense that it does not need to prove anything or explain everything. Its purpose lies elsewhere. Willman asks a very relevant question in regard to *Libra*: "In what way can a work of art operating outside the world of empirical facts and established 'reality' help us to understand the JFK assassination?" (623) The purpose of literature is to create meaning that exists outside of the empirical. It can offer a kind of "truth" in that it can provide us with perspectives on the human experience. As Oswald's mother says in explanation of her son's actions, "Your honor, I cannot state the truth of this case with simple yes and no. I have to tell a story" (*Libra* 449). Jonathan interprets the ending of *Libra* and the facts. For him *Libra* is merely another ripple in that tide, precisely because it so clearly is not "apart and complete" within the literature of the assassination. *Libra* in the guise of fiction offers only "half-facts" presented through the eyes and actions of a cast of characters not

a single member of which comes to life (*Contemporary Literary Criticism* 1989: 68).

Capote and Mailer have made efforts to follow the same direction, choosing a theme dealing with criminals leading to their executions. They have put in efforts and time to give the readers an in-depth insight into the becoming of criminals, the role of parental attitude towards their children and the resulting behavioral deterioration of Perry and Gary, these two texts under scrutiny in this chapter. Capote is inclined to present Perry to be repentant through manipulation of facts and giving an impression that 'I 've never felt close to it' (Mailer: *Pontifications* 175).

Ultimately, Mailer has tried to present what he felt about the American culture of his time. He had a feeling that the Western Voices were quite ineffective in resolving the problems that were prevalent in its social structure. Mailer depicts that whole of the Mormon community is hostile towards him.

All these authors, Capote, Mailer and DeLillo, have shown their sympathy more towards the criminals, Perry Smith, Gary Gilmore and Oswald, instead of the victims. They have presented these criminals as mysterious characters with troubled childhoods, with reasons for their criminal tendencies, once again skewing the rhetoric in their favour. These villains were already notorious in the public mind, and are effused with the sense of tragedy.

The Executioner's Song not only signaled Mailer's last journalistic fiction, but the last of this tradition. No doubt there are novels that combine reality and fiction together; nevertheless, none has set about to deliberately blend journalistic techniques with literary techniques. For instance, Don DeLillo's *Libra* seemed at first to be in

a similar vein, however, Lee Harvey Oswald's tale in it, did not reflect anything truly factual as he states in the author's note, at the end of the novel, he "made no attempt to furnish factual answers to any questions raised by the assassination" (DeLillo 462). *Libra* and *Falling Man* by DeLillo can be considered more like pieces of historical fiction, rather than journalistic fiction.

CHAPTER 6

Reconsidering Nuclear Age: Writing Factual Narratives of Trauma

CHAPTER 6

Reconsidering Nuclear Age: Writing Factual Narratives of Trauma

E vents, whether natural or man-made, mostly inflict trauma on survivors, depending upon the frequency of the events, its severity, and its unexpectedness. The traumatic condition results into powerlessness and insecurity. Meaning of existence is lost sometimes. It has been observed and stated by scholars that if the traumatic events are narrated, it may help in easy recovery. The story of suffering if brought in front of the eyes of the survivors helps in emotional release. Furthermore, literature about the real and shocking historical events are a means of catharsis. These theme since 1945 have been the most thoroughly explored one.

Some literary classics have cast a wistful glance back at the aftermaths of the major nuclear attacks, like on Hiroshima and the World Trade Centre (known widely as 9/11), like John Hersey's *Hiroshima* (1946), Nevil Shute's *On the Beach* (1957), Jonathan Schell's *The Fate of the Earth* (1982), Jonathan Safran Foer's *Extremely Loud and Incredibly Close* (2005), and Don DeLillo's *Falling Man* (2007), each representing the nightmarish event in its own

way. Out of these, *Hiroshima* and *Falling Man* can be categorized as journalistic fiction. Most of the authors who wrote on this subject are trying to project, and thus warn of the danger that confronts us. This chapter examines how writers were quick to register a series of written responses and after effects of these events in the form of some major texts dealing with nuclear attacks from modern history. The bombing of Hiroshima in *Hiroshima* (1946) by John Hersey is significant from the point of view of narratology and rhetoric. In this chapter, the techniques of narratology, especially point of view, narrator, characterization, structure, suspense, closure/climax, have been used to study these texts.

Apart from other after effects of nuclear attacks, trauma may last for a few days or may take a lifetime to overcome. The word 'trauma' comes from the Greek word 'wound.' The consensus is that trauma refers to physical wounds, but it is also used in psychology and the caring professions to refer to a 'psychological wound' – that is, the harm done to a person's psychological well-being by one or more events that cause major levels of distress. According to psychoanalysts J. Laplanche and G.B. Pontalis, trauma can be defined as "an event in the subject's life defined by its intensity, by the subject's incapacity to respond adequately to it, and by the upheaval and long-lasting effects that it brings about in the psychical organization" (465).

Judith Herman, in *Trauma and Recovery*, presents a wide spectrum into which traumatic disorders can be categorized, from "effects of a single overwhelming event to the more complicated effects of prolonged and repeated abuse" (79). Trauma, in the psychological sense, is an invisible emotional shock, the effect of which leads to a

long-term neurosis and may or may not be possible to recover from. The term trauma has been used to describe a wide variety of experiences all of which share in common the individual's recognition of her/his own vulnerability resulting in "some kind of internal breach or damage to existing mental structures" (Chris Brewin 2003: 5).

One of such striking narrative response to nuclear violence in literary history is *Hiroshima* by John Hersey, published in 1946. On 6th and 9[th]August, 1945, the US dropped atomic bombs- first on Hiroshima and then on Nagasaki – in order to bring about an end to the war with Japan. For the first time in history, weapons of such massive destruction were used against civilians. The bombing of Hiroshima was, in several respects, an unprecedented event. It was a novelty, on the most basic level, because the atomic bomb was a new type of weapon, based on new concepts in physics. Its effects as well as the mechanisms were also new. The immediate effects of the bomb and the radiation sickness that plagued survivors in the years that followed were like none that humans had ever experienced.

The bombing of Hiroshima depicted the amount of power released by the atomic bomb, and the scale of harm inflicted on its victims exceeded that of any other single weapon that had been used in human history. The victims, therefore, had to respond not only to devastation and disaster, but also to the newness and unfamiliarity of injuries. Ruth Benedict believed that the effects were so severe that 'some Americans have reacted with painful guilt at the thought that they belong to the nation which catapulted this horror into the houses and streets of a city of whose very existence they had previously never heard' (1997: 300). Only a few paragraphs in *Hiroshima*

(116-118) depict the ethical aspects of using the atomic bomb, though one would have to read between the lines to understand this.

DeLillo's *Falling Man*, which is a mixture of real-life and fictitious characters, represents the life of a survivor of the 9/11 explosion at the World Trade Centre in Washington D.C. These attacks were a series of terrorist attacks by four passenger airliners turned into suicide attacks on the United States in New York City, New York, and Arlington County, Virginia, on September 11, 2001. Suspicion for the attack fell on the Islamic terrorist group al-Qaeda. It is believed to be the most deadly attacks in the history of America, killing 2,996 people and 19 terrorists.

Two of the planes, American Airlines Flight 11 and United Airlines Flight 175, were crashed into the North and South towers, respectively, of the World Trade Center complex in New York City, followed by a third plane, American Airlines Flight 77, hitting the Pentagon in Arlington County, leading to a partial collapse in its western side. The fourth plane, United Airlines Flight 93, actually targeted at Washington D.C., but incidentally crashed into a field near Shanksville, Pennsylvania. This attack resulted into serious damage to the economy of Lower Manhattan and on global markets on one side, and many closings, evacuations, and cancellations on the other hand. Many adults died leaving behind numerous orphans. The aftermaths were physically, socially, mentally, and emotionally traumatic. Follow up in the form of Cleanup of the World Trade Center site was completed in May 2002, and the Pentagon was repaired within a year. On November 18, 2006, construction of One World Trade Center began and it opened on November 3, 2014.

Falling Man is less about war and more about the effects of war on society and the people living in the aftermath of a traumatic experience. Like most other literary responses in the US to 9/11 attacks, *Falling Man* focuses on an intimate issue of broken marriage instead of the changes in society at large. The novel's title refers to a performance artist who suspends himself in midair, mimicking the shocking images of people jumping and falling from the towers. The title also refers to Keith, who is in every sense of the word falling i.e. he is in a state of emotional collapse, as he becomes more and more distant to his family, and tries to escape from the memory of attacks through poker playing.

The narrative structure of *Hiroshima* traces the experience of six residents who survived the atomic blast of Hiroshima at 8:15 am. Miss Toshiko Sasaki, a personnel clerk; Dr. Masakazu Fuji, a physician; Mrs. Hatsuyo Nakamura, a tailor's widow with three small children; Father Wilhelm Kleinsorge, a German missionary priest; Dr. Terufumi Sasaki, and the Reverend Kiyoshi Tanimoto are the six survivors Hersey chose from about forty people he interviewed, having different ages, education, financial status, and employment. The book opens with what each person was doing moments before the blast, and follows their next few hours, continuing through the next several days, and then ending with their situation a year later.

Through in-depth research and personal interviews, John Hersey makes *Hiroshima* an invaluable resource for any investigation into the reactions of the survivors. He manages to recreate the trauma of survivors he interviewed while the disaster was occurring and in the days and weeks that followed, capturing the way they struggled to somehow deal with something that at the time was

new and inconceivable. Looking into Hersey's account, it seems that, among the diverse and personal struggles the survivors faced, they were all in some way struck by a feeling of trauma, pain, and helplessness. The survivors responded to this helplessness in multiple ways: some tried to understand what happened to them, as though some scientific theory, or else political theory, would help them handle the situation of which they were victims. Others tried to act as exercising agencies, like cleaning wounds, providing or seeking out religious guidance, and providing medical aid, which could give them some sense of control over the situation. And others still resigned themselves to this helplessness.

People after the bombing, had no idea about the nature of the weapon which brought so much of destruction in Hiroshima. In this concern Hersey states, "most of them were too busy or too weary or too badly hurt to care that they were the objects of the first great experiment in the use of atomic power [...]" (49). Victims couldn't comprehend the nature of this weapon. This resulted in a sense of helplessness that was not material, but intellectual: the inability of survivors to locate causes for the effects they suffered. This kind of primary and secondary experience leads to an understanding that although technology is something that improves human capabilities, yet paradoxically it also sometimes aggravates human feelings of helplessness.

As Hersey writes: "Those victims who were able to worry at all about what had happened thought of it and discussed it in more primitive, childish terms – gasoline sprinkled from an airplane, maybe, or some combustible gas, or a big cluster of incendiaries, or the work of parachutists" (49). Once the news was released, scientists

made efforts to understand the radiation levels, the heat of the explosion, and the nature of new radiation sickness. As quoted in *Contemporary Literary Criticism*, Yavenditti argued that "Hiroshima" was popular, not because Hersey advanced theories about the will to survive, but because he did what no one had accomplished before; he recreated the entire experience of atomic bombing from the victims' point of view' (1997: 309). Yavenditti also said: "Hersey chose these six largely because he could bridge the language barrier more easily with them than he could with many other survivors whom he interviewed" (Ibid. 309).

Jamie Poolos, in *Atomic Bombing of Hiroshima and Nagasaki*, observed that being chosen for its industrial and military value, Hiroshima was an ideal drop location for the first atomic bomb. After Little Boy (term used for the bomb) was loaded into the B-29 bomber known as the Enola Gay, the crew set off for the Japanese city. The bomb was detonated directly above Hiroshima and created a large, mushroom-shaped cloud above the city (2008: 96). Hersey proves himself successful in presenting more reliable information in as exact a form as possible. For instance, he tells exactly how far each of the survivors were from the centres of the blast at the moment of detonation, and Japanese scientists used "Lauritsen electroscopes" to measure the radioactivity, and have given the results of the test (*Hiroshima* 95). We are able to know the precise centre of the blast and exactly what their findings were: "… the exact centre was a spot a hundred and fifty yards south of the terii and a few yards southest of the pile of ruins that had once been the Shima Hospital" (Ibid. 96).

The narrative structure of *Hiroshima* follows a chronological manner that follows the characters' lives,

from the morning the bomb fell to forty years later. Hersey jumps from one character to other, and then, back again in each chapter, to nurture the reader's interest in each sub-plot. The opening chapter, "A Noiseless Flash" gives short scenarios of what each was doing moments before and immediately after the blast. This chapter introduces the six main characters and gives details of their location and activity at the time of attack. Hersey in a philosophical tone impresses upon the reader how unpredictable the next moment is, and how life changes after the atom bomb hits. In one instant, the entire city switches from common, every-day tasks to a panicked struggle for survival.

"The Fire," the second chapter, follows each victim as they begin to assess their surroundings. All face a different sort of horror as they realize their lives have been spared yet the world has changed tremendously. Here, through the eyes of the survivors, the initial horrors of the atomic experience are shown. The uncertainty and fear from the bomb's devastation is long lasting. Survivors continue to be terrified throughout the day as they wonder what had happened. Most surviving citizens are badly wounded and nauseated, without adequate food, shelter, or water. This chapter highlights Hersey's talent both as a narrative storyteller, and as a journalist capable of careful observation and reportage. Hersey includes statistics without taking the focus off his main characters, and as a result we are riveted by these six human stories. The stories appear to proceed simultaneously, as if we are able to follow the progression of events all at once.

The third chapter, "Details Are Being Investigated," depicts that the inhabitants of Hiroshima are facing rumors about the bomb and eagerly waiting for any official word. Information is scarce and the phrase

"details are being investigated" is repeatedly announced throughout the city. This chapter is the longest and gives details about what is happening to the six as the day passes into night. The feeling of despair and apathy is prominent because of the government's inadequate response to the disaster. People are traumatized and largely left to fend for themselves, at least for the first few days. The government does not provide accurate information about the bomb to the people. Another important scene of moral transformation and humanistic responsibilities of man in this chapter is when Rev. Tanimoto reads a psalm to Mr. Tanaka who is dying, which shows his pastor heart and Christian forgiveness, as well as his recognition that all people deserve help when they are in desperate conditions.

The title of the fourth chapter is "Panic Grass and Feverfew." The effect of the bomb on the vegetation left the underground organs of plants intact and stimulated growth of wild flowers and plants, like panic grass and feverfew. Hersey concludes the stories with a report of where each victim is at this point in his or her life a year after the detonation of the bomb. The juxtaposition of new life, even plant life with dead buildings and human ashes symbolizes how life has to go on for the survivors of Hiroshima, and how they too quickly return to living even after such destruction. Dr. Fuji was one of the most well off, but his misfortune reminds the reader that simply because they survived such a monumental trauma does not mean that the characters are blessed with easy lives afterward.

The last chapter "Aftermath" reviews the broad perspective of both the bomb's societal impact as well as its powerful effect on individuals over an entire lifetime. For example, through Mrs. Nakamura's story, Hersey puts

forth the point that although her quality of life gradually improves over the years, she can never really escape her atom bomb experience, as her body remains weak. Dr. Sasaki is also haunted by his failure to properly attend all the dead at Red Cross Hospital. Likewise Hersey works on the traumatized lives of other characters. All through these chapters, the narrative structure is cinematic, showing a series of brief cuts, focusing on particular activities at particular times, securing reality every time. But at times the narration has been sacrificed for the sake of authenticity because Hersey feels that writing *Hiroshima* was dealing with "history's least imaginable event." He uses elaborate narrative structures not as an aid to comprehension, but rather as unnecessary ornamentation. But overall the plot moves forward in a schematic manner from the day of attack to the settling lives of survivors.

On the other hand, the narrative structure in *Falling Man* interposes several sub-plots against the major narrative. There are surprising interludes dealing with poker tournaments, writing classes for Alzheimer patients, a performance artist known as the *Falling Man*, and the machinations of the Al-Qaeda hijackers. DeLillo builds these stories by piling up dozens of small set pieces of three or four pages. His plots move forward through these vignettes, and he constantly shifts the scene in the manner of a film director, never letting any storyline dominate for more than a few pages at a time, it being the trademark of his style. The narrative opens with a strong sense of falling. The imagery on the first page gives a sensation of things coming down:

> "... a time and space of falling ash and near night They ran and fell ... with

> debris coming down around them …
> the buckling rumble of the fall …. This
> was their world now. Smoke and ash
> came rolling down streets … office paper
> flashing past … otherworldly things in
> the morning pall." (FM 3)

This is an experience of being trapped in one of the towers and running away from them as they fall apart, and tumble down around the survivors.

The image of falling that we saw from the beginning, is continued throughout the novel and becomes representative of the fact that Keith, the novel's male protagonist, does not realize and cannot accept that he has survived. His trauma is clearly an example of what Cathy Caruth argues: "trauma consists not only in having confronted death but in having survived, precisely, without knowing it" (Caruth 64).

In order to come to terms with his survival, Keith tries to find Florence, owner of the briefcase he took by accident when escaping the tower. He listens to her experience of the fall:

> She tried to recall things and faces,
> moments that might explain something
> or reveal something. She believed in the
> guide dog. The dog would lead them to
> safety. She was going through it again and
> he was ready to listen again. He listened
> carefully, noting every detail, trying to
> find himself in the crowd. (FM 58-59)

Finding himself in the crowd will prove to Keith that he was actually there, will prove that his presence is more than just a memory. Keith is trying to establish a referential truth to his unclaimed experience of being in the towers, and escaping them. Getting away from the towers, Keith stopped and "tried to tell himself that he was alive but the idea was too obscure to take hold" (FM 6).

DeLillo names the three sections by some person's name i.e. 'Bill Lawton,' 'Ernst Hechinger,' 'David Janiak,' respectively. But in each case the name is somehow wrong; it is not what the person is known by. Bill Lawton is a child's corruption of Bin Laden. Ernst Hechinger is the real name of Lianne's mother's boyfriend, who was involved with a terrorist organization as a young man. David Janiak is the real name of the performance artist, known as the *Falling Man*. Lianne thinks that it "could be the name of a trump card in a tarot deck, *Falling Man*, name in gothic type, the figure twisting down in a stormy night sky" (221). Then there is a short chapter dedicated to Hammad and Amir, the terrorists who will be on board American Airlines Flight 11. The names of these interludes are place names i.e. "On Marienstrasse," "In Nokomis," and finally "In the Hudson Corridor," which set the scene for a glimpse of the terrorists' training followed by their final minutes of action. These "name chapters" and "place chapters" differ in their structure and their temporal direction.

Falling Man's core plot is very simple. The first part depicts the days only after the attacks, part two is set some months after, and finally part three is set three years after the catastrophe. The main protagonists, Lianne and Keith, hope that they can be a family again, after the explosions. Initially this seems possible; but later Keith drifts away from Lianne and is attracted to Florence. Then he deserts

her too and takes to gambling. The plethora of secondary storylines makes it a fragmented and sometimes bewildering experience. DeLillo writes on the subjects like poker, Alzheimer sufferers, Nina's paintings, and Justin's friends. The individual sections are vivid enough seeming to be pieces from different jigsaws letting the narratives circle each other, resisting easy resolution. DeLillo plays daring games with chronology, returning in the final pages, to the moments that take place immediately before the opening of this novel, when the planes hit the towers. The narrative here demands high drama and intensity, and DeLillo rises to the occasion.

The narrator in *Hiroshima* is Hersey himself and through the eye of a journalist he moves from one character to another, throwing light on their points of view. Hersey expresses his observations in the third person, focusing on the actions of the six main characters. He also gives the reader a glimpse into what they were thinking and feeling, based on his interviews with them. The point of view of the book is that of an objective observer. The author interviews each main character, and in a journalistic fashion, knits their stories together without adding his own biases or moral judgments. In this way it seems as if the readers hear the stories from the character's mouth.

In this regard, Zavarzadeh in *Contemporary Literary Criticism* says that Hersey substitutes portrait for incident or situation: the entire book uses the technique of portraiture as narration (1997: 315). He describes the technique of narration in *Hiroshima* as 'synchronic narration,' where the flow of time is stopped and the contents of the moment are registered simultaneously (316). Hersey has recorded the experience of the six main persons in Chapter I, and then transcribed their new life

in the remaining three chapters showing the reorientation of their new actualities. Though the general narrative point of view is a controlled omniscience, Hersey at times intrudes in the narrative, for instance "These four did not realize it, but they were coming down with the strange, capricious disease which came later to be known as radiation sickness" (*Hiroshima* 90). Hersey narrates the story of the destruction of Hiroshima from the point of view of characters who managed to survive.

In *Falling Man* almost all its characters are allowed representation and the narrative point of view keeps on shifting from one character to another. At the end of *Falling Man* the readers witness the traumatic event directly first through the protagonist's eyes on board the hijacked plane and then from the terrorist's point of view. The moment the plane hits the tower and he dies, the point of view is propelled out of his body and into the protagonist's physical experience of the explosion.

Keith, the protagonist, is a vaguely notorious fellow who is also a keen poker player. For Lianne's mother, Nina, Keith was "sheer hell on women" — "living breathing hell." Lianne had thrown him out of her life just before the attack on the WTC, but now, after his brush with death, she thought he might have changed, and grown up into his role as a "husbandman" (FM 74). In the ensuing days and weeks, they tend to their young son, Justin.

Keith appears to be a pathetic and immature person. His life suffered trauma and shock, and is altered by 9/11 like the lives of thousands of other people who were perhaps more grievously injured than Keith, but they didn't react by leaving home and work to pursue a mindless round of pain relief games in Vegas. This narrative would have been more appealing if DeLillo had captured the impact

of 9/11 on the country, or New York, or a spectrum of survivors, or even a couple of interesting individuals, or had illuminated the zeitgeist in which 9/11 occurred or the shell-shocked world it left in its wake. But instead of all this, DeLillo pays more attention to the two trifling images: one of a performance artist re-enacting the fall of bodies from the burning World Trade Center, and one of a self-absorbed man, who came through the fire and ash of that day, and decided to spend his foreseeable future playing card games.

There are different types of narrators, one of which is the extradiegetic narrator, who is not present in the narrative. *Hiroshima* is one of the comprehensive examples of extradiegetic level of narration. We are introduced to different survivors of the atomic bomb and the traumatic representation of their lives.

In verbal fiction "stories are generally told in a present, past or future tense" (Genette 215). Most of the time events are told after "they happen (ulterior narration) to mention a few texts where this most frequent form of narration is used" (Rimmon-Kenan 89). Genette calls this "subsequent narrating in which the use of past tense is enough to make a narrative subsequent, although without indicating the temporal interval which separates the moment of the narrating from the moment of the story" (Genette 220). So, *Hiroshima* and *Falling Man* both, as journalistic fiction is supposed to be, fall under the above explained category.

Further, characterization is an essential tool used by literary journalists. The major real characters in *Hiroshima* are Miss Toshiko Sasaki, Dr. Masakazu Fujii, Mrs. Hatsuyo Nakamura, Father Wilhelm Kleinsorge, Dr. Terufumi Sasaki, and Rev. Kiyoshi Tanimoto. Of the six persons whose tale Hersey chronicles, two were doctors,

and two being Christian clergy members. Hersey chose his subjects so that his American readers could relate to them: "The very qualities that make Hersey's survivors atypical of Japanese culture make them recognizable and even sympathetic to American readers" (Jones 215). Miss Sasaki is a personnel clerk at the East Asia Tin Works factory who is in her early twenties and lives with her parents and young sibling at the time of the blast. During the attack her left leg is severely injured due to the falling of bookshelves. Dr. Fujii is a middle-aged physician and owns his own private hospital. He is not completely unsympathetic to those around.

Mrs. Nakamura, a widow with three young children, is a tailor by profession. She struggles to make ends meet, both before and after the attack. Father Kliensorge is a thirty-eight year-old German missionary priest with the Society of Jesus (Jesuits). He loves the Japanese people and is committed to his work in *Hiroshima*, but doesn't like the prejudice of war-time Japan. Dr. Sasaki works at the Hiroshima Red Cross Hospital in the capacity of a surgeon. He is the only intact doctor after the bomb attack and treats thousands of victims from all over the city. Rev. Tanimoto, a considerate pastor, is hard-working and largely safe. He spends the first several days after the attack benevolently caring for the wounded and needy.

Some of the minor characters are Mr. Fukai (a secretary of the Catholic diocese) and other dead and dying masses. Mr. Fukai very generously refuses to escape with Father Kleinsorge. An estimate says that 100,000 died in the atomic bomb blast in Hiroshima, out whom many died instantly, but thousands endured for several hours to a few days before yielding to extreme radiation and graphic wounds. Mainly these six major characters

chosen by Hersey are 'types' who represent all those who have been afflicted by the atom bomb.

There is a variety of characters in *Falling Man* who try to cope up with the trauma in their own possible ways. Keith, the main character, spends the novel exploring some understanding of the unbearable nature of his survival, in the ruins of his post-traumatic experience. We can hear the search in Keith's voice when he sneaks back to his apartment near Ground Zero and stands in the empty hallway, "He said, 'I'm standing here,' and then, louder, 'I'm standing here'" (FM 27).

His search also includes replacing a lost object to its proper place, which he has unknowingly hidden from Lianne and only now sees for the "first time":

> The briefcase was smaller than normal and reddish brown with brass hardware, sitting on the closet floor. He'd seen it there before but understood for the first time that it wasn't his. Wasn't his wife's, wasn't his. He'd seen it, even half placed it in some long-lost distance as an object in his hand, the right hand, an object pale with ash, but it wasn't until now that he knew why it was here. (FM 35)

This briefcase is an object formed of ash symbolizing death. He wants to return it to its owner, or to the owner's family, and mark his attempt to illuminate the threshold between life and death, to come to terms with his survival and the death of so many others.

Falling Man begins with smoke and ash coming from the burning towers, and traces the consequences

of this global shock in the lives of a few people. Its opening shows the detailed scene of moments after the disastrous explosion in the towers of WTC. Keith cannot believe that he has escaped. The narrative dramatizes his attempt to understand his survival through repetitions of the traumatic experiences. As the trauma is real and public, it allows DeLillo to employ images, characters, and repetitious structures that work on the reader's individual experience of 9/11. "We find Keith turning up on the doorstep of Lianne, his estranged wife, and she agrees he can live with her and their son Justin indefinitely while he recovers" (Dugdale). Lianne's mother Nina, a former college lecturer; Nina's lover Martin, an art dealer who spends much of his time in Europe; Alzheimer's patients for whom Lianne, a freelance book editor, organizes story-telling sessions; and other men who take part in Keith's weekly poker game, are other significant characters.

Another important eponymous character is *Falling Man* who is a performance artist showing falls in public. He wears a safety harness beneath his suit and reminds those watching of the images of men falling or jumping from the Twin Towers. The purpose of *Falling Man* is to bring us back to the event. DeLillo writes, "He brought it back, of course, those stark moments in the burning towers when people fell or were forced to jump" (33). Through the *Falling Man* we are able to relive the moment of uncertainty, the moment of attack, when the towers were still burning. It is a traumatic re-experiencing in the real sense. Lianne can barely watch: "This was too near and deep, too personal" (163). All the three parts of the novel end with a depiction of (or fallen) man: Hammad, a hijacker first seen as part of an Islamist cell in Hamburg, then in the US, preparing for his mission, and finally

heading towards Manhattan in a hijacked plane. People like Hammad, one of the hijackers of American Airlines Flight 11, according to Nina are "virus that reproduces itself outside history" (112-3).

As readers of a traumatic narrative, we share in these repeated attempts to witness retrospectively, alongside Keith and others who "were walking backwards, looking into the core of it all, all those writhing lives back there, and things kept falling, scorched objects trailing lines of fire" (FM 4). DeLillo provides a moving visual image of the internal trauma borne by the victims when Keith sees "with police tape wrapped around her head and face, yellow caution tape that marks the limits of a crime scene" (FM 5). Keith also experiences other, smaller belated reactions that keep returning throughout the novel as he attempts to understand his survival, including the briefcase he unthinkingly takes from the building and the damage done to his arm (FM 5).

In *Falling Man*, DeLillo provides a view of how unexpectedly calamity can instigate what is known in trauma studies as "secondary trauma." Figley and Kleber further explain, in their article "Beyond the 'Victim': Secondary Traumatic Stress," how traumatic experience can 'contaminate' beyond the reach of a discrete event and 'infect' those close to the victim of the event itself. They distinguish "primary stressors" as "confrontation with ... an extreme event," and go on to define a "secondary traumatic [or stressor]" as:

> the knowledge of a traumatizing event experienced by a significant other. For people who are in some way close to a victim, the exposure to this knowledge

> may also be a confrontation with the powerlessness and disruption. Secondary traumatic stress refers to the behaviors and emotions resulting from this knowledge. It is the stress resulting from hearing about the event and/or helping or attempting to help a traumatized or suffering person. This conceptualization of primary and secondary traumatic stress describes the distinction between those "in harm's way" and those who care for them and become impaired in the process. (78)

Authors conclude the essay by describing secondary trauma as "a form of empathy" (93).

Lianne is also afflicted by secondary trauma, and she is more shocked because of the dispute in her marriage. Keith's sudden appearance at her door is surprising not only because she knew he worked in the towers and feared for his life, but also because he had been distant from the family for a lengthy time prior to the attacks. She tells her mother Nina that when he arrives it is as an apparition, a thing from the other side, "It was not possible, up from the dead, there he was in the doorway. It was so lucky Justin was here with you. Because it would have been awful for him to see his father like that. Like gray soot head to toe. I don't know, like smoke, standing there with blood on his face and clothes" (FM 8). Smoke and ash serve as emblems of the dead, coming to stand in for the remains of those who didn't escape the towers as well as those who did.

DeLillo's characters are the residents of New York, who are shocked, and don't find any sort of redemption or regeneration in the aftermath of attacks. Though the

effects of trauma will be completely unique to each, yet the survivors may judge them based on things like proximity to the event, number of loved ones lost, or degrees of physical damage sustained. It is also important to note that Keith is unable to communicate with Lianne the way he does with another survivor like Florence, precisely because of these factors, and because he feels that Lianne too 'doesn't know.'

Each character in DeLillo's novel deals in a different manner with the incomprehensible and horrifying happenings of 9/11. Martin, Nina's mysterious European lover, feels: "One side has the capital, the labor, the technology, the armies, the agencies, the cities, the laws, the police, and the prisons. The other side has a few men willing to die." Nina believes "it's not the history of Western interference that pulls down these societies. It's their own history, their mentality. They live in a closed world, of choice, of necessity. They haven't advanced because they haven't wanted to or tried to" (118). But DeLillo's point is that most of us simply don't want to think too hard or too long about what happened on that very day. Most of us don't want to think in difficult ways about what is difficult to think about. We rather try to escape or repress memories.

In addition to the use of different types of narrators, these authors have tried to make their narratives more factual through their descriptions, making use of "sub-narratives" which, in the case of Hersey, involve the survivor's efforts to understand what has happened to them. In the beginning he describes the moments before the blast, when all were totally naïve: "At the time, none of them knew anything," (*Hiroshima* 4) but immediately after the blast, we find Mr. Tanimoto rising from the debris

of the house into which he was moving the belongings of a friend and concluding that "a bomb had fallen directly on it," (*Hiroshima* 9). Hersey describes the surprise evident at this moment:

> From the mound, Mr. Tanimoto saw an astonishing panorama. Not just a patch of koi, as he had expected, but as much of Hiroshima as he could see through the clouded air was giving off a thick, dreadful miasma. He wondered how such extensive damage could have been dealt out of a silent sky; even a few planes, far up, would have been audible. (*Hiroshima* 25)

One by one Hersey describes the expressions and feelings of all the main characters, for instance of Father Kliensorge:

> He found his room in a state of weird and illogical confusion. A first-aid kit was hanging undirected on a hook by the wall, but his clothes, which had been on other hooks nearby, were nowhere to be seen. His desk was in splinters all over the room, but a mere papier-mache suitcase, which he had hidden under the desk, stood handle-side up, without a scratch on it, in the doorway of the room, where he could not miss it. (*Hiroshima* 30)

Like Mr. Tanimoto, Father Kliensorge and the other Jesuits assumed that they were in the center of a "local

circle of destruction," (31) and are overwhelmed when they learn about the extent of damage occurred.

Hersey observed many significant physical changes: a young man whose hair turns white; new X-ray plates in storage in a hospital basement mysteriously exposed; people who die suddenly within hours or days after the blast, plants growing at a luxuriant rate, confounding the human misery around. His concentration on details brings the sense and image of event to the mind of the readers. Here is another example of Hersey's descriptive power at its peak. Hersey reports the actions of Mr. Tanimoto who views survivors in Asano Park:

> He walked to the river bank and began to look for a boat in which he might carry some of the most severely injured across the river from Asano Park, and away from the spreading fire. Soon he found a good-sized pleasure punt drawn up on the bank, but in and around it was an awful tableau five dead men, nearly naked, badly burned, who must have expired more or less all at once, for they were in attitudes which suggested that they had been working together to push the boat down into the river. Mr. Tanimoto lifted them away from the boat, and as he did so, he experienced such horror at disturbing the dead preventing them, he momentarily felt, from launching their craft and going on their ghostly way that he said out loud, "Please forgive me for taking this boat. I must use it for others, who are alive." (50)

This passage is describing the gruesome and pathetic scene of mercy. Mr. Tanimoto is in search of a boat to carry the survivors to the other side of river and asks the 'dead' in the boat to lend the same for those alive. This sort of detailed description arouses pity for those affected and dismay against this horrific inhumane act, and proves to be an indispensible tool of journalistic fiction.

Hersey lets Father Kleinsorge describe the most gruesome scenes in the entire book. In one of the scenes we find Kleinsorge searching for water and he comes across a faucet that still works. Then he comes upon twenty men in uniform, who were all "in exactly the same nightmarish state: their faces were wholly burned, their eye sockets were hollow, the fluid from their melted eyes had run down their cheeks." He speculates that they must have been antiaircraft personnel and had their faces "upturned when the bomb went off." He adds, "their mouths were mere swollen, pus-covered wounds, which they could not bear to stretch enough to admit the spout of the teapot (he used to carry the water). Father Kleinsorge searches for and finds a piece of grass and made it into a straw, and "gave them all water to drink" (68). The narration here is a means of directing us towards the most heinous and painful aspect of the advancement of technology and weapons.

Similarly, DeLillo's descriptive powers are also very appreciable, for instance, when he describes the *Falling Man*'s performance that stands in for a public traumatic experience. Lianne first encounters him, only days after the attack, hanging from an elevated roadway:

> A man was dangling there, above the
> street, upside down. He wore a business

> suit, one leg bent up, arms at his sides. A safety harness was barely visible, emerging from his trousers at the straightened leg and fastened to the decorative rail of the viaduct. She'd heard of him, a performance artist known as Falling Man. He'd appeared several times in the last week, unannounced, in various parts of the city, suspended from one or another structure, always upside down, wearing a suit, a tie, and dress shoes. He brought it back, of course, those stark moments in the burning towers when people fell or were forced to jump. (FM 33)

Falling Man's generic appearance, shown through the words of DeLillo, depicts him to be a symbol of all victims in the towers who never thought of what approached that September morning. Moreover, the last breathtaking page of the novel describes the plane hitting the first tower, first seen from Hammad's point of view, which then at the moment of impact is transferred seamlessly to Keith's point of view. This circular structure of beginning and ending with the disaster seems to be indicating that there is no escape from this tragedy.

Themes are the fundamental and often universal ideas explored in a literary work. The coming together of community, at the time of collapse and crisis, is an important theme visible in *Hiroshima*. Characters take care of victims, as of their own family members. For example, people taking care of one another on the riverbank at Asano Park and in the East Parade Ground, providing water, food, and comfort as though they were

a family. Since the bomb destroyed families and homes, the citizens of Hiroshima are forced to come together and make a new kind of family. Father Kleinsorge, whose birth family is otherwise in Germany, generates a family out of his comradeship with his fellow priests and later, with Miss Sasaki, the Nakamuras, the Kataoka children and many other people he encounters in the period following the attack. The disruption of life in Hiroshima and its inhabitants have been put together by Hersey through the narrative collages consisting of individual portraits, general scenes, and discursive passages. To make the account more realistic, Hersey adds many factual details in *Hiroshima* which consist of speeches and announcements made by President Truman (65), the technical details and investigation of the scientists of Japan (95-97) and real and identifiable persons as characters like six major characters, John D. Montgomery (105), and Prof. Y. Hiraiwa of Hiroshima University of Literature and Science (115).

Survival, both of individuals and the community, is another important theme. The book generalizes people's reactions in the hour of crisis; how do they deal with this situation morally; how they choose to rebuild their lives; and also how the city of Hiroshima rebuilds itself after the disaster. Dr. Fujii, for example, pours himself into pleasure-seeking activities. He prospers financially and avoids health problems from the radiation, but sacrifices closeness with his family, and misses the opportunity for a fulfilled life of service. The will to keep on living even in the face of such destruction, when none is left untouched, is a subject of learning.

In *Falling Man* the theme of memory moves through every page like a shadow, along with the unpredictable nature of luck and circumstance. Keith is haunted by

the agonizing memories of a weekly poker game enjoyed by a group of men, not all of whom survived that grim day. Lianne works as a freelance editor and volunteers for a senior center, leading a journaling class for a group of newly diagnosed Alzheimer's patients. She cannot come to terms with her father's suicide, after receiving a similar diagnosis. Two persons (Keith and Florence) who worked in the towers meet when some personal items are recovered, and share a brief sexual relationship. They feel that only they can discuss the events of that day because nobody else would understand in a better way what they have borne. Eventually Keith starts visiting Las Vegas casinos assuming he can only feel comfortable in an impersonal world where luck and chance rule the day, and where players always lose.

Being a writer who has written obsessively, and insightfully, about the role of mass media in constructing our world of seductive and deceptive images, in novels like *White Noise*, *Mao II*, *Libra*, and *Underworld*, DeLillo rarely comes to this subject in *Falling Man*. Only a few of Keith and Lianne's son Justin's images depict them in front of the TV, "staring helplessly into the glow, a victim of alien abduction" (FM 117). And later in a scene Keith and Lianne talk about their son and the TV glows mutely in the background: "There was stock footage on the screen of fighter planes lifting off the deck carrier. He waited for her to ask him to hit the sound button" (131). So the role of the media remains almost mute here.

Themes common in *Hiroshima* and *Falling Man*, therefore, are the attempts to create a semblance of order in the new, confused world; to hang onto or to construct some sort of meaning in the chaotic meaninglessness. This has always been an important theme for DeLillo, but in

his earlier novels, the longing for order often manifested itself as paranoia. Some more themes common to both the texts are the unpredictability of the next moment and the life of a human being and suffering. DeLillo's style of moving forward and backward through the novel introduces characters and situations and progressively shows the interconnectedness of their lives.

Thus what DeLillo's *Falling Man* seems to suggest, as done by other 9/11 works, is that the best way to come out of this traumatic experience is to move into the near and the intimate; by moving into this place, we may be able to work through the trauma. There is no naïve return to innocence in *Falling Man* because Keith and Lianne are not reunited. There is, however, a certain nostalgic feeling at the novel's end. As readers, we are left with this image of Lianne: "She was ready to be alone, in a reliable calm, she and the kid, the way they were before the planes appeared that day, silver crossing blue" (FM 236). Lianne is left ready for the rest of her life to recover from the trauma. It may also be read as a nostalgic desire to return to a simpler, better time before the fall. The novel ends with a return to the trauma of the fall depicting the perspective of one of the terrorists aboard the first plane to crash into the World Trade Center. Almost unnoticeably, the perspective shifts to that of Keith, in the tower as the crash occurs. We get a new description of his experience on the tower and his escape from it. The ending ties the novel into a kind of narrative loop, insisting that we are not free from the specter of the fall, as it will continue to haunt us for quite a long time. Even the finishing lines seem to indicate this: "Then he saw a shirt come down out of the sky. He walked and saw it fall, arms waving like nothing in this life" (FM 246).

In the closing pages of *Falling Man*, DeLillo resolves the confusion by returning full circle to where it started (in this case the morning of the attacks); and in the final paragraphs, Hammad on the hijacked plane suddenly metamorphoses into Keith in the soon-to-be-destroyed towers. DeLillo shows how terrorist and terror-survivor are associated. It is another attempt to give cohesion to a frustratingly disjointed novel. DeLillo is successful in presenting something new in material that the readers have looked at and read about repetitively. The thoughts going on in the mind of the attacker before the attempt of the attack on the towers have been expressed very effectively using certain small sentences like:

> 'Recite the sacred words.
>
> Pull your clothes tightly about you.
>
> Fix your gaze.
>
> Carry your soul in your hand.'(FM 238)

The three individual chapters within the novel deal with the movement of the hijacker of American Airlines Flight 11, Hammad, as he progresses towards the attacks. After seeing Hammad at preparation in Hamburg and Florida, the final section begins as he is in the plane flying across the Hudson Corridor. As Hammad sits in his seat, DeLillo writes about the impact, making an exceptional moment of writing. Description of the scene in the cockpit shifts abruptly to the office where Keith was working:

> A bottle fell off the counter in the galley,
> on the other side of aisle, and he watched

it roll way and that, a water bottle, empty,
making an arc one way and rolling
the other, and he watched it spin more
quickly and then skitter across the floor
an instant before the aircraft struck the
tower, heat, then fuel, then fire, and a blast
wave passed through the structure that
sent Keith Neudecker out of his chair and
into a wall. He found himself walking into
a wall. He didn't stop the telephone until
he hit the wall. The floor began to slide
beneath him and he lost his balance and
eased along the wall to the floor. (FM 239)

This is a lengthy description covering the whole of last
chapter 'In the Hudson Corridor'. It ends when Keith, being
lucky, finds himself alive and out of the towers in between
the 'rubble underfoot and there was motion everywhere,
people running, things flying past … (FM 246).

DeLillo attempts to render the moment of impact in
words. We begin with movement, the roll and arc and
spin of a bottle on the floor of the aircraft, becoming more
agitated as the plane accelerates towards the tower. That
movement is transferred to the movement of explosion as
the plane rips into the building. We feel the "blast wave"
exploding through the building sending Keith flying
into a wall. This transference of subject from Hammad
to Keith in one sentence is convincing and ferocious. We
are made; in as clear a way as literature can allow, to sense
the impact of the plane. The text also becomes dislocated
and shadowy after the collision, when Keith hits the wall
becoming confused and out-of-time. Although DeLillo

was not present during the falling of the towers, yet he catches the instant flawlessly and makes it momentous.

So in the end not much is really transformed in the lives of the characters after the 9/11 in *Falling Man*. The outcome is that DeLillo's characters continue on with their doggy lives. Justin drifts into predictable, laconic, and vaguely annoying teenhood. Keith deserts Florence, stays away from Lianne, and indulges himself in the poker-tournament circuit, to remember his two poker-playing allies who died in the towers' collapse. Lianne accepts that "she was ready to be alone, in reliable calm, she and the kid, the way they were before the planes appeared that day, silver crossing blue" (236), and finds it impossible, and not quite impossible, both at the same time.

There is an individual outcome in *Hiroshima* for each of the characters. Hersey's rhetoric depicts them to be sometimes tragic, and sometimes, inspirational. All draw attention to the massive impact that the atomic bomb exposure had on their family lives, careers, and attitude towards life. The protagonists continue struggling against the effects of the bomb. Similarly, in *Falling Man*, Keith, Lianne, Justin, Nina and her boyfriend, Martin, are the protagonists. The intimate close-up of Keith and Lianne, and their increasingly desperate attempt to come to terms with the attack is the nucleus of the novel. The antagonist i.e. the atomic bomb in both the texts caused so much of destruction, pain, and loss for the main characters as well as the entire city of Hiroshima and the World Trade Centre in Washington D.C. Hersey and DeLillo added no judgment of their own but presented the characters' interpretation of events.

The climax in *Hiroshima* is reached a few days after the bomb has hit, when the main characters are still in

doubt whether they will live or die. It can be argued that much of *Hiroshima* and *Falling Man* are in fact the climax. In case of *Hiroshima* only the first chapter, in which the main characters' everyday lives are described, and the last chapter, when years have passed since the bomb, are not parts of this extended climax. In *Falling Man*, the climax is reached as soon as the novel starts after the bomb hits the towers of WTC, and the main character Keith is coming out of it after a narrow escape. He pursues a safe shelter and returns to Lianne and their son Justin, and the rest of the novel depicts their attempt to come to terms with each other and with the inconceivable event of September 11. In these texts, both the writers through their research and depiction of facts want to divert the minds of readers towards the ugly face of advancement of technology which led people to bear so much of pain, sufferings, and never ending after-effects.

George H. Mead finds the way of ending the book by Hersey to be critical to our better understanding of an event. "Data are isolated elements in a world of things," he writes; they have no intrinsic significance and do not convey meaning "until the data have taken on the form of things in same sort of ordered whole" (1959: 94). Hersey creates a sense of closure by recapitulating the conditions of each of the survivors:

> A year after the bomb was dropped, Miss Sasaki was a cripple; Mrs. Nakamura was destitute; Father Kleinsorge was back in the hospital; Dr. Sasaki was not capable of the work he once de; Dr. Fujii had lost the thirty-room hospital it took him many years to acquire, and had no prospects

> of rebuilding it; Mr. Tanimoto's church
> had been ruined and he no longer had
> his exceptional vitality. The lives of these
> six people, who were among the luckiest
> in Hiroshima, would never be the same.
> (*Hiroshima* 114)

So if we read within the words we would understand that although Hersey's narrative has ended, yet the effects of bomb have not. It's the fate of Japan that it has recently borne another similar tragedy in the form of multiple disasters, especially the nuclear meltdown in Fukishima. It was as if history was repeating itself.

Falling Man's visionary nature concurrently suggests the suspension of time and considerable action that dispels panic and promotes resolution and recovery. Through *Hiroshima*, *Falling Man*, and other similar books, readers are encouraged to enter the psychic terrain genuinely, but with a collective reconciliation. Such literature asks us not only to gaze on unspeakable loss, but also interprets the effective and symbolic values that it holds for all. These nonfictional texts eventually lead up to a suggestion of hope for a 'new' America.

DeLillo's novels are not simply meant to convey emotion or tell a story, they are also carefully constructed to critique the contemporary understanding of cultural and societal historical constructions. To quote Peter Boxall: "DeLillo's novels can be thought of as an extended enactment of the exhaustion of possibility in post-war culture. It is a familiar refrain in his writing that even the most fleeting urge to invention, to fabrication or to dissent, is cancelled by the interpolating power of a culture which has become, in another of DeLillo's key words,

self-referring" (Boxall 4-5). Moreover, it is in the narrative that tries to make sense of a traumatic event itself that we will find the reference needed for the narrative to become a truthful account of what has taken place.

Thus we find that these artists have tried to give some kind of closure to the terrible catastrophes by representing them in the form of narratives. They have conveyed the confusion and trauma of their times covering a large number of characters, sometimes becoming unwieldy also. In an interview, DeLillo explains the fictional aspect of journalistic fiction: "fiction offers patterns and symmetry that we don't find in the experience of ordinary living. Stories are consoling" (Connolly 31). Although the endings of these narratives depict that life has to go on, yet DeLillo implies that another world is possible beyond wars and empires, and that peace is also possible. Hersey believes that characters achieve growth as a result of their experiences.

CHAPTER 7

Summarizing Thoughts

CHAPTER 7

Summarizing Thoughts

These American journalistic authors have mediated 'the real' by representations that do not merely reflect reality, but create meanings out of it. They have used the genre of journalistic fiction that bridges the journalistic and literary worlds, simultaneously communicating new ideas, and raising provocative questions. These texts move from fiction to reality and from reality to fiction in their search for meaning. American journalistic fiction is rich, complex, and as a means of understanding American values, worth a close reading. Through this kind of fiction the readers are forced not only to recall the major historical events narrated, but also their reactions and thoughts about them. The events portrayed in these books are not only difficult to understand but scarcely believable also.

These American writers started their career as novelists, and achieved success, but later devoted themselves more and more to journalistic fiction. *The Armies of the Night* by Mailer revitalized his flagging career making him again one of the leading voices in American literature. In *Of a Fire on the Moon*, Mailer takes into account a moment of national importance in which he is more concerned about the difficulties of representing

the moon landing. His next work, *The Executioner's Song*, which won him the second National Book Award, is more of a fictional depiction of true crime (murders committed by Gary Gilmore) than his experimental and chaotic march to the Pentagon in *The Armies of the Night*. These authors aim at exploring the complexities of American violence from a variety of points of view. All the subjects focused upon by them are crucial, fundamental, universal, and thought provoking in nature.

They have used the tool of description to widen the sphere of knowledge as well as experience of readers, throwing light on almost all aspects related to real life i.e. from the trivial to the most crucial subjects. John Hersey has used simple language very skillfully to represent the aftermaths of the most catastrophic nuclear disaster in *Hiroshima*, and re-discussed its effects once again after forty years in the form of an additional chapter 'Aftermaths' in *Hiroshima*. In *In Cold Blood*, Truman Capote has highlighted and laid bare the facts surrounding a real incident of the multiple murders of the Clutter family by Perry Smith and Dick Hickock in Kansas, with great detail. The backward and forward movement of chapters draws the picture of the society and culture as developed over the past decades, and the possibilities for living in it.

These themes also exist outside their textual organization, and so their representations can be compared to other representations. The narrative techniques, real backgrounds, recurring figures, and thematic constructs in these texts form the strong basis for journalistic fiction. Each selected work is an individualized attempt, at being coherent and varying in style. For instance, Mailer in *The Armies of the Night*, through a strong, subjective and rhetorical vision, represents the chaos of contemporary

reality. In *The Executioner's Song*, he uses simple language to present the conflicting and fragmented viewpoints on the subject of capital punishment, a style he did not use in any of his other work.

Further, these authors have used the same historical facts as available to anybody else to say many things about America through their rhetoric. Such facts are always open to negotiation, revision, correction, and interpretation. 'Facts are silent,' as Conrad said 'and any singing they do depends on their orchestration by a human arranger' (qtd. by Tony Tanner, *Contemporary Literary Criticism*, Vol. 58: 102). For instance, the facts related to the life of Lee Harvey Oswald and assassination of John F. Kennedy, have been used differently by Mailer in *Oswald's Tale* and DeLillo in *Libra*. Both have shared the same reference world, but written to serve deliberately different aims. Like Mailer, DeLillo also constructs a large social and national vision combining different viewpoints, documents, and ways of speaking, keeping his narrative style simple, and using colloquial discourse. *Libra* has been regarded as "a sometimes fictional, sometimes factual biography of Lee Harvey Oswald that blurs the boundaries of fact and fiction" by Lehman (1997: 25), and it has achieved a complex literature form by reworking "distinctions between fact and fancy, truth and fiction, objectivity and subjectivity" (Tabbi 1995: 176). DeLillo's narrative suggests the ultimate hopelessness of Oswald's efforts to change the world history. Whereas Mailer, in *Oswald's Tale*, takes Oswald's political aims more seriously, and corrects the language of his writings, which is partly impaired by dyslexia.

Mailer has undergone a lot of change while treating the subject of crime in *The Executioner's Song*, lacking

much of his vehemence of *The Armies of the Night*. In order to alter the contemporary consciousness and to find the most effective means to this end, he gradually kept changing and refining his methods. He thought himself to be the fittest hero, the boldest, the most memorable and real. He found in himself the two schizophrenic halves of the American psyche, the dream of the extraordinary, and the mundane reality, all coming together. Laura Adams states:

> He is no Superman but a very human being who on occasions summons up the courage to rise above the beast in himself, to outweigh and redeem his failures, although because he is human he will fail again. This knowledge is what makes him a whole man and can make America a whole nation. (1979: 341)

After reading Mailer's work the basic question which comes up in one's mind is: Is the American dream turning into a nightmare?

Hersey's aim in writing *Hiroshima* is to help readers find their own deepest feelings about the new instrument of killing, instead of accepting the author's feelings. In the beginning when he reached Hiroshima he found the researching of this story to be a kind of horror. On his first-hand investigations in Japan, Hersey had a feeling of revulsion towards the weapon, a compassion for its victims, and a deliberately understated admiration for the survivors as fellow human beings. One gets this feeling after reading *Hiroshima* because it is entirely a factual account with which readers can identify. Michael

J. Yavenditti in his article, "John Hersey and the American Conscience," in *Contemporary Literary Criticism* states that by the horror and trauma which it described, "*Hiroshima* revived the moral question of whether the United States should have used the bomb" (1997: 309). A recent nuclear disaster that happened in Japan was depicted in William Vollmann's *Into the Forbidden Zone: A Trip through Hell and High Water in Post-Earthquake Japan* (an electronic form of literature). Although it was not an attack this time (being a natural calamity), yet it once again recalled all the sufferings and tragic feelings borne by the survivors in Hiroshima in 1945 and afterwards. It was as if history was repeating itself.

Hersey depicted death and suffering due to radiation poisoning. He raised the ethical question of the bomb's use, left it unresolved, and challenged the readers to examine their own thoughts. By inviting a sympathetic vicarious identification with the atomic bomb victims his article inspired self-questioning and indignation. It prompted some Americans to rethink their previous approvals of the atomic bombings, while it intensified the anger of those who had initially condemned the bomb's use. Further, by building his story around six survivors, Hersey encouraged readers to empathize with the Japanese victims rather than to view them with detachment, indifference, and hatred. It also persuaded many readers that atomic bombing was qualitatively different from other kind of bombings. It sensitized people in many ways. One reader declared: "God bless and keep the editors who showed such courage and cared so much for humanity and civilization" (qtd. in *Contemporary Literary Criticism* 1997: 309). Eleven percent of *The New Yorker*

correspondents mentioned the shame and responsibility they felt for making this deed possible.

Mailer's prophetic inclinations have shaped most of his works. He preferred writing journalistic fiction because through this mode he could suggest not only the sources of the "plague" he saw everywhere, but also its possible remedies. His aim was to tell more about America. In 1959 Mailer announced his goal of creating "a revolution in the consciousness of our time" (*Advertisements for Myself* 17). Hellmann also argued that Mailer's theme was "the necessity of fiction for the apprehension of complex reality" (56-57). Mailer believed that we always pursue the good but don't know what the good is. He admitted learning from the Gilmore saga that society might be not evil but, rather, "a sad comedy" (Lennon 1988: 240). *The Executioner's Song* also expressed Mailer's love for America.

Libra is about the influence and identification of general public with the famous personalities. Oswald finds many coincidences of his and President Kennedy's life, like both had brothers named Robert, their wives got pregnant at the same time, and their military service in the Pacific. Sometimes he would force coincidences, as he did at the time of the shooting. Oswald believes that the chance passing of Kennedy's motorcade below the window, where he works as the Texas School Book Depository in Dallas, must mean that he is destined to shoot the President. By shooting Kennedy, Oswald takes revenge against all the famous men whom he blames for confining him to small rooms or the life he had been living. *Libra* also highlights the role of the media. After the assassination Oswald faces imprisonment. He is satisfied with the feeling that though his body is in prison

his name is carried by radio and TV stations across the world: "Everybody knew who he was now. This charged him with strength" (*Libra* 435). He feels proud as he has displaced media attention from the President to himself, occupying Kennedy's place in the limelight.

John F. Kennedy is referred to as America's first "television president" in recognition of his skills of using media to get elected and become popular. President Kennedy himself once admitted, "We couldn't survive without TV" (*John Kennedy and the Media: The First Television President* 43). Moreover, it was the effect of media and its repeated replay of Kennedy's assassination which incited Jack Ruby to assassinate Oswald: 'He [Ruby] anticipates for himself the star treatment which he will receive as Kennedy's avenger' (*Libra* 437).

Although *Fire* shows Mailer's disdain for technology, yet he is highly impressed by the astronauts whom he calls "shining knights of technology" (*Fire* 103). He is impressed by the way they work like interchangeable parts of the machines they design and operate, all seeming like each other, and if needed they could change roles with each other and yet work effectively. They believe in team work instead of individuality. Neil Armstrong (one of the astronauts) is the American Dream personified: small-town poor beginnings; hard work and determination; courage in the face of danger; intelligence and hard training; and the biggest of all pay-offs, the first man to walk on the moon.

In an article "The Taking of the Moon: The Struggle of the Poetic and Scientific Myths in Norman Mailer's *Of a Fire on the Moon*," Alvin B. Kernan states that there is no humanistic concern in Mailer's *Fire* and the entire effort seems to be meaninglessly dreary in this official version

(14). In *Fire*, we get a fragmented narrative of a poet who lacks any firm and logical grasp of events, and is trying confusedly to impose his romantic ways of understanding, on the events he cannot comprehend. He goes back again and again to explain the details of the moon landing and his own responses to it. He hopes that with enough words and feelings he could write and animate the trip to the moon so as to satisfy human desire for meaning and to fill the voids. Mailer wants the reader to reconsider the true meaning of the use of technology, especially of the moon landing. This disdain for the space program is nothing but his skepticism about what this use of technology is doing to our culture and society.

Out of the four authors under examination here, only Mailer's work is written in an overtly self-conscious manner as he assumes the role of both author and central character in his texts (*Armies* and *Fire*). *Hiroshima*, *In Cold Blood* and *The Executioner's Song*, propel the stories forward using dramatic and chronological narratives. *The Armies of the Night*, *Falling Man*, *Libra*, and *Of a Fire on the Moon* are experimental fictions, reflecting the true nature of reality and its inability to be represented accurately. Capote eliminates himself from his texts by developing an omniscient style of presenting events from the perspectives of many people, as it should be in journalistic fiction. Capote even trains himself to accurately memorize conversations, transcribe those into notes, and so rely less on the use of a tape recorder or camera while interviewing subjects. The omniscient point of view in *In Cold Blood* is an "empirical omniscience" as it is based on thorough research and not imagination (Zavarzadeh 120).

The exponents of this genre have constructed meanings, in journalistic fiction dealing with real and usually inexplicable events. Basically, in each chapter the strategies discovered to be unique to individual authors are: Hersey's flat and plain representation of facts; Capote's authorial silence; Mailer's self-dramatization, meta-discourse and self-reflexion; and Don DeLillo's cinematic and hyper-textual style.

Thus the rhetoric of literary journalists suggests that they are more interested in what these events and actions mean, or what they reveal about the national character of the time. Whether it is a multi-narrative of *In Cold Blood*, or meta-subjectivity in *The Armies of the Night* or the cinematic representation of events in *Libra*, journalistic fiction is quite aware of its involvement in its search for meaning. It is written to show how we feel about the past.

With the passage of time, the authors who wrote fiction dealing with real events kept changing their strategies with regard to collection of data. In the recent fiction, authors depend less on personal experience and primary data. For instance, starting from John Hersey's *Hiroshima*, Capote's *In Cold Blood*, Mailer's *The Armies of the Night*, *The Executioner's Song* and *Of a Fire on the Moon*, through Don DeLillo's *Libra*, to *Falling Man*, it is found by critics that the authors are relying more on secondary data available, for example other texts on the same events available at the time.

Regarding the extent to which the truth is tampered with, it is observed that data is often manipulated by these authors. Philip K. Tompkins charged Capote of distorting the evidence to match his artistic vision. His most serious charge is that Capote altered facts and quotations to skew the portrait of one of the killers, Perry Smith, so as to

depict him not like a cold-blooded murderer but a victim having a miserable childhood. Commenting on *Libra*, Terrance Rafferty notes: "Whatever has been presented is not truth as DeLillo writes at the end of the book, that his work 'makes no claim to literal truth,' and that 'it is only itself, apart and complete.' This truth is actually 'the fear that has been hoarded, cared for, lovingly developed, and polished with a fetishist's single-minded devotion'" (*Contemporary Literary Criticism* 91). The purpose, basically, is to blur the genres of literature and journalism, and yet maintain a fine balance between fact and fiction.

In the later period of their literary career, these authors not being purely journalistic turned back to fiction writing. Capote and John Hersey never wrote any more successful work of journalism after *In Cold Blood* and *Hiroshima*, respectively. Mailer also turned to fiction and took up his old mantle of the novelist and essayist after *The Executioner's Song*. But it has to be admitted that this phase was in fact one of the most creative and influential periods of their writing lives. DeLillo, on the other hand, being more recent, is still making efforts to write about contemporary issues of concern, using fictional as well as journalistic techniques. Thus by choosing such themes and events, these authors intend to foreground a feeling of deep concern for America, its culture and society, which is changing at such a fast pace and forgetting its values and ethics.

Journalistic fiction celebrates a unique and different experience beyond ordinary life, set apart and on the edge. It uses deliberate narratives, rhetorical devices in order to bring about specific, aesthetic, emotional, and ethical effects, while dealing with historical, social, and political events with which the reader is potentially familiar. All

the four authors have explored in this study have used concrete reportage. These authors have avoided much commentary and tried more to 'show' than to 'tell', by using scene-by-scene construction, and authorial silence so as to engage the reader. So the main concern of contemporary American literary journalism is to express the inexplicable. Not only do the levels of fictionality and factuality oscillate in these works, but there is also a significant structural and, obviously, thematic disparity. David Lodge, in his essay "The Novelist at the Crossroads" writes:

> The assumption behind such experiments is that our 'reality' is so extraordinary, horrific or absurd, that the methods of conventional realistic limitation are no longer adequate. There is no point in carefully creating fiction that gives an illusion of the life where life itself seems illusory.... Art can no longer compete with life on equal terms, showing the universal in the particular. (3)

The fact that these writers are concerned and even obsessed with contemporaneous events in their works, leads the reader to contemplate the ways in which time will affect the value and relevance of their work. Past experiences show that many writers, who have confined themselves to short-term questions, have often been by-passed by time. Their work is not considered 'universal' in nature, and so loses interest when the issue loses relevance.

No doubt Capote, Hersey and Mailer have died, but Perry Smith, 'Mailer', and Gary Gilmore, the characters

in the books like *In Cold Blood*, *The Armies of the Night*, and *The Executioner's Song*, have become immortal. Don DeLillo, who rejoices in adding unexpected insertions into the even flow of time, unlikely juxtapositions of reality and strange collisions of character and personality shall be remembered both for his highly cinematic and hyper-textual style in portraying the crisis of contemporary America.

These narratives have been given suitable endings, but the readers are expected to understand that each ending is a beginning towards better comprehension. What becomes evident is that journalistic narratives have unique and highly efficient ways of expressing real events and the problems of concern. Historical analysis, close readings and comparisons of the selected texts suggest that journalistic fiction constitutes an important form of modern-day source of in-depth information. The social, political and economic contexts of these texts, and the themes addressed in them, raise interesting questions for further study. The authors' choice of journalistic fiction as a genre over other genres is their attempt to grapple with 'what is real' as 'reality grows more strange and inexplicable.'

ABBREVIATIONS:

ICB- In Cold Blood
Armies- The Armies of the Night
Fire- Of a Fire on the Moon
ES- The Executioner's Song
Un- Underworld
FM- Falling Man

Works Cited:

Primary Sources:

Capote, Truman. *In Cold Blood: A True Account of Multiple Murder and its Consequences.* London: Penguin, 1965. Print.

Capote, Truman, M. Thomas Inge. *Truman Capote: Conversations.* Mississippi: UP of Mississippi, 1987. Print.

DeLillo, Don. *Libra.* London: Penguin, 1988. Print.

- - -. *Underworld.* London: Penguin, 1997. Print.

- - -. *Falling Man.* London: Penguin, 2007. Print.

- - -. "The Power of History." *The New York Times Magazine.* 7 Sept. 1997: 60-63. Web. 12 Feb. 2010.

- - -. "In the Ruins of the Future." *Harper's.* 22 Dec. 2001: 33-40. Web. 03 Mar. 2011. http:// www.guardian. co.uk/books/2001/dec/22/fiction.

Hersey, John. *Hiroshima.* USA: Vintage, 1946. Print.

Mailer, Norman. *The Armies of the Night: History as a Novel/ The Novel as History.* London: WeidenFeld and Nicholson, 1968. Print.

- - -. *Of a Fire on the Moon.* Boston: Little Brown, 1970. Print.

- - -. *The Executioner's Song.* New York: Vintage, 1979. Print.

- - -. *The Spooky Art: Some thoughts on Writing.* New York: Random, 2003. Print.

Secondary Sources:

Abbott, H. Porter. *The Cambridge Introduction to Narrative*. Cambridge: Cambridge UP, 2002. Print.

Abrahamson, David. *The Voice behind the Voice: Narration in the Literary Journalism of Ernest Hemingway, Lillian Ross, and Hunter S. Thompson*. C A: U of California. 2000. Web. 23 Dec 2009.

Abrams, M. H. *A Glossary of Literary Terms*. Singapore: Thompson, 1999. Print.

Adams, Laura, ed. *Existential Battles: The Growth of Norman Mailer*. Athens: Ohio UP, 1976.

- - - . "Introduction." *Will the Real Norman Mailer Please Stand Up?* London: Kennikat P, 1974. 3-9. Rpt. in *Contemporary Literary Criticism*. Ed. Dedria Bryfonski. Vol. 11. Detroit: Gale, 1979. 339-345. Print.

Aldridge, John W. *Classics and Contemporaries*. Chicago: U of Missouri P, 1992. Web. 18 Aug. 2012.

Algeo, Ann M. *The Courtroom as Forum: Homicide Trials by Dreiser, Wright, Capote, and Mailer*. New York: Peter, 1996. Web. 30 Sept. 2010.

Allan, Stuart, ed. *Journalism: Critical Issues*. Jaipur: Rawat, 2005. Print.

Alter, Alexandra. "Don DeLillo on His New Book 'Point Omega' - WSJ.com." 29 Jan. 2010. Online.wsj. com. Web. 12 Aug. 2012. http://en.wikipedia.org/ wiki/Don_DeLillo#cite_note-entertainment. timesonline.co.uk-7

- - -. "Don DeLillo on Point Omega and His Writing Methods - WSJ.com." 30 Jan. 2010. Online.wsj. com. Web. 12 Aug. 2012. http://en.wikipedia.org/

wiki/Don_DeLillo#cite_note-entertainment.
timesonline.co.uk-7

Altschull, J. Herbert. *From Milton to McLuhan: The Ideas behind American Journalism.* New York: Longman, 1990. Print.

Alvarez, A. "Reflections in a Bloodshot Eye." *Commonweal,* 7 June 1968. Web. 22 July 2010.

Amis, Martin. "Survivors of the Cold War." *The New York Times.* 5 Oct. 1997. Web. 12 Nov. 2010. <http://www.nytimes.com/books/97/10/05/reviews/971005.05amisdt.html>.

"An Introduction." *Argumentation, Logic and Debate.* Web. 23 July 2012. *http://www2.bakersfieldcollege.edu/jgiertz/argumentation%20Chapter%201.htm*

Anderson, Chris. *Style as Argument: Contemporary American Nonfiction.* Carbondale: Southern Illinois UP, 1989. Print.

Andrews, M. S. D. Sclater, C. Squire, and A. Treacher, eds. *Lines of Narrative.* London: Routledge, 2000. Web. 30 Jan 2009.

Annesley, James. "Thigh bone connected to the hip bone: Don DeLillo's *Underworld* and the Fictions of Globalization." *American Studies* 47.1 (2002): 85-95. *JSTOR.* Web. 9 Dec. 2011.

Arlen, Michael J. "Notes on the New Journalism." *The Atlantic Monthly* 229.5 (1972): 61-71. Web. 17 Feb. 2010.

Asch, Nathan. Review. *New Republic* 4 Sept. 1935: 108. Web. 2 Nov. 2010.

Auer, J. Jeffrey, ed. *The Rhetoric of Our Times.* New York: Meredith, 1969. Print.

Bacon, Wallace A. *The Art of Interpretation.* New York: Holt, 1979. Print.

Bailey, Jennifer. *Norman Mailer: Quick Change Artist.* London: Macmillan, 1970. Print.

Bakhtin, Mikhail. "Discourse in the Novel: (1934-1935)." *The Dialogic Imagination: Four Essays.* Ed. Michael Holquist. Austin: U of Texas P, 1981. 259-422. Web. 4 Sept. 2010.

Bal, Mieke. *Narratology: Introduction to the Theory of Narrative.* Trans. Christine van Boheemen. Toronto: U of Toronto P, 1985. Web. 13 Mar. 2011. http://thinkingculture.blogspot.in/2004/09/bal-narratology-introduction-to-theory.html

- - -. "Poetics Today." *Poetics Today* 21: 3 (2000): 479-502. *Project Muse.* Web. 12 Dec. 2010.

Bander, Robert G. *American English Rhetoric: Writing From Spoken Models for Bilingual Students.* New York: Holt, 1971. Print.

Barry, Peter. *An Introduction to Literary and Cultural Theory.* 2nd ed. Manchester: Manchester UP, 2002. Print.

Barthes, Roland. *S/Z: An Essay.* 20th ed. Hill and Wang, 1975. Print.

- - -. "Theory of the Text." *Untying the Text: A Post-Structuralist Reader.* Ed. Robert Young. London: Routledge, 1981. 31-47. Print.

Barthes, Roland and Lionel Duisit. "An Introduction to the Structural Analysis of Narrative." *New Literary History* 6.2, On Narrative and Narratives (1975): 237-272. *JSTOR.* Web. 23 May 2009.

Baudrillard, Jean. *Simulacra and Simulation.* Trans. Sheila Faria Glaser. Ann Arbor: U of Michigan P, 1994. Web. 11 Sept. 2010.

Beale, Walter H. *A Pragmatic Theory of Rhetoric.* Carbondale: Southern Illinois UP, 1987. Print.

Begiebing, Robert J. *Acts of Regenerations: Allegory and Archetype in the Works of Norman Mailer.* London: U of Missouri P, 1980. Print.

Behar, Jack. "History and Fiction." *Novel: A Forum on Fiction* 3.3 (Spring, 1970): 260-265. *JSTOR.* Web. 9 Dec 2011.

Bentley, Phyllis. *Some Observations on the Art of Narrative.* Home & Van Thal, 1946. Print.

Benedict, Ruth. "The Past and the Future." *The Nation* 163.23 (1946): 656, 658. Rpt. in *Contemporary Literary Criticism.* Ed. Deborah A. Stanley. Vol. 97. Detroit: Gale, 1997. 296-325. Print.

Berger, A. *Narratives in Popular Culture, Media, and Everyday Life.* London: Sage, 1993. Print.

Berner, R. Thomas. *The Literature of Journalism.* State College: Strata, 1999. Print.

Berry, Joseph P. *John Kennedy and the Media: The First Television President.* Lanham, Md: UP of America, 1987. Web. 12 July 2012.

Bilton, Alan. "Don DeLillo." *An Introduction to Contemporary American Fiction.* New York: New York UP, 2002. 17-50. Print.

Bjärstorp, Sara. *Confirming Truth in Capote's: In Cold Blood, A Narratological Analysis of Autobiographical Elements.* Linnaeus U. 2010. E Diss. Web. 8 Oct. 2011.

Black, Edwin. *Rhetorical Criticism: A Study Method.* Madison: U of Wisconsin P, 1978. Print.

Blom, Mattiias Bolkeus. *Stories of Old: The Imagined West and the Crisis of Historical Symbology in the 1970s.* Uppsala: Acta Universitatis Upsaliensis, 1999. Web. 9 Oct. 2011.

Bloom, Harold. *Bloom's Modern Critical Views: Norman Mailer.* New York: Chelsea, 1986. Print.

- - -. *Bloom's Modern Critical Views: Don DeLillo.* New York: Chelsea, 2003. Print.

Bonati, Felix Martinez. *Fictive Discourse and the Structures of Literature: A Phenomenological Approach.* London: Cornell UP, 1981. Print.

Bonheim, Helmut. *The Narrative Modes: Techniques of the Short Story.* Cambridge: D.S. Brewer, 1992. Print.

Booth, Wayne C. *The Rhetoric of Fiction.* Chicago: U of Chicago P, 1961. Web. 20 Jan. 2010.

- - -. *The Rhetoric of Fiction.* 2nd. ed. Chicago: U of Chicago P, 1983. Print.

- - -. *The Rhetoric of Fiction.* 2nd. ed. Harmondsworth: Penguin, 1987. Print.

- - -. "The Rhetoric of Fiction and the Poetics of Fiction." *Novel* 1. (1968): 105-17. Web. 20 Jan. 2010.

Boudreaux, Kenny. "Fact in the Form of Fiction: The Art of Literary Journalism Gaining Momentum." 25 Nov. 2010. Web. 20 Sept. 2011. http://kennyboudreaux. writersresidence.com/samples/fact-in-the-form-of-fiction-the-art-of-literary-journalism-gaining-momentum

Bowman, Wayne D. "Why Narrative? Why Now?" *Research Studies in Music Education* 27.5 (2006) Web. 7 Aug. 2012. http:// www.brandonu.ca/music/files/2010/08/ Whyx20Narrativex20NIMEx20keynote.pdf

Boynton, R. S. *The New New Journalism: Conversations with America's Best Nonfiction Writers on Their Craft.* New York: Vintage, 2005. Print.

Boxall, Peter. *Don DeLillo: The Possibility of Fiction.* New York: Routledge, 2005. Print.

Brandy, Leo. *Norman Mailer: A Collection of Critical Essays.* New Jersey: Prentice, 1972. Print.

Branigan, Edward. *Narrative Comprehension and Film.* London: Routledge, 1992. Web. 18 Aug. 2012.

Breslin, James E. "Style in Norman Mailer's '*The Armies of the Night*'." *The Yearbook of English Studies* 8 (1978): 157-170. *JSTOR.* Web. 9 Dec. 2011.

Bretnor, Reginald. *The Craft of Science Fiction: A Symposium on Writing Science Fiction and Science Fantasy.* New York: Harper, 1976. Print.

Brewin, Chris R. *Posttraumatic Stress Disorder: Malady or Myth?* London: Yale U P, 2003. Web. 2 Jan. 2010.

Brinnin, John Malcolm. *Truman Capote.* London: Sidgwick, 1984. Print.

- - -. *Truman Capote: Dear Heart, Old Budd.* Delacourte P, 1986. Print.

Brodbeck, May, James Gray, and Walter Metzger. *American Non-Fiction, 1900-1950.* Westport : Greenwood P, 1970. Print.

Brooks, Cleanth, and Robert Penn Warren. *Modern Rhetoric.* New York: Harcourt Brace Jovanovich, 1979. Print.

Brooks, Peter. *Reading for the Plot: Design and Intention in Narrative.* Cambridge: Harvard UP, 1984. Print.

Brummett, Barry. *Rhetorical Dimensions of Popular Culture.* London: U of Alabama P, 1991. Print.

Bryer, Jackson R., ed. *Sixteen Modern American Authors: A Survey of Research and Criticism since 1972.* Vol. 2. Durhem: Duke UP, 1969. Print.

Bryfonski, Dedria, ed. *Contemporary Literary Criticism.* Vol. 13. Detroit: Gale, 1980. Print.

Bufithis, Phillip H. *Norman Mailer.* New York: Ungar, 1978. Print.

Caesar, ed. "Don DeLillo: A writer like no other." *The Sunday Times.* 21 Feb. 2010. Web. 3 July 2012. *http:// en.wikipedia.org/wiki/Don_DeLillo#cite_note- entertainment.timesonline.co.uk-7*

Campbell, Karlyn Kohrs. *The Rhetorical Act.* CA: Wadsworth. 1982. Print.

Carey, J. *A Short History of Journalism for Journalists: A Proposal and Essay.* Dec. 2007: 3-16. Web. 12 Aug. 2012.

Carpenter, Ronald H. *History as Rhetoric: Style, Narrative, and Persuasion.* U of South Carolina P, 1995. Print.

Caruth, Cathy. *Unclaimed Experience: Trauma, Narrative, and History.* Baltimore: Johns Hopkins UP, 1996. Print.

Champagne, Roland. *Literary History in the Wake of Roland Barthes: Re-Defining the Myths of Reading.* Alabama: Summa, 1984. Print.

Chatman, Seymour. "The Structure of Narrative Transmision." *In Style and Structure in Literature.* Ed. Roger Fowler. Ithaca: Cornell UP, 1975. Print.

- - -. *Story and Discourse: Narrative Structure in Fiction and Film.* London: Cornell U P, 1980. Print.

Clarke, Gerald. *Capote: A Biography.* New York: Simon, 1988. Print.

Cohn, Dorrit. "Signposts of Fictionality: A Narratological Perspective." *Poetics Today* 11.4 (Winter 1990): 775-804. Web. *JSTOR.* 8 April 2008.

Connery, Thomas B. "Preface." *A Sourcebook of American Literary Journalism: Representative Writers in an Emerging Genre.* New York: Greenwood P, 1992. Print.

- - -. "A Third Way to tell the Story: American Literary Journalism at the turn of the Century." *Literary*

Journalism in the Twentieth Century. Ed. Norman Sims. New York: Oxford UP, 1990. Print.

Connolly, Kevin. "An Interview with Don DeLillo." *Conversations with Don DeLillo.* Ed. Thomas DePietro. Jackson: UP of Mississippi, 2005. 25-39. Print.

Capote. Dir. Bennett Miller. Perf. Philip Seymour Hoffman, Catherine Keener. Clifton Collins. USA: Sony Pictures Classics, 2005. Film.

Cowart, David. *Don DeLillo: The Physics of Language.* Athens: U of Georgia P, 2002. Print.

- - -. *History & the Contemporary Novel.* Carbondale: Southern Illinois UP, 1989. Print.

- - -. "Norman Mailer: Like a Wrecking Ball from Outer Space." *Critique* 51.2 (2010): 159-167. *Routledge.* Web. 15 Mar. 2011.

Culler, Jonathan. "Story and Discourse in the Analysis of Narrative." *The Pursuit of Signs: Semiotics, Literature, Deconstruction.* Ithaca: Cornell UP, 1981.

- - -. *Structuralist Poetics: Structuralism Linguistics and the Study of Literature.* London: Routledge, 1975. Print.

Cummings, Corin. *Shades of Journalism: An Apprenticeship in Literary Journalism.* 1995. Web. 13 Sept. 2008.

Daiches, David. *Critical Approaches to Literature.* London: Longman, 1956. Print.

Davis, Joe Lee, John T. Frederick, and Frank Luther Mott, ed. *A Treasury of American Literature.* Vol II Charles Scrinner, 1948. Print.

De Bellis, Jack. "Visions and Revisions: Truman Capote's *In Cold Blood.*" *Journal of Modern Literature* 7.3 (1979): 519-536. Web. 11 Sept. 2011.

DeCurtis, Anthony. "'An Outsider in This Society': An Interview with Don DeLillo." *Introducing Don DeLillo*. Ed. Frank Lentricchia. Durham: Duke UP, 1991. 43-66. Print.

DeLillo, Don. Interview by Robert McCrum. "Don DeLillo: 'I'm not trying to manipulate reality – this is what I see and hear." *The Observer* 8 Aug. 2010. Web. 12 Aug. 2012.

- - -. "Cosmopolis Interviews - Rob Pattinson, David Cronenberg, Don Delillo." ONDT. 23 April 2012. Web. 14 Aug. 2012. http://ohnotheydidnt.livejournal.com/68430780.html#ixzz29wGQmKDf

Didion, Joan. "I want to go ahead and do it." *Critical Essays on Norman Mailer*. Ed. Michael J. Lennon. Boston: CK, 1986. Print.

Dugdale, John. "Art and Terror: *Falling Man*." *Literary Review*. Web. 9 July 2012. http://www.literaryreview.co.uk/dugdale_05_07.html

Duvall, John N. *Don DeLillo's Underworld: A Reader's Guide*. New York: Continuum, 2002. Print.

- - -, ed. *The Cambridge Companion to Don DeLillo*. Cambridge: Cambridge UP, 2008. Print.

- - -, ed. *Modern Fiction Studies* 57.3 (Fall 2011). John Hopkins UP. Print.

Eason, David. "The New Journalism and the Image-World." *Literary Journalism in the Twentieth Century*. Ed. Norman Sims. Oxford: Oxford UP, 1990. Print.

Edmundson, Mark. "Romantic Self-Creations: Mailer and Gilmore in *The Executioner's Song*." *Contemporary Literature* 31.4 (1990): 434-447. Web. 13 Jan. 2011.

Ehrlich, Robert. *Norman Mailer: The Radical as Hipster*. New York: Scarecrow P, 1978. Print.

Eisinger, Chester E. *Fiction of the Forties*. Chicago: U of Chicago P, 1963. Print.

Elie, Paul. "DeLillo's Surrogate Believers." *Commonwealth* 124.19 (November 7, 1997): 19-22. Rpt. in *Contemporary Literary Criticism*. Ed. Jeffrey W. Hunter. Vol. 143. Detroit: Gale, 2001. 160-231. Print.

Faris, Wendy B. *Labyrinths of Languages*. London: John Hopkins UP, 1988. Print.

Fish, Stanley. "Rhetoric." *Critical Terms for Literary Study*. Eds. Frank Lentricchia and Thomas McLaughlin. 2nd ed. Chicago: U of Chicago P, 1990. 203-22. Print.

Fishkin, Shelly Fisher. *From Fact to Fiction: Journalism & Imaginative Writing in America*. Oxford U P, 1988. Print.

Fludernik, Monika. *The Fictions of Language and the Languages of Fiction: The Linguistic Representation of Speech and Consciousness*. London: Routledge, 1993. Web. 22 Dec. 2010.

- - -. *An Introduction to Narratology*. New York: Routledge, 2009. Print.

Foley, Barbara. *Telling the Truth: The Theory and Practice of Documentary Fiction*. London: Cornell U P, 1986. Print.

Forster, E. M. *Aspects of the Novel*. Harcourt Brace Jovanovich, 1985. Print.

Foster, Richard Jackson. *Norman Mailer*. Minneapolis: U of Minnesota P, 1968. Print.

Franklin, Jon. *Writing for Story: Craft Secrets of Dramatic Nonfiction by a Two-Time Pulitzer Prize Winner.* New York: New American Library, 1987. Print.

FriedMan, Alan. *The Turn of the Novel: The Transition to Modern Fiction.* Oxford: Oxford UP, 1966. Print.

Frye, Northrop. *Anatomy of Criticism.* New Jersey: Princeton UP, 2000. Print.

Frus, Phyllis. *The Politics & Poetics of Journalistic Narrative.* Cambridge UP, 2009. Print.

García Landa, *Structural Narratology.* 1994. Online edition (2005) 2005-05 21: < http://www.unizar. es/departamentos/filologia_inglesa/garciala/ publicaciones/structuralnarratology/>

Gardner, James. "A Review of *Underworld.*" *National Review* 49.22 (November 24, 1997): 60-61. Rpt. in *Contemporary Literary Criticism.* Ed. Jeffery W. Hunter. Vol. 143. Detroit: Gale, 2001. 160-231. Print.

Garson, Helen S. *Truman Capote.* New York: Ungar, 1980. Print.

Geertz, Clifford. *Local Knowledge.* New York: Basic, 1983. Print.

- - -. *Works and Lives: The Anthropologist as Author.* Stanford: Stanford UP, 1988. Print.

Genette, Gerard. *Narrative Discourse.* Trans. Jane E. Lewin. Ithaca: Cornell UP, 1980. Print.

- - -. *Narrative Discourse Revisited.* Trans. Jane E. Lewin. Ithaca: Cornell UP, 1988. Print.

Ghent, Dorothy Van. *The English Novel: Form & Fiction.* London: Harper Torch Books, 1953. Print.

Gleason, Paul. "History as Accretion and Excavation." *Critical Ecologies.* 2004-08-24. Web. 2 July 2011.

http://www.electronicbookreview.com/thread/criticalecologies

Glendy, Michael K. *Modern Novelists: Norman Mailer.* New York: St. Martin P, 1995. Print.

Glenn, Cheryl. *Unspoken: A Rhetoric of Silence.* Carbondale: Southern Illinois UP, 2004.

Goldstein, William. "P W Interviews: Don DeLillo." *Conversations with Don DeLillo.* Ed. Thomas DePietro. Jackson: U P of Mississippi, 2005. 47-51. Web. 19 Apr. 2012.

Grobel, Lawrence. *Conversations with Capote.* New York: New American Library, 1995. Print.

Guest, David. *Sentenced to Death: The American Novel and Capital Punishment.* Mississippi: UP of Mississippi, 1997. Print.

Guillemette, Lucie, and Cynthia Lévesque. "Narratology." *Signo.* Web. 23 Sept. 2010. http://www.signosemio.com/genette/narratology.asp

Gunton, Sharon R, ed. *Contemporary Literary Criticism.* Vol. 19. Detroit: Gale, 1981. Print.

Gutkind, Lee. *The Art of Creative Nonfiction: Writing and Selling the Literature of Reality.* New York: Wiley, 1997. Print.

Hackman, Paul Stewart. "The Media Assemblage: The Twentieth-Century Novel in Dialogue with Film, Television, and New Media." Diss. Illinois: U of Illinois, 2010. Print.

Hall, Sharon K, ed. *Contemporary Literary Criticism.* Vol. 34. Detroit: Gale, 1985. Print.

Hamilton, Hamish. "In Cold Print: Capote." *The Economist.* 9 pars. 27 August 1988. Lexis-Nexis.

Happe, François. "'Jade Idols' and 'Ruined Cities of Trivia': History and Fiction in DeLillo's *Libra.*" *American*

Studies in Scandinavia 28.1 (1996): 23-35. Web. 13 July 2012.

Hartsock, John. *A History of American Literary Journalism: The Emergence of a Modern Literary Form.* Amherst: U of Massachusetts P, 2000. Print.

Heiney, Donald, and Lenthiel H. Downs. *Recent American Literature after 1930.* New York: Barron, 1974. Print.

Hellman, John. *Fables of Fact: The New Journalism as New Fiction.* Chicago: U of Ill. P, 1981. Print.

Helton, Michael. *Truman Capote's Nonfiction Novel "In Cold Blood" and Bennett Miller's Biopic "Capote": A Comparison.* GRIN Verlag, 2009. Print.

Helyer, Ruth. "'Refuse Heaped Many Stories High': DeLillo, Dirt, and Disorder." *Modern Fiction Studies* 45.4 (Winter, 1999): 987-1006. Rpt. in *Contemporary Literary Criticism.* Ed. Jeffrey W. Hunter. Vol. 143. Detroit: Gale, 2001. 160-231. Print.

Hendin, Josephine. *A Concise Companion to Postwar American Literature and Culture.* MA: Blackwell Pub., 2004. Web. 12 May 2008.

- - - . "Angries: S-M as a Literary Style," *Harper's Magazine* 248.1485 (February, 1974): 87-93. Rpt. in *Contemporary Literary Criticism.* Ed. Daniel G. Marowski. Vol. 38. Detroit: Gale, 1986. 77-87. Print.

- - - . *Vulnerable People: A View of American Fiction since 1945.* Bombay: Oxford UP, 1979. Print.

Herman, David. "Stories as a Tool for Thinking." *Narrative Theory and the Cognitive Sciences.* Ed. David Herman. Stanford: CSLI, 2003. 163-192. Print.

Heyne, Eric. "Towards a Theory of Literary Nonfiction." Modern Fiction Studies 33. 3 (1987), 479-490. Print.

Hicks, Wynford, Sally Adams, and Harriett Gilbert. *Writing for Journalists.* New York: Routledge, 1999. Print.

Hill, Knox C. *Interpreting Literature.* Chicago: U of Chicago P. 1966. Print.

Hollowell, John. *Fact & Fiction: The New Journalism and the Nonfiction Novel.* London: U of Illinois P, 1981. Print.

- - -. *Narrative & Structure: Exploratory Essays.* London: Cambridge UP, 2010. Print.

- - -. "Style over Substance in Capote's *In Cold Blood*." 123HelpMe.com. Web. 26 Sep 2010.

Honeycutt, Lee, Comp. "Aristotle's *Rhetoric*." Web. 21 Feb. 2012. http://rhetoric.eserver.org/aristotle/index. html

Howard, Maureen. *The Penguin book of Contemporary American Essays.* New York: Penguin, 1985. Print.

Humphries, David T. *Different Dispatches: Journalism in American Modernist Prose.* New York: Routledge, 2005. Print.

Hutcheon, Linda. *A Poetics of Postmodernism: History, Theory, Fiction.* New York: Routledge, 1988. Print.

Ickstadt, Heinz. "Loose Ends and Patterns of Coincidence in Don DeLillo's *Libra*." *Historiographic Metafiction in Modern American and Canadian Literature.* Eds. Bernd Engler & Kurt Müller. Germany: Ferdinand Schöningh, 1994. 299-312. Web. 12 Jan. 2012.

Infamous. Dir. Douglas McGrath. Prod. Christine Vachon. Perf. Toby Jones, Sandra Bullock, Daniel Craig. Warne Independent Pictures, 2006. Film.

Inge, M. Thomas. *Truman Capote: Conversations.* Jackson, Mississippi: UP of Mississippi, 2004. Print.

Iser, Wolfgang. "Narrative Strategies as a Means of Communication." *Interpretation of Narrative.* Ed. Mario J. Valdes and Owen J. Miller. Toronto: U of Toronto P, 1978. Web. 3 July 2010.

- - -. *The Act of Reading.* Baltimore: Johns Hopkins UP, 1978. Web. 8 Oct. 2010.

- - -. *The Implied Reader.* Baltimore: Johns Hopkins UP, 1974. Web. 8 Oct. 2010.

Jahn, Manfred. *Narratology: A Guide to the Theory of Narrative.* Cologne: U of Cologne. 2005. Print.

Jelinek, Estelle C. *The Tradition of Women's Autobiography: From Antiquity to the Present.* Boston: Twayne, 1986. Print.

"John Hersey, Author of 'Hiroshima,' Is Dead at 78." *The New York Times.* March 25, 1993. Web. 23 Mar. 2009.

Joshi, Reetinder. *The Political Imagination of Norman Mailer.* Diss. Punjabi U of Patiala, 1996. Print.

Kakutani, Michiko. "Of American as a Splendid Junk Heap." *The New York Times.*16 Sept. 1997. Web. 3 July 2010.

Kaufman, Donald L. "Catch-23: The Mystery of Fact (Norman Mailer's Final Novel?)" *Twentieth Century Literature* 17.4 (1971): 247-256. Print.

Kazin, Alfred. 'The Trouble He's Seen.' *The New York Times Book Review.* 1-2 (5 May 1968): 26.

- - -. *Bright Book of Life: American Novelists and Storytellers from Hemingway to Mailer.* Boston: Little, 1970. Print.

- - -. *"The World as a Novel: From Capote to Mailer." The New York Books Review* XVI.6 (April 8, 1971): 26-30. Web. 12 July 2011.

Kearns, Michael. *Rhetorical Narratology.* Lincoln: U of Nebraska P, 1999. Print.

Keesey, Douglas. *Don DeLillo.* New York: Twayne, 1993. Print.

Kellman, Stevan G. "Mailer's Strains of Fact." *Southwest Review* 68. Dallas: Southern Methodist UP, 1983. Web. 13 Mar. 2011.

Kermode, Frank. *The Sense of an Ending: Studies in the Theory of Fiction.* Oxford: Oxford UP, 1966. Print.

- - -. *The Genesis of Secrecy: On the Interpretation of Narrative.* Cambridge: Harvard UP, 1979. Print.

Kernan, Alvin B. "The Taking of the Moon: The Struggle of the Poetic and Scientific Myths in Norman Mailer's *Of a Fire on the Moon.*" *Bloom's Modern Critical Views: Norman Mailer.* 2003: 7-31. Print.

Kerrane, Kevin and Ben Yagoda, ed. *The Art of Fact: A Historical Anthology of Literary Journalism.* New York: Simon, 1998. Print.

Kettle, Arnold. *An Introduction to the English Novel.* Harper, 1960. Print.

Kindt, Tom, and Hans-Harald Müller. *The Implied Author: Concept and Controversy.* Berlin: de Gruyter, 2006. Web. 20 Mar. 2010.

Kleber, Rolf J., Charles R. Figley, and Berthold P. R. Gersons, eds. *Beyond Trauma: Cultural and Societal Dynamics.* New York: Plenum, 1995. Web. 21 Sept. 2010.

Knellwolf, Christa, and Christopher Norris, ed. *The Cambridge History of Literary Criticism.* Vol. 9. Cambridge UP, 2001. Web. 25 Dec. 2009.

Koch, Tom. *Journalism for the 21ˢᵗ Century: Online Information, Electronic Databases, and the News.* New York: Praeger, 1991. Print.

Koval, Ramona. "Norman Mailer and the American Way." *The Australian Broadcasting Corporation's Gateway to Arts and Culture.* 13 Feb. 2003 www. abc.net.au/arts/books/stories/s424265.htm

Kramer, Hilton. "Review of *Of a Fire on the Moon*." *The Washington Post Book World* (Jan. 10, 1971).

Kramer, Mark. "Breakable Rules for Literary Journalists." *Literary Journalism.* Ed. Norman Sims and Mark Kramer. New York: Ballantine, 1995. 21-34. Print.

Kraus, Elisabeth, and Carolin Aner. *Simulacrum America: the USA and the Popular Media.* Camden House, 2000. Print.

Krebs, Albin. "Truman Capote Is Dead at 59; Novelist of Style and Clarity." *New York Times* (August 28, 1984). Web.

Kronick, Joseph. "*Libra* and the Assassination of JFK: A Textbook Operation." *Arizona Quarterly* 50.1 (1994): 109-132. Web. 13 Mar. 2011.

Kunitz, Stanley, ed. *Twentieth Century Authors.* First Supplement, 1955. Web. 22 June 2010.

Landow, George P. *Elegant Jeremiahs: The Sage from Carlyle to Mailer.* Ithaca: Cornell UP, 1986.

- - - . *Hypertext 2.0: The Convergence of Contemporary Critical Theory and Technology.* London: Johns Hopkins UP, 1997. Print.

Lang, Amy Schrager. *The Syntax of Class.* Princeton: Princeton U P, 2003.

Laplanche, J. and J.B. Pontalis. *The Language of Psycho-Analysis.* Norton, 1967. Print.

LeClair, Tom. "An Underhistory of Mid-Century America." *The Atlantic Monthly* 280.4 (October 1997): 113-116. Web. 21 Nov. 2010.

Lee, James Melvin. *History of American Journalism.* New York: Garden City, 1917. Print.

Leeds, Barry H. *The Structural Vision of Norman Mailer.* London: UP of London, 1969. Print.

Lehman-Haupt, Christopher. "A Pilgrim's Regress in Dallas, November' 63." *New York Times* (18 July 1988): C15. Rpt. in *Contemporary Literary Criticism.* Ed. Jean C. Stine. Vol. 27. Detroit: Gale, 1984. 76-86. Print.

Lehtimäki, Markku. *The Poetics of Norman Mailer's Nonfiction. Self-Reflection, Literary Form, and the Rhetoric of Narrative.* E Diss. Finland: Tampere UP, 2005.

Leigh, Nigel. *Radical Fictions and the Novels of Norman Mailer.* London: Macmillan, 1990. Print.

Leisy, Ernest E. *The American Historical Novel.* Oklahoma: U of Oklahoma P, 1950. Print.

Lennard J. Davis. *Factual Fictions: The Origins of the English Novel.* New York: Columbia UP, 1983. Print.

Lennon, Michael J. *Critical Essays on Norman Mailer.* London: UP of Mississippi, 1986. Print.

- - -. *Conversations with Norman Mailer.* London: UP of Mississippi, 1988. Print.

Lentricchia, Frank. "*Libra* as Postmodern Critique." *South Atlantic Quarterly* 89.2 (1990): 431-453. Web. 10 Jan. 2010.

- - -. *The Edge of Night.* New York: Random, 1994. Print.

Lentricchia, Frank, and Thomas McLaughlin, eds. *Critical Terms for Literary Study*. 2nd ed. Chicago: U of Chicago P, 1990. Print.

Levine, Paul. "Reality and Fiction." *The Hudson Review* 19.1 (1966): 135-138. Web. 10 Jan. 2010.

Liddell, Robert. *A Treatise on the Novel*. London: Cape, 1963. Print.

Lodge, David. "Composition, Distribution, Arrangement: Form and Structure in Jane Austen's Novels." *After Bakhtin: Essays on Fiction and Criticism*. London: Routledge, 1990. Print.

- - -. *The Novelist at the Crossroads*. Cornell U P, 1971. 10-12. Rpt. in *Contemporary Literary Criticism*. Ed. Carolyn Riley. Vol. 4. Detroit: Gale, 1975. 318-324. Print.

Lounsberry, Barbara. *The Art of Fact: Contemporary Artists of Nonfiction*. New York: Greenwood P, 1990. Print.

Lubbock, Percy. *The Craft of Fiction*. Scribner: 1921. Print.

Lukacs, George. *The Historical Novel*. London: Merlin P, 1962. Print.

"Mailer, Norman." *Encyclopedia Britannica* 2007. Encyclopedia Britannica Online. 19 June 2007 <http://www.search.eb.com.lp.hscl.ufl.edu/eb/article-254015>.

Malin, Irving, ed. Truman Capote's *In Cold Blood: A Critical Handbook*. Belmont: Wadsworth, 1968. Print.

Malpas, Simon, and Paul Wale, eds. *The Routledge Companion to Critical Theory*. Oxford: Routledge, 2006. Print.

Manoff, Robert, and Michael Schudson. *Reading the News: A Pantheon Guide to Popular Culture.* New York: Pantheon, 1986. Print.

Manso, Peter. *Mailer: His Life and Times.* New York: Simon, 1985. Print.

Many, Paul. "Towards a History of Literary Journalism." *Michigan Academician* 24 (1992). Web. 12 Feb. 2010.

Marchand, Philip. "When Garbage and Paranoia Rule." *Toronto Star* (4 Oct. 1997): M17.

Marowski, Daniel G., ed. *Contemporary Literary Criticism.* Vol. 40. Detroit: Gale, 1986. Print.

Martin, Robert A. *The Writer's Craft: Hopwood Lectures, 1965-81.* Ann Arbor: U of Michigan P, 1986. Print.

Martin, Wallace. *Recent Theories of Narrative.* London: Cornell UP, 1986. Print.

Marx, Leo. *The Machine in the Garden: Technology and the Pastoral Ideal in America.* London: Oxford UP, 1964. Web. 25 June 2011.

McConnel, Frank. "Books and the Arts: '*The Executioner's Song*'." *The New Republic* 181.17 (October 27, 1979): 28-30. *Contemporary Literary Criticism.* Ed. Dedria Bryfonski, and Laurie Lanzen Harris. Vol. 14. Detroit: Gale, 1980. 348-354. Print.

McDonald, Henry. "The Narrative Act: Wittgenstein and Narratology." *Surfaces* IV (1994). U of Montreal P, Web. 15 Apr. 2008.

McHale, Brian. "Free Indirect Discourse: a survey of recent accounts." *Poetics and Theory of Literature* 3 (1978): 249-87. Web. 23 Mar. 2010.

McLaughlin, Robert L. "Shot Heard round the world." *America Book Review* 19.2 (January, 1998): 20-22. Rpt. in *Contemporary Literary Criticism.* Ed.

Jeffrey W. Hunter. Vol. 143. Detroit: Gale, 2001. 160-231. Print.

McAleer, John J. "*An American Tragedy* and *In Cold Blood*: Turning Case History into Art." *Thought* 47 (Winter 1972). Web. 12 Mar. 2010.

Mead, George Herbert. *The Philosophy of the Present*. Illinois: Open Court, 1959. Print.

Mendelson, Phyllis Carmel, and Dedria Bryfonski, ed. *Contemporary Literary Criticism*. Vol. 7. Detroit: Gale, 1977. Print.

Merill, Robert. "Mailer's Sad Comedy: The Executioner's Song." *Texas Studies in Literature and Language* 34.1 (1992): 128-48. Print.

- - -. *Norman Mailer*. New York: Twayne, 1978. Print.

- - -. *Norman Mailer Revisited*. New York: Twayne, 1992. Print.

Mexal, Stephan J. "SpectacularSpectacular!: *Underworld* and the Production of Terror." *Studies of the Novel* 36.3 (Fall 2004). *University of North Texas*. Web. 20 Mar. 2011.

Mills, Harry. *Mailer: A Biography*. New York: Empire, 1982. Print.

Minot, Stephen. *Literary Nonfiction: The Fourth Genre*. London: Longman, 2003. Print.

Mitgang, Herbert. "Reanimating Oswald, Ruby et al. in a Novel on the Assassination." *The New York Times* (19 July 1988). Web. 17 July 2011.

Monzoni, Alessandro, Sandra Bermann, and Del Romanzo Storico. *On the Historical Novel*. U of Nebraska P, 1996. Print.

Moretti, Franco. *Graphs, Maps, Trees: Abstract Models for a Literary History*. New York: Verso, 2005. Print.

Morreall, John. "The Myth of the Omniscient Narrator." *The Journal of Aesthetics and Art Criticism* l.52.4 (1994): 429-435. *JSTOR*. Web. 2 Feb. 2011.

Mott, Christopher M. "*Libra* and the Subject of History." *Critique: Studies in Contemporary Fiction* 35.3 (1994): 135-40. Print.

Mott, Frank Luther. *The News in America.* Cambridge: Harvard UP, 1952. Print.

Munson, Gorham B. *Style and Form in American Prose.* New York: Doubleday, 1929. Print.

Murphy, James E. "The New Journalism: A Critical Perspective." *Association for Educators in Journalism* (1974): 16. Web. 13 Dec. 2011.

Nachman, Larry David. "Crime and the Need to Punish." *Salmagundi* 49 (Summer 1980): 132-142. *JSTOR.* Web. 8 Dec. 2011.

Nagano, Yoshihiro. "Inside the Dream of the Warfare State: Mass and Massive Fantasies in Don DeLillo's *Underworld.*" *Critique* 52.3 (2010): 241-256. *Routledge.* Web. 15 Mar. 2011.

Newall, Paul. "Introducing Philosophy 21: Rhetoric." *The Galilean Library* (2005). Web. 13 Jan 2009.

Newfield, Jack. *Columbia Journalism Review,* July-August 1972. Web. 20 Feb. 2011.

- - -. "The Truth about Objectivity." *Liberating the Media.* Ed. Charles C. Flippan, 59-6. Web. 18 May 2011.

Nicol, Charles. "Studying the Sloppy Woodsman." *National Review* (June 21, 1974): 710-11. Rpt. in *Contemporary Literary Criticism.* Ed. Carolyn Riley. Vol. 4. Detroit: Gale, 1975. 318-324. Print.

Oates, Joyce Carol. "The Technology of the Unconscious: The Art of Norman Mailer." *New Heaven, New*

Earth: The Visionary Experience in Literature.
London: Victor Gollancz, 1976. Web. 19 May 2011.

Onega, Susana, and Jose Angel Gracia Landa, eds.
"Introduction". *Narratology: An Introduction.*
London: Longman, 1996: 1-41. Print.

Palmer, Alan. "The Construction of Fictional Minds."
Narrative 10.1 (January 2002): 28-46. *Project Muse.* Web. 7 Sept. 2011.

Parrish, Timothy L. "Pynchon and DeLillo." *UnderWords: Perspectives on Don DeLillo's Underworld.* Eds.
Joseph Dewey, Steven G. Kellman, and Irving
Malin. Newark: U of Delaware P, 2002. 79-92.
Print.

Passaro, Vince. "Dangerous Don DeLillo." *The New York Times* (19 May1991). Web. 19 May 2011. http://
en.wikipedia.org/wiki/Don_DeLillo#cite_note-
entertainment.timesonline.co.uk-7

Pavel, Thomas G. "Literary Narratives." *Discourse and Literature.* Ed. Teun Adrianus Van Dijk.
Amsterdam: John Benjamins, 1985. 85-103. Web.
23 Oct. 2011.

Perkins, George. *The Theory of the American Novel.* New
York: Holt, 1970. Print.

Phelan, James. *Worlds from Words: A Theory of Language in Fiction.* Chicago: U of Chicago P, 1981. Print.

- - -. *Reading People, Reading Plots: Character, Progression, and the Interpretation of Narrative.* Chicago: U of
Chicago P, 1989. Web. 22 Sept. 2011.

- - -. *Reading Narrative Form, Ethics, Ideology.* Columbus:
Ohio State UP, 1989. Print.

- - -. *Narrative as Rhetoric.* Columbus: Ohio State UP,
1996. Print.

Phelan, James, and Peter J. Robinowitz. *Understanding Narrative.* Columbus: Ohio State UP, 1994. Print.

Plimpton, George. "The Story Behind a Nonfiction Novel." *New York Times* (16 Jan 1966): BR2. Web. 10 Feb. 2010.

- - -. *Writers at Work: The Paris Review Interviews, Sixth Series.* New York: Viking P, 1984. Print.

Poirier, Richard. *Norman Mailer.* New York: Viking P, 1972. Print.

Poolos, Jamie. *Atomic Bombing of Hiroshima and Nagasaki.* New York: Infobase, 2008. Web. 12 Aug 2011.

Prince, Gerard. *Narratology: The Form and Functioning of Narrative.* Berlin: Mouton, 1982. Print.

- - -. "Narrative pragmatics, message, and point." *Poetics* 12 (1983): 527-536. Web. http://www.pierregander. com/phd/courses/narratology/prince.html

- - -. *Dictionary of Narratology.* Revised ed. Lincoln: Nebraska P, 2003.Web. 12 Jan. 2012.

Propp, Vladimir. *Morphology of the Folktale.* Bloomington: Indiana UP, 1928. Print.

Radford, Jean. *Norman Mailer: A Critical Study.* London: MacMillan P, 1975. Print.

Rajnath, ed. *Twentieth Century American Criticism: Interdisciplinary Approaches.* New Delhi: Edward Arnold-Heinemann, 1977. Print.

Ramus, Peter. *"Arguments in Rhetoric against Quintilian."* 1549, tr. C. Newlands 1986. Web. 3 Sept. 2011. http://home.uchicago.edu/~ahkissel/rhetoric/ ramus.html

Reed, Kenneth T. *Truman Capote.* Boston: Twayne, 1981. Print.

Reeve, N. H. "Oswald Our Contemporary: Don DeLillo's *Libra*." *An Introduction to Contemporary Fiction:*

International Writing in English since 1970. Ed. Rod Mengham. Cambridge: Polity, 1999. 135-49. Print.

Refferty, Terrance. "Self-Watcher." *The New Yorker* LXIV.32 (September 26, 1988): 108-10. Rpt. in *Contemporary Literary Criticism.* Ed. Daniel G. Marowski and Roger Matuz. Vol. 54. Detroit: Gale, 1989. 78-95. Print.

Rhodes, Joe. *Rhetoric and Civilization.* LA: Jewett Media Services, 2011. Web. 12 Aug. 2012.

Richter, David H. *Fable's End: Completeness and Closure in Rhetorical Fiction.* Chicago: U of Chicago P, 1974. Print.

Riley, Carolyn, ed. *Contemporary Literary Criticism.* Vol. 1. Detroit: Gale, 1973. Print.

Riley, Carolyn, and Phyllis Carmel Mendelson, ed. *Contemporary Literary Criticism.* Vol. 5. Detroit: Gale, 1976. Print.

Ricketson, Matthew. "Truman Capote and the World He Made." *Meanjin* 69.3 (Spring 2010): 89-101. Web. 2 Feb. 2012.

Rimmon-Kenan, Shlomith. *Narrative Fiction: Contemporary Poetics.* London: Methuen, 1983. Print.

- - -. *Narrative Fiction: Contemporary Poetics 2nd Edition.* New York: Routledge, 2002. Print.

Roberts, W. Rhys, trans. *Rhetoric.* Procyon, 1996. Web. 12 July 2012. http://libertyonline.hypermall.com/Aristotle/Rhetoric/Rhetoric.html

Robinowitz, Peter J. *Before Reading: Narrative Conventions and the Politics of Interpretation.* London: Cornell UP, 1987. Print.

Rollyson, Carl. *The Lives of Norman Mailer: A Biography.* New York: Paragon, 1991. Print.

- - -. "Biography in a New Key." *Chicago Review* 31.4 (Spring 1980): 31-38. *JSTOR*. Web. 8 Dec. 2011.

Ron, Moshe. "Free Indirect Discourse, Mimetic Language Games and the Subject of Fiction." *Poetics Today* 2.2 (1981): 17-39. Web. 10 Jan. 2010.

Root, Robert L. *The Rhetoric of Popular Culture: Advertising, Advocacy, and Entertainment.* New York: Greenwood P. 1987. Print.

Rovit, Earl. "True Life Story." *The Nation* (20 Oct. 1979): 376-378. Web. 12 Nov. 2011.

Royal, Cindy. "The Future of Literary Journalism on the Internet." Austin: U of Texas, 2000. 1-27. Web. 20 Sept. 2011. http://www.CindyRoyal.com

Rucker, Bryce W. *Report at its Best.* Iowa: Iowa State UP, 1964. Print.

Ruppersburg, Hugh and Tim Engles. "Introduction." *Critical Essays on Don DeLillo.* Eds. Ruppersburg and Engles. New York: GK, 2000. 1-27. Print.

Russell, Bertrand. *Fact & Fiction.* Simon, 1962. Print.

Schmid, David. "The Nonfiction Novel." *The Cambridge History of the American Novel.* Ed. Leonard Cassuto, and Benjamin Reiss. Cambridge: Cambridge UP, 2011. 986-1001. Print.

Schmuhl, Robert, ed. *Responsibilities of Journalism.* New Delhi: East-West P, 1984. Print.

Scholes, Robert, and Robert Kellogg. *The Nature of Narrative.* New York: Oxford UP, 1966. Print.

Scura, Dorothy M. *Conversations with Tom Wolfe.* London: UP of Mississippi, 1990. Print.

Selden, Raman. *The Theory of Criticism: from Plato to the Present (A Reader).* London: Longman. 1988. Print.

Severo, Richard. "John Hersey, Author of '*Hiroshima*', Is Dead at 78." *The New York Times* (March 25, 1993): B11. Rpt. in *Contemporary Literary Criticism.* Ed. James P. Draper. Vol. 81. Detroit: Gale, 1994. 328-337. Print.

Shields, Charles J. *Mockingbird: A Portrait of Harper Lee.* New York: Henry, 2006. Print.

Short, Mick. *Exploring the Language of Poems, Plays and Prose.* Harlow: Longman, 1996. Web. 20 April 2011.

Sims, Norman. "The Art of Literary Journalism." *Literary Journalism.* Ed. Norman Sims, and Mark Kramer. New York: Ballantine, 1995. 3-19. Print.

- - -, ed. *Literary Journalism in the Twentieth Century.* New York: Oxford UP, 1990. Print.

Simon, John. "Mailer on the March." *The Hudson Review* 21.3 (Autumn, 1968): 541-545. *JSTOR.* Web. 9 Dec 2011.

Sloan, W. David, and Lisa Mullikin Parcell, eds. *American Journalism: History, Principles, Practices.* Jefferson: McFarland, 2002. Print.

Speare, Morris Edmund. *The Political Novel: It's Development in England and in America.* New York: Russell, 1966. Print.

Stein, Gertrude, Thornton Wilder, and Liesl M. Olson. *Narration: Four Lectures.* Chicago: U of Chicago P, 2010. Print.

Steinbeck, E., and R. Wallsten, eds. *Steinbeck: A Life in Letters.* New York: Viking, 1975. Web. 4 Jan. 2011.

Stevenson, Lionel. *The English Novel: A Panorama.* Houghton Mifflin, 1960. Print.

Stine, Jean C., ed. *Contemporary Literary Criticism.* Vol. 28. Detroit: Gale, 1984. Print.

"Stranger Than Fiction." *Times Literary Supplement* (17 Mar. 1966). Web. 13 March 2010.

Stull, James N. *Literary Selves: Autobiography and Contemporary American Nonfiction.* New York: Greenwood P, 1993. Print.

Sturess, Philip J. M. *Narrativity: Theory & Practice.* New York: Clarendon P, 1992. Print.

Subramanyam, N. S. *Movements in Modern English Novel.* Gwalior: Kitab Ghar, 1967. Print.

Tabbi, Joseph. "Mailer's Psychology of Machines." *PMLA* 106. 2 (Mar., 1991): 238-250. *JSTOR.* Web. 8 Dec. 2011.

Talese, Gay, and Barbara Lounsberry, eds. *The Literature of Reality.* New York: Harper, 1996. Print.

Tanner, Tony. "Afterthoughts on Don DeLillo's *Underworld.*" *Raritan* 17A (1998): 48-71. Web. 12 Mar. 2012.

- - -. "Death in Kansas." *The Spectator* 216. 7186 (March 18, 1966): 331-32. Rpt. in *Contemporary Literary Criticism.* Ed. Roger Matuz. Vol. 58. Detroit: Gale, 1990. 84-136. Print.

The Executioner's Song. Dir. Lawrence Schiller. Perf. Tommy Lee Jones, Christine Lahti, and Rosanna Arquette. USA: NBC, 1982. Film.

Thomas, Glen. "History, Biography, and Narrative in Don DeLillo's *Libra.*" *Twentieth Century Literature: A Scholarly and Critical Journal* 43.1 (1997): 107-124. Web.

Toolan, Michael J. *Narrative: A Critical Linguistic Introduction.* 2nd ed. New York: Routledge, 2001. Print.

Topping, Donna, and Roberta McManus. *Real Reading, Real Writing.* Portsmouth: Heinemann, 2002. Print.

Towers, Robert. "From the Grassy Knoll." *The New York Books Times Review* XXXV.13 (August 18, 1988): 6-7. Rpt. in *Contemporary Literary Criticism.* Ed. Daniel G. Marowski, and Roger Matuz. Vol. 54. Detroit: Gale, 1989. 175-180. Print.

Tyler, Anne. "Dallas Echoing Down the Decades." *The New York Times Book Review* (July 24, 1988): 22-3. Rpt. in *Contemporary Literary Criticism.* Ed. Daniel G. Marowski, and Roger Matuz. Vol. 54. Detroit: Gale, 1989. 175-180. Print.

Underwood, Doug. *Journalism and the Novel Truth and Fiction, 1700–2000.* Cambridge: Cambridge U P. 2008. Web. 12 Feb. 2010.

Updike, John. *Hugging the Shores: Essays in Criticism.* New York: Penguin, 1985. Print.

- - -. *Due Considerations: Essays and Criticism.* New York: Knopf, 2007. Print.

Vickers, Brain. *In Defence of Rhetoric.* Oxford: Clarendon P, 1988. Print.

Waldron, Randall H. "The Naked, the Dead, and the Machine: A New Look at Norman Mailer's First Novel." *PMLA* 87. 2 (Mar., 1972): 271-277. *JSTOR.* Web. 29 Jan. 2011.

Walton, Dauglas. *Media Argumentation: Dialectic, Persuasion, and Rhetoric.* Cambridge: Cambridge U P, 2007. Web. 18 Aug. 2012.

Watt I and Carnochan W. *The Rise of the Novel*. California: U of California P, 2001. Web. 18 Aug. 2012.

Watt, Ian. *The Rise of the Novel*. Los Angeles: U of California P, 1957. Web. 9 July 2011.

Watt, William W. *An American Rhetoric*. New York: Holt, 1964. Print.

Waugh, Patricia. *Literary Theory and Criticism*. New York: Oxford UP, 2006. Print.

Weber, Ronald, ed. *The Reporter as Artist: A Look at the New Journalism Controversy*. New York: Hastings, 1974. Print.

- - -. *The Literature of Fact*. Athens: Ohio UP, 1980. Print.

- - -. "Hemingway's Permanent Records." *Literary Journalism in the Twentieth Century*. Ed. Norman Sims. New York: Oxford UP, 1990. 21-52. Print.

- - -."Murder as Subject." *The Sewanee Review* 88. 4 (Fall, 1980): 659-664. *JSTOR*. Web. 8 Dec. 2011.

Weinberg, Helen. *The New Novel in America: the Kafkan Mode in Contemporary Fiction*. New York: Cornell UP, 1970. Print.

Weingarten, Marc. *The Gang That Wouldn't Write Straight: Wolfe, Thompson, Didion, Capote, and the New Journalism Revolution*. New York: Crown P, 2006. Print.

Wenke, Joseph. *Mailer's America*. Hanover: UP of New England, 1987. Print.

Werge, Thomas. "An Apocalyptic Voyage: God, Satan, and the American Tradition in Norman Mailer's '*Of a Fire on the Moon*'." *The Review of Politics* 34. 4 (Oct., 1972): 108-128. *JSTOR*. Web. 9 Dec. 2011.

West, Paul. *The Modern Novel*. Vol. 2. London: Hutchinson, 1963. Print.

White, Hayden. "The Value of Narrativity in the Representation of Reality." *Narratology*. Eds. Susana Onega and Jose Angel Garcia Landa. London: Longman, 1996. 273-285. Print.

- - -. *Tropics of Discourse: Essays in Cultural Criticism*. Baltimore: Johns Hopkins UP, 1978. Web. 13 Mar. 2011.

- - -. "The Historical Text as Literary Artefact." *In The Writing of History: Literary Form and Historical Understanding*. Ed. Robert H. Canary, and Henry Kozicki. Madison: U of Wisconsin P, 1978. 41-62. Web. 13 Mar. 2011.

Whittemore, Reed. *The Poet as Journalist: Life at the New Republic*. Washington D.C.: New Republic, 1976. Print.

Wiegand, David. "We Are What We Waste." *San Francisco Chronicle* (21 Sept. 1997): 1, 6. Web. 12 Oct. 2011.

Wilkins, L. "Humankind, Nature and the New Journalism: A Return to the Mythopoeic." *Ecquid Novi* 10:1 & 2 (Winter 1989): 179-197.Web. 4 July 2011. http://list.msu.edu/cgibin/wa?A3=ind9612b&L=AEJMC&E=0&P=1033657&B=--&T=text%2Fplain

Willman, Skip. "Art After Dealey Plaza: DeLillo's *Libra*." *MFS: Modern Fiction Studies* 45.3 (1999): 621-640. Web. 2 Dec. 2011.

- - -. "Traversing the Fantasies of the JFK Assassination: Conspiracy and Contingency in Don DeLillo's *Libra*." *Contemporary Literature* 39.3 (1998): 405-433. Web. 2 Dec. 2011.

Wilson, Andrew. "American Minimalism: The Western Vernacular in Norman Mailer's *The Executioner's Song*." *European journal of American studies* [Online] 1 (23 May 2009): 2. Web. 5 Aug. 2012.

URL: http://ejas.revues.org/7532; DOI: 10.4000/ejas.7532

Wimsatt, William K., and Cleanth Brooks. *Literary Criticism: A Short History*. London: Routledge, 1957. Print.

Wolfe, Tom. *The Purple Decades*. New York: Farrar Straus Girour, 1982. Print.

Wolfe, Tom, and E. W. Johnson, ed. *The New Journalism*. New York: Harper, 1973. Print.

Wood, Michael. "Post-Paranoid." *London Review of Book* (5 Feb. 1998). Web. 21 Mar. 2011. <http//www.lrb.co.uk/v20n03/wood0119.html>.

Yagoda, Ben. "*In Cold Facts, Some Books Falter.*" *The New York Times* (15 March 1998), late ed. Lexis-Nexis.

Yaros, R. "Is it the Medium or the Message?" *Communication Research* 33:4 (Aug. 2006): 285-309. Web. 12 Aug. 2012.

Yardley, Jonathan. "Appointment in Dallas." *Book World-The Washington Post* (July 31, 1988): 3. Rpt. in *Contemporary Literary Criticism*. Ed. Daniel G. Marowski, and Roger Matuz. Vol. 54. Detroit: Gale, 1989. 175-180. Print.

Yavenditti, Michael J. "John Hersey and the American Conscience: The Reception of *Hiroshima*." *Pacific Historical Review* XLIII.1 (February, 1974): 24-49. Rpt. in *Contemporary Literary Criticism*. Ed. Deborah A. Stanley. Vol. 97. Detroit: Gale, 1997. 296-325. Print.

Zavarzadeh, Mas'ud. *The Mythopoeic Reality: The Post-War American Nonfiction Novel*. Urbana, Il: U of Illinois P, 1980. Print.

Zdovc, Sonja Merljak. *Literary Journalism in the United States of America and Slovenia.* UP of America, 2008. Web. 15 Sept. 2010.

http://en.wikipedia.org/wiki/Infamous_(film)

http://en.wikipedia.org/wiki/Capote_(film)

http://en.wikipedia.org/wiki/The_Executioner%27s_Song_(film)